PERSPECTIVE IN ACTION

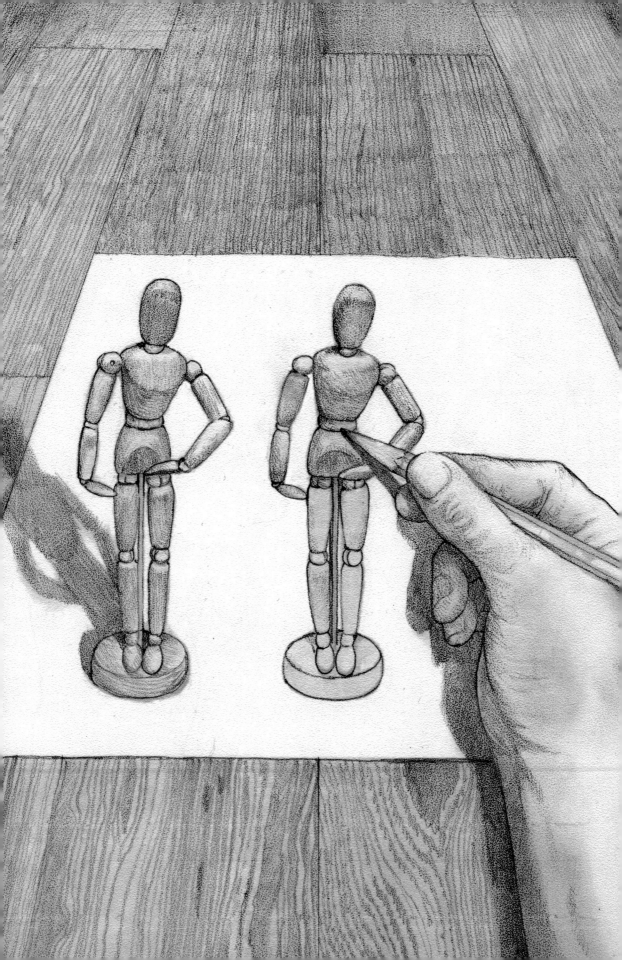

PERSPECTIVE IN ACTION

Creative Exercises for Depicting Spatial Representation
from the Renaissance to the Digital Age

DAVID CHELSEA

WATSON-GUPTILL PUBLICATIONS
California | New York

CONTENTS

INTRODUCTION

Perspective has given me wings as an artist, and it has been my joy over the past two decades to share my knowledge of it with readers. In my previous books, *Perspective! for Comic Book Artists* and *Extreme Perspective! For Artists*, I lifted up the hood and showed you the inner mechanics of perspective. Now let's take it for a spin and see how fast the thing will go. We'll need to pack a little heavier on this trip, so in addition to the standard pencils, rulers, and paper, you'll need to get comfortable with compasses, light tables, foam core board, and more. We won't just be drawing perspective on paper; we'll be learning how to create interesting projects, murals, and simple animations. Some of this material may already seem familiar. While I touched lightly on anamorphosis (a distorted form of drawing requiring the viewer to occupy a specific vantage point to reconstitute the image) and spherical perspective in my previous book, *Extreme Perspective!*, they seemed to call for fuller explanation, and they get it in this book. A couple of topics that have long intrigued me, stereo perspective and motion perspective, also get a thorough exploration.

 I have tried to keep the theoretical and mathematical aspects of the subject to a minimum in this book, and to provide details and exact instruction in how to create each project described, with a full list of materials. Hopefully, by the end of it, you will have a good enough understanding of the basic principles to create new and unique perspective projects of your own.

1
BASICS

Anyone familiar with my other two perspective books, *Perspective! for Comic Book Artists* and *Extreme Perspective! For Artists*, will not really need to look at this chapter. This is just for the reader who may be new to perspective and needs a grounding in the basics of constructing one-, two-, and three-point perspective. However, I do include one not-so-basic element: "the Unified Field," a way to work out any angle of one-, two-, or three-point perspective within a single picture. It has always been a problem in constructing three-point perspective that there is no easy way to combine it in the same picture with one- or two-point perspective, or with a different angle of three-point perspective. When you rotate an object relative to its surroundings, the vanishing points (the distant points where the parallel lines on a rectilinear object converge) rotate too. They must occupy new, very specific positions depending on the precise angle of rotation. Placing them wrong introduces an unavoidable element of distortion.

In the past, my efforts to work out every possible angle of perspective in a single drawing have involved constructing a large chart mapping out every possible vanishing point on multiple horizons, with lines between them making hyperbolic tracks in the sky. The problem is that to truly include every possible angle of perspective you need a very large chart indeed. This is because all vanishing points but the central one are at infinity in one-point perspective; angles of perspective that are very close to one-point will have vanishing points located at a ludicrous distance from the center of vision. My other attempt at a visual representation of the Unified Field involved a complicated Escher-type globe on which the corners of multiple tilted cubes could be plotted, wound up resembling a tangled basket. I'm not sure even Escher could have made that one seem clear. Finally, I sketched out not a chart but a method to find vanishing points that I believe will work in all cases. Happily, I stumbled on the method outlined in this chapter in time to include it in this book, although I really wish I had thought of it twenty years ago when I did my first perspective book. At my age, I am happy to still be making discoveries.

An early draft of the Unified Field, necessarily cropped, because its full size is infinite.

IN ORDER TO UNDERSTAND THE REST OF THE BOOK, YOU DO NEED A BASIC UNDERSTANDING OF ONE-, TWO-, AND THREE-POINT PERSPECTIVE. IF YOU'VE ALREADY READ EITHER OF MY OTHER PERSPECTIVE BOOKS, YOU CAN SKIP THIS PART.

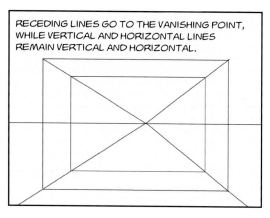

IN ONE-POINT PERSPECTIVE, YOU START BY DRAWING THE HORIZON AND MARKING A CENTRAL VANISHING POINT (THAT'S THE POINT WHERE RECEDING LINES MEET).

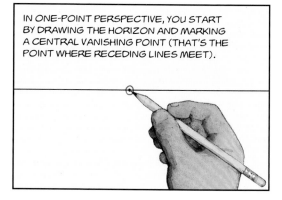

RECEDING LINES GO TO THE VANISHING POINT, WHILE VERTICAL AND HORIZONTAL LINES REMAIN VERTICAL AND HORIZONTAL.

SO FAR, SO SIMPLE. WHAT REALLY TAKES ONE-POINT PERSPECTIVE TO THE NEXT LEVEL IS ADDING ANOTHER VANISHING POINT OFF TO THE SIDE.

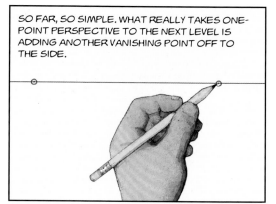

THIS IS THE DIAGONAL, OR 45°, VANISHING POINT. IT ENABLES YOU TO DRAW A SQUARE TILE PATTERN ON THE FLOOR . . .

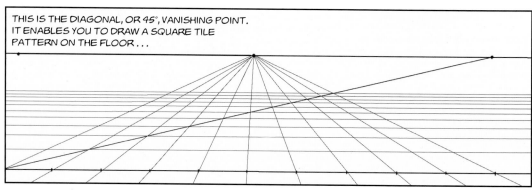

. . . WHICH ENABLES YOU TO DRAW WALLS WITH THE SQUARES ALL THE SAME SIZE . . .

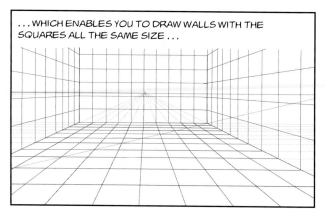

. . . AND THAT ENABLES YOU TO CREATE REGULAR AND CONSISTENT MEASUREMENT ANYWHERE IN THE PICTURE.

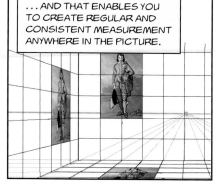

IN ADDITION TO AN UPRIGHT VIEW, ONE-POINT PERSPECTIVE CAN ALSO BE USED TO CONSTRUCT A VIEW FROM ABOVE OR BELOW.

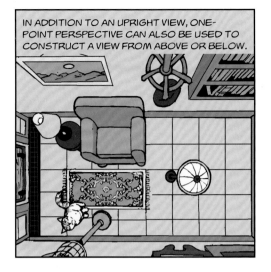

ON TO TWO-POINT PERSPECTIVE: YOU ALSO START BY DRAWING THE HORIZON, BUT THIS TIME YOU PUT TWO VANISHING POINTS ON IT.

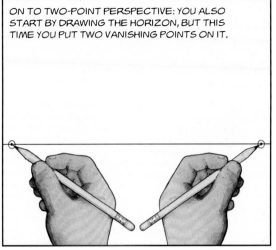

AN OBJECT DRAWN IN TWO-POINT PERSPECTIVE WILL HAVE TWO SETS OF HORIZONTAL LINES RECEDING TO VANISHING POINTS, BUT ITS VERTICAL LINES WILL REMAIN UPRIGHT AND PARALLEL.

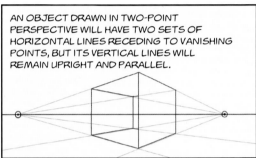

GETTING CONSISTENT MEASUREMENT IN TWO-POINT PERSPECTIVE IS MORE COMPLICATED THAN IN ONE-POINT. BEGIN BY SELECTING A POINT ON THE HORIZON TO BE YOUR CENTER OF VISION.

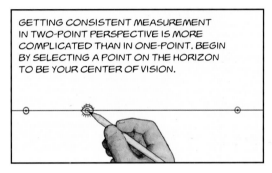

DRAW A VERTICAL LINE UNDER THE SELECTED POINT EXTENDING DOWN THE PAGE.

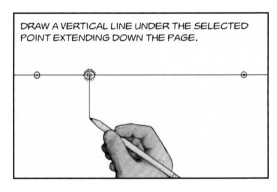

NOW, DRAW A HALF-CIRCLE FROM ONE VANISHING POINT TO THE OTHER.

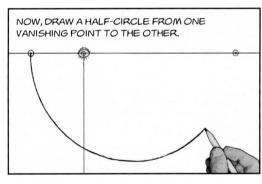

DRAW STRAIGHT LINES FROM EACH VANISHING POINT TO THE POINT WHERE THE HALF-CIRCLE INTERSECTS THE LINE UNDER THE CENTER OF VISION.

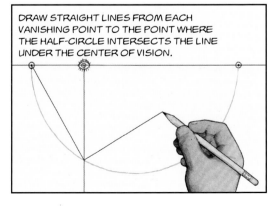

THOSE LINES WILL MEET AT A PERFECT 90° ANGLE. USE A PROTRACTOR TO DRAW A LINE AT 45°, INTERSECTING THE HORIZON.

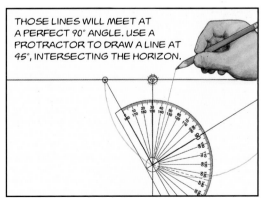

THE POINT WHERE THAT LINE INTERSECTS THE HORIZON IS THE DIAGONAL VANISHING POINT--THAT IS, THE VANISHING POINT FOR DIAGONALS OF ALL SQUARES PARALLEL TO THE GROUND.

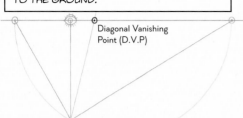

Diagonal Vanishing Point (D.V.P)

DRAW A PERFECT SQUARE WITH THE 90° ANGLE AS ITS BOTTOM CORNER.

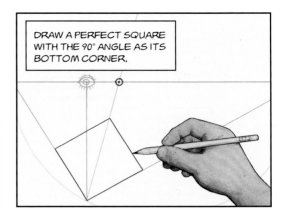

DRAW A VERTICAL LINE OVER THE BOTTOM CORNER, EXACTLY THE LENGTH OF YOUR SQUARE.

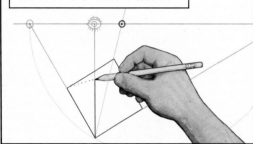

DRAW A HORIZONTAL LINE UNDER THE BOTTOM CORNER. FROM THE LEFT AND RIGHT CORNERS, DROP VERTICAL LINES DOWN TO INTERSECT THAT LINE.

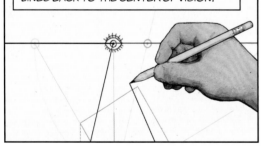

FROM THE INTERSECTION POINTS, DRAW LINES BACK TO THE CENTER OF VISION.

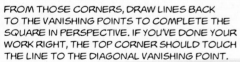

THE TWO POINTS WHERE THESE LINES INTERSECT THE LINES YOU HAVE ALREADY DRAWN INDICATE THE LEFT AND RIGHT CORNERS OF THE SQUARE IN PERSPECTIVE.

FROM THOSE CORNERS, DRAW LINES BACK TO THE VANISHING POINTS TO COMPLETE THE SQUARE IN PERSPECTIVE. IF YOU'VE DONE YOUR WORK RIGHT, THE TOP CORNER SHOULD TOUCH THE LINE TO THE DIAGONAL VANISHING POINT.

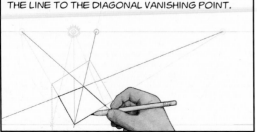

USING BOTH VANISHING POINTS IN COMBINATION WITH THE DIAGONAL VANISHING POINT, YOU SHOULD BE ABLE TO DRAW AN ACCURATE SQUARE GRID IN TWO-POINT PERSPECTIVE.

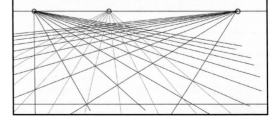

NOW, TO BUILD A WALL WITH EQUAL DIVISIONS IN TWO-POINT PERSPECTIVE: REMEMBER THAT VERTICAL LINE YOU DREW?

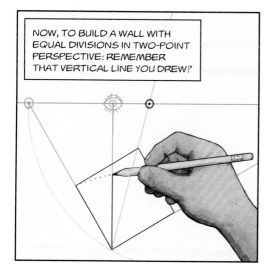

DRAW LINES FROM THE TOP OF THAT VERTICAL LINE BACK TO BOTH VANISHING POINTS.

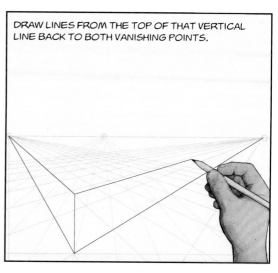

ERECT VERTICAL LINES OVER THE SQUARE DIVISIONS ON THE FLOOR.

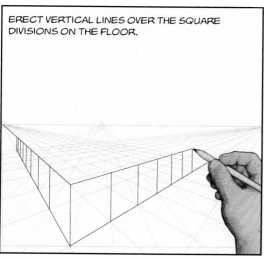

ADDING MORE RECEDING LINES TO MAKE THE WALL TALLER IS SIMPLE. THE VERTICAL DIVISIONS ARE THE SAME HEIGHT AS THE ORIGINAL VERTICAL LINE.

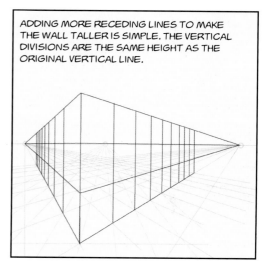

YOU CAN BUILD NEW WALLS BY EXTENDING THE DIVISIONS FROM AN EXISTING WALL BACK TO THE VANISHING POINT, AND ERECTING NEW VERTICALS OVER DIVISIONS IN THE FLOOR.

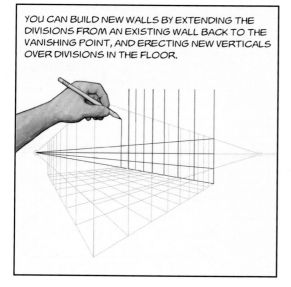

ALL THE WALLS, FLOORS, OR CEILINGS YOU DRAW WILL HAVE SAME-SIZE TILES, AND YOU CAN USE THOSE TILES FOR CONSISTENT MEASUREMENT ANYWHERE IN THE PICTURE.

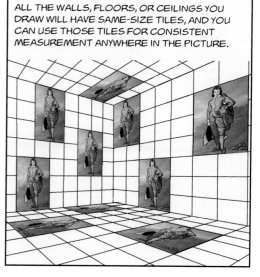

TWO-POINT PERSPECTIVE CAN BE USED SIDEWAYS
TO CONSTRUCT A SCENE FROM ABOVE OR BELOW.

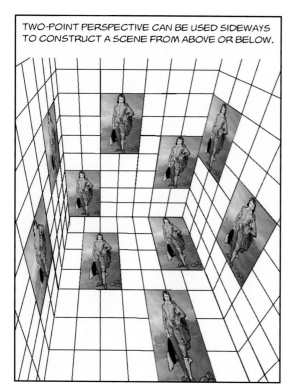

LIKE TWO-POINT PERSPECTIVE,
THREE-POINT PERSPECTIVE
BEGINS WITH A HORIZON WITH
TWO VANISHING POINTS ON IT.

THE DIFFERENCE
IS THAT YOU
ADD A THIRD
VANISHING POINT
AT THE BOTTOM,
AND TWO MORE
LINES TO FORM
A TRIANGLE.

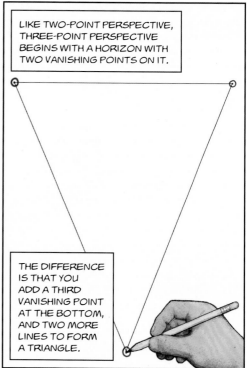

THE NEXT STEP: DRAW A
VERTICAL LINE FROM THE
BOTTOM VANISHING POINT
UP TO THE HORIZON.

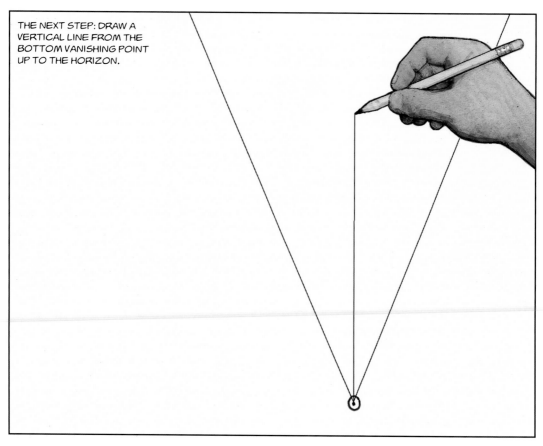

AFTER THAT, DRAW A PERPENDICULAR LINE
FROM THE LEFT EDGE OF THE TRIANGLE TO
THE RIGHT VANISHING POINT.

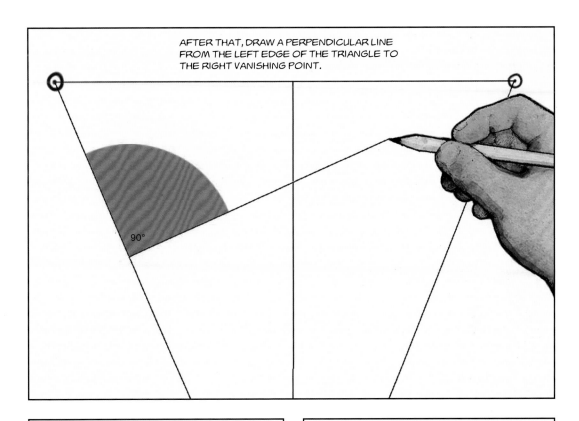

90°

THE POINT WHERE THOSE LINES INTERSECT
IS THE CENTER OF VISION. DRAW A THIRD
LINE THROUGH THAT POINT FROM THE LEFT
VANISHING POINT TO THE RIGHT EDGE OF
THE TRIANGLE.

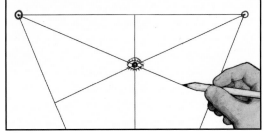

NOW, DRAW A HALF-CIRCLE BELOW THE
TOP HORIZON (THE OTHER TWO LINES
OF THE TRIANGLE ARE ALSO HORIZONS).

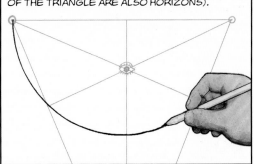

AT THE POINT WHERE THE HALF-CIRCLE
INTERSECTS THE CENTRAL VERTICAL LINE,
DRAW TWO LINES TO THE TOP TWO VANISHING
POINTS, FORMING A 90° ANGLE.

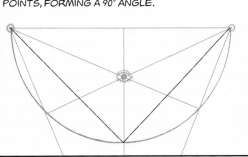

USE A PROTRACTOR TO FIND THE 45°
VANISHING POINT ON THE TOP HORIZON.

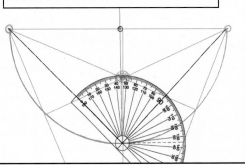

YOU WILL NEED TO FIND THE 45° VANISHING POINTS ON THE LEFT AND RIGHT SIDES OF THE TRIANGLE AS WELL.

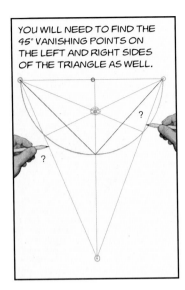

TO FIND ONE, DRAW A HALF-CIRCLE AROUND EITHER LINE FROM VANISHING POINT TO VANISHING POINT AND MARK WHERE THE HALF-CIRCLE INTERSECTS THE LINE PERPENDICULAR TO THAT SIDE OF THE TRIANGLE.

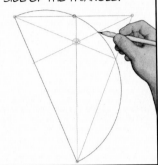

DRAW LINES FROM THE VANISHING POINTS MEETING AT A RIGHT ANGLE AT THE INTER-SECTION POINT, THEN USE A PROTRACTOR TO FIND THE 45° VANISHING POINT ON THAT SIDE OF THE TRIANGLE.

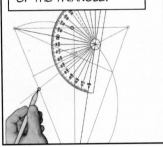

NOW, DRAW LINES FROM EACH OF THOSE 45° VANISHING POINTS TO THE VANISHING POINT ON THE OPPOSITE CORNER OF THE TRIANGLE.

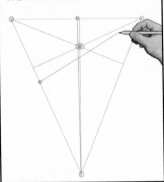

DRAWING A LINE FROM THE REMAINING VANISHING POINT THROUGH THE POINT WHERE THEY CROSS AUTOMATICALLY GIVES YOU THE THIRD 45° VANISHING POINT.

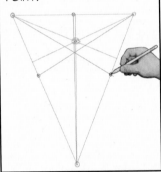

FROM THERE, YOU CAN CREATE A THREE-POINT GRID BY DIVIDING UP EACH QUADRILATERAL SECTION INTO SQUARE TILES USING DIAGONALS AND THE THREE VANISHING POINTS.

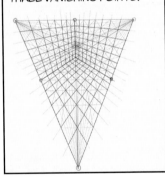

OR, YOU COULD START BY ARBITRARILY PICKING A POINT TO BE THE CORNER OF THE WALL.

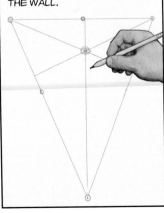

DEFINE THE EDGES OF A WALL BY DRAWING LINES BACK TO THE BOTTOM AND LEFT VANISHING POINTS.

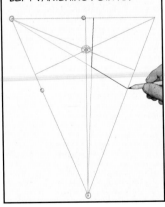

ADD ANOTHER PARALLEL LINE ON THE WALL AT WHATEVER HEIGHT YOU CHOOSE.

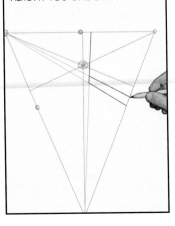

THEN, DRAW A LINE FROM THE 45° VANISHING POINT TO FIND THE CORNER OF A SQUARE TILE IN PERSPECTIVE.

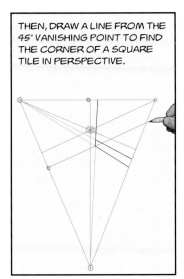

DRAW ANOTHER LINE FROM THE BOTTOM VANISHING POINT TO ESTABLISH THE EDGE OF A VERTICAL ROW OF TILES.

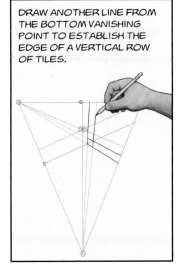

LITTLE BY LITTLE, USING LINES FROM THE 45° VANISHING POINT AND THE LEFT AND BOTTOM VANISHING POINTS, YOU CAN DRAW A WALL OF TILES.

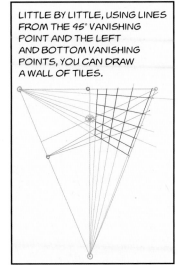

USING THE VANISHING POINT ON THE RIGHT, CARRY THE DIVISIONS FROM THE RIGHT WALL OVER TO THE LEFT WALL AND FLOOR.

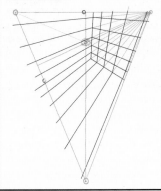

THE TOP 45° VANISHING POINT WILL SHOW YOU WHERE THE DIVISIONS ARE ON THE FLOOR.

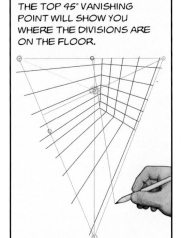

THE NEXT STEP IS OBVIOUS: DRAW LINES BACK TO THE LEFT VANISHING POINT . . .

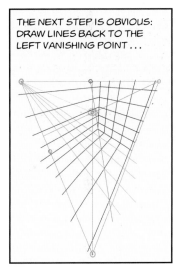

. . . AND THEN, DRAWING THROUGH THE INTERSECTIONS WITH THE LEFT EDGE OF THE FLOOR, ADD VERTICAL LINES TO THE LEFT WALL.

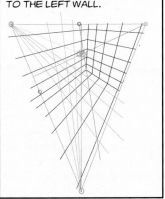

ONCE YOU HAVE THE WALLS AND FLOOR ENTIRELY DIVIDED UP . . .

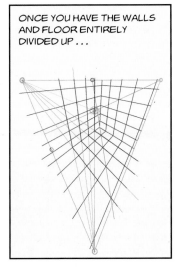

. . . MAKING EQUAL MEASUREMENTS ANYWHERE IN THE PICTURE A SNAP!

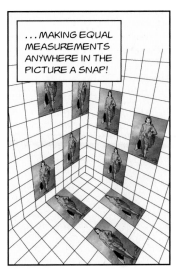

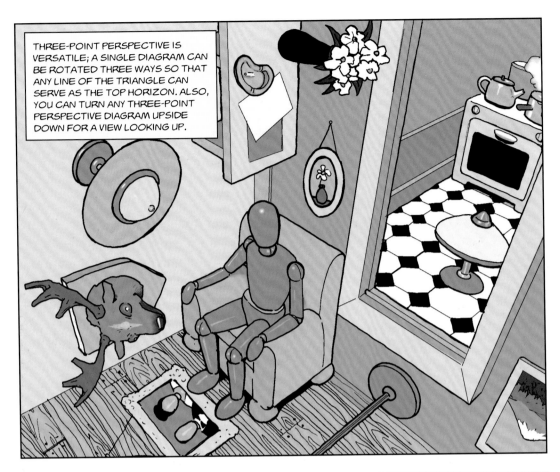

THREE-POINT PERSPECTIVE IS VERSATILE; A SINGLE DIAGRAM CAN BE ROTATED THREE WAYS SO THAT ANY LINE OF THE TRIANGLE CAN SERVE AS THE TOP HORIZON. ALSO, YOU CAN TURN ANY THREE-POINT PERSPECTIVE DIAGRAM UPSIDE DOWN FOR A VIEW LOOKING UP.

THOSE ARE PRETTY MUCH THE BASICS OF ONE-, TWO-, AND THREE-POINT PERSPECTIVE. NOW LET'S GET INTO SOMETHING NOT SO BASIC, BUT VERY USEFUL: HOW TO COMBINE THEM ALL IN A SINGLE PICTURE, USING A METHOD I CALL "THE UNIFIED FIELD."

LET'S START WITH A ONE-POINT PERSPECTIVE.

DRAW AN EYE AROUND THE CENTRAL VANISHING POINT TO SHOW THAT IT IS THE CENTER OF VISION. WE'RE GOING TO BE MOVING PERSPECTIVE AROUND VERY SHORTLY, BUT THE CENTER OF VISION WILL REMAIN FIXED.

THE 45° VANISHING POINTS AT THE SIDE OF THE PICTURE WILL COME IN VERY HANDY LATER.

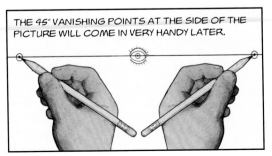

THE POINT UNDER THE HORIZON WHERE YOU MEASURE THE ANGLES FOR TWO-POINT PERSPECTIVE IS THE SAME DISTANCE UNDER THE HORIZON AS THE 45° VANISHING POINT IS FROM THE CENTRAL VANISHING POINT.

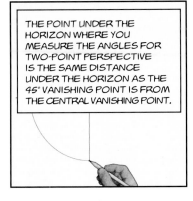

CENTER A PROTRACTOR ON THAT POINT TO MAKE TWO MARKS ON THE HORIZON, EACH 30° FROM THE CENTER OF VISION.

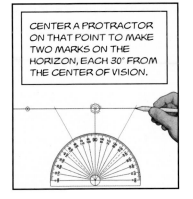

A CIRCLE DRAWN THROUGH THOSE TWO MARKS DEFINES A 60° CONE OF VISION, THE AREA IN WHICH YOU'LL DO MOST OF YOUR DRAWING.

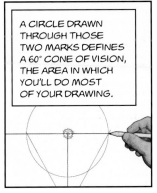

TO MAKE A SYMMETRICAL TWO-POINT PERSPECTIVE, TRANSFORM EACH 45° VANISHING POINT INTO A PLAIN VANISHING POINT, AND MAKE THE CENTRAL VANISHING POINT A 45° VANISHING POINT.

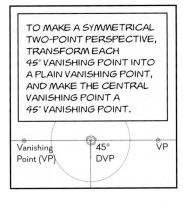

Vanishing Point (VP) 45° DVP VP

LINES DRAWN FROM THE VANISHING POINTS TO THE MEASURING POINT WILL MEET AT A 90° ANGLE.

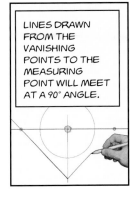

TILT THE LINES IN ONE DIRECTION OR ANOTHER AND THEY MARK NEW VANISHING POINTS ON THE HORIZON. THE RED MIDDLE LINE SHOWS WHERE THE 45° VANISHING POINT GOES.

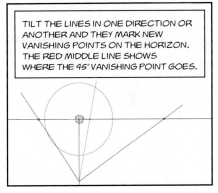

THE WHOLE PROCESS WILL WORK SIDEWAYS FOR TWO-POINT VIEWS TIPPED UP OR DOWN.

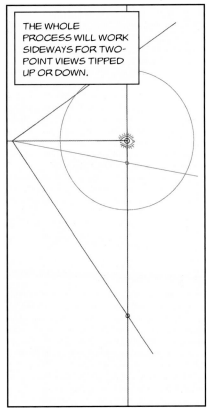

NOW, THE HARD PART: TURNING THAT TWO-POINT PERSPECTIVE INTO A THREE-POINT PERSPECTIVE.

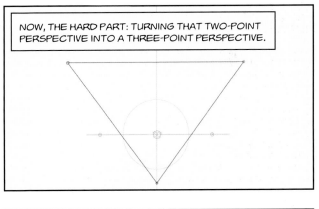

ONE PIECE OF KNOWLEDGE HELPS YOU GET THERE: EVERY VERTICAL LINE IN THIS THREE-POINT DIAGRAM COVERS 90°, ONE-QUARTER OF YOUR FIELD OF VISION (EVERYTHING THAT CAN BE SEEN FROM THAT SPOT, INCLUDING WHAT'S BEHIND YOUR HEAD).

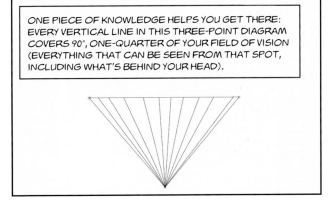

HERE'S WHY: IF YOU IMAGINE YOUR EYE IS AT THE CENTER OF A CIRCLE, THE AREA BETWEEN THE HORIZON AND THE POINT UNDER YOUR FEET IS EXACTLY 90°, ONE-QUARTER OF THAT CIRCLE.

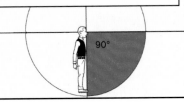

EACH OF THESE LINES COVERS 90° OF THE CIRCLE.

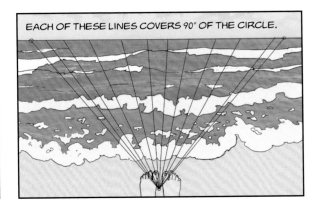

LET'S GO BACK TO THE SIDEWAYS TWO-POINT DIAGRAM. ADD A HORIZON AT THE TOP AND A VANISHING POINT AT THE BOTTOM.

THE QUESTION IS, WHERE DO WE PUT THE OTHER TWO VANISHING POINTS?

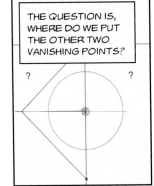

EACH V.P. IN A SYMMETRICAL 45° PERSPECTIVE IS AS FAR FROM A POINT ON THE HORIZON DIRECTLY OVER THE CENTER OF VISION AS THAT POINT IS FROM THE MEASURING POINT.

FIND A NEW MEASURING POINT BY TRANSFERRING THE LENGTH OF A LINE BETWEEN THE MEASURING POINT AND THE CENTER OF THE TOP HORIZON DOWN TO A POINT DIRECTLY UNDER THE CENTER OF VISION.

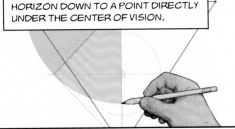

NOW THAT YOU HAVE FOUND THAT POINT, PIVOT A 90° CORNER ONE DIRECTION OR ANOTHER TO ESTABLISH NEW VANISHING POINTS ON THE TOP HORIZON.

THIS METHOD WORKS FOR THREE-POINT PERSPECTIVE TIPPED FURTHER UP OR DOWN.

ESTABLISH THE TOP HORIZON AND THE BOTTOM VANISHING POINT USING A 90° ANGLE PIVOTING ON THE SIDEWAYS MEASURING POINT, AND CARRY OVER THAT LENGTH BETWEEN THE MEASURING POINT AND HORIZON TO FIND A NEW MEASURING POINT.

THEN, USE THAT MEASURING POINT TO ESTABLISH NEW VANISHING POINTS ON THE HORIZON.

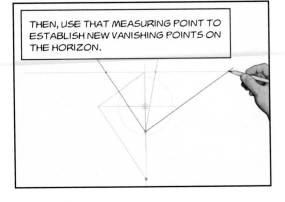

YOU SHOULD ALREADY KNOW HOW TO FIND
THE 45° VANISHING POINTS; IF NOT, REFER
BACK TO PAGE 10.

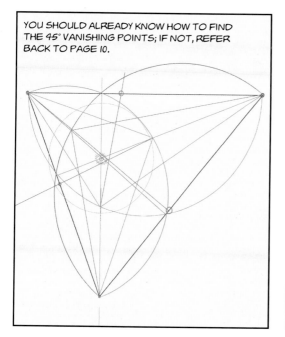

WHAT REMAIN CONSTANT NO MATTER
HOW MANY DIFFERENT ANGLES OF THREE-
POINT PERSPECTIVE YOU CONSTRUCT
ARE THE POSITION OF THE CENTER OF
VISION, THE SIZE OF THE CONE OF VISION,
AND THE PLACEMENT OF THE BOTTOM
VANISHING POINT DIRECTLY UNDER THE
CENTER OF VISION.

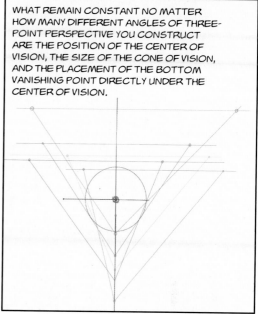

WITH THIS METHOD, YOU CAN MIX ANY ANGLE OF ONE-, TWO-, AND
THREE-POINT PERSPECTIVE AND BE CERTAIN THAT THEY WILL REMAIN
INTERLOCKED AND CONSISTENT, WITH ALL VANISHING POINTS CORRECTLY
POSITIONED AND WITH THE CENTER OF VISION AND CONE OF VISION THE
SAME FOR ALL OBJECTS. WELCOME TO THE UNIFIED FIELD!

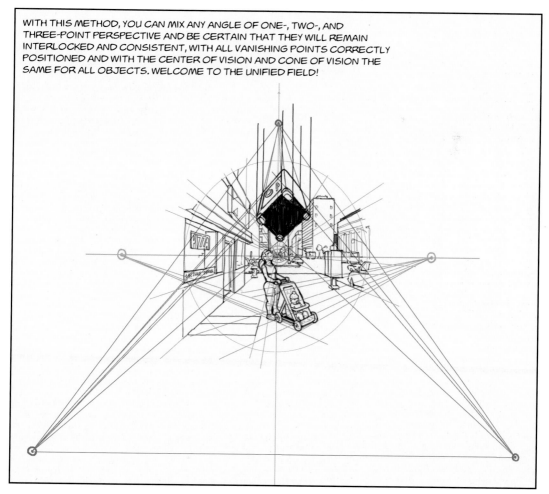

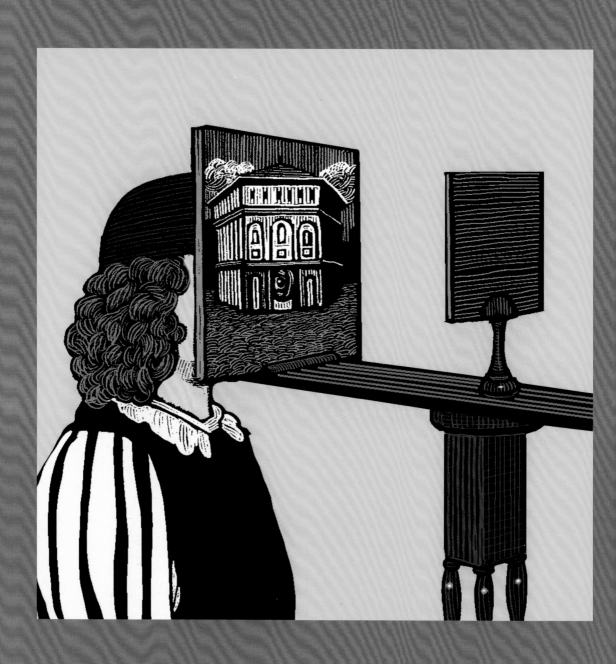

2
BEGINNINGS

Perspective begins with observing that the apparent size of objects decreases with distance. This seems obvious now, but for most of history, artists made no attempt to reproduce the effect. Paleolithic cave painters (the earliest artists we know about) for the most part avoided any suggestion of a space behind their figures. The Egyptians were uninterested in making things appear natural; it was nothing to them if a man was too big to fit through his own door. The geometry in paintings discovered in Rome and Pompeii suggests that, by Roman times, painters had figured out perspective to some extent (even if the lines don't appear to go to a vanishing point). If so, the knowledge was lost by the Middle Ages, when receding lines tended to be parallel, or to actually diverge. By the fourteenth century, artists like Giotto began to show convergence in receding lines in a way that suggests perspective, but haphazardly. That is where things stood when Florentine artist and architect Filippo Brunelleschi tackled the problem in the early 1400s.

All we have of Brunelleschi's first perspective demonstration is a passage in Antonio Manetti's biographical sketch, in which he describes a panel depicting the Baptistery in Florence, painted "with such care and delicacy in the black-and-white colors of the marble that no miniaturist could have done it better." When viewed from the correct point in space, Brunelleschi's panel exactly lined up with the scene around it. Oddly, Brunelleschi painted his panel in reverse, requiring the spectator to view it in a mirror through a hole drilled in the panel. The methodology of Brunelleschi's demonstration is disputed to this day among art historians. However, I am convinced that Brunelleschi must have painted on a mirror. In the pages ahead, I will show you how.

The artist David Hockney has recently stirred up controversy with his theory that artists in the Renaissance were tracing from images projected by lenses and curved mirrors. Software developer Tim Jenison decided to put Hockney's ideas to the test and devised a complex arrangement of lenses and mirrors in order to create a replica of Jan Vermeer's painting *The Music Lesson*. I offer an approximation of his method in this chapter as well.

Drawing of Brunelleschi's first
perspective demonstration, 1400s.

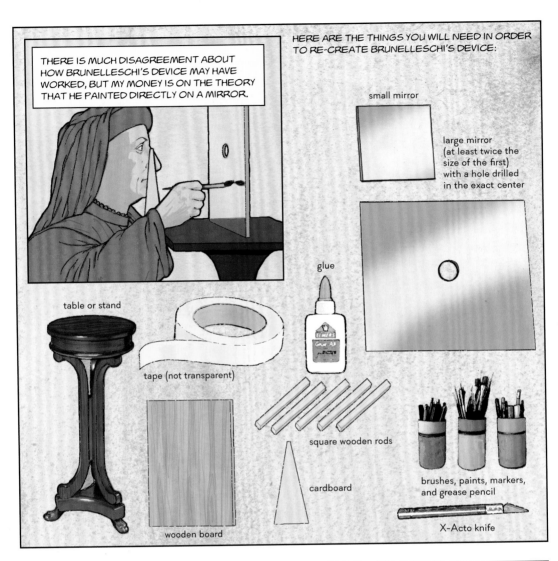

THERE IS MUCH DISAGREEMENT ABOUT HOW BRUNELLESCHI'S DEVICE MAY HAVE WORKED, BUT MY MONEY IS ON THE THEORY THAT HE PAINTED DIRECTLY ON A MIRROR.

HERE ARE THE THINGS YOU WILL NEED IN ORDER TO RE-CREATE BRUNELLESCHI'S DEVICE:

small mirror

large mirror (at least twice the size of the first) with a hole drilled in the exact center

glue

table or stand

tape (not transparent)

square wooden rods

cardboard

brushes, paints, markers, and grease pencil

X-Acto knife

wooden board

IF YOU DON'T HAPPEN TO HAVE A DRILL CAPABLE OF MAKING A HOLE IN GLASS, HAVE SOMEONE DO IT FOR YOU AT THE GLASS STORE. A 1-INCH DIAMETER HOLE IS A GOOD SIZE.

CUT AN EYEPIECE OUT OF CARDBOARD, CLOSE TO THE THICKNESS OF YOUR MIRROR. MAKE IT HALF THE HEIGHT OF THE MIRROR, TO EXACTLY LINE UP WITH THE HOLE.

GLUE DOWN FOUR RODS ON YOUR BOARD TO MAKE SLOTS JUST WIDE ENOUGH TO PLACE YOUR MIRRORS AND EYEPIECE IN. THERE IS NO SET DISTANCE BETWEEN THEM, BUT REMEMBER THAT THE FARTHER APART THE SLOTS ARE, THE SMALLER THE MIRROR WILL APPEAR.

PLACE THE EYEPIECE AND DRILLED MIRROR IN THE SLOTS.

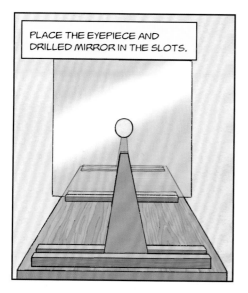

SET UP A STAND IN FRONT OF THE THING YOU WANT TO PAINT AND PLACE THE BOARD ON TOP OF IT, WITH THE MIRROR REFLECTING THE SCENE YOU WANT TO PAINT.

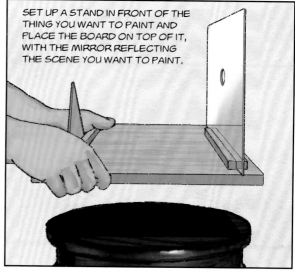

VERY IMPORTANT: MARK WITH TAPE THE SPOT WHERE THE SUPPORT STANDS.

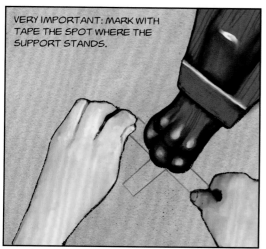

BEGIN TO SKETCH, USING A GREASE PENCIL OR MARKER THAT CAN MAKE MARKS ON GLASS.

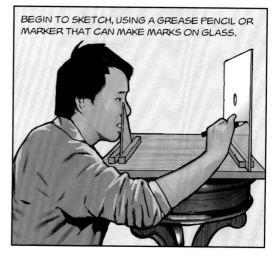

YOU WILL NEED TO WORK AROUND THE REFLECTION OF YOUR HAND, THE STAND, AND YOUR HEAD.

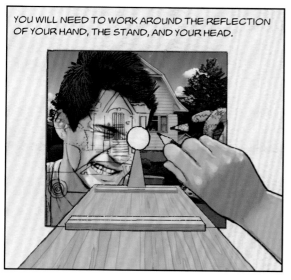

ONCE THE OUTLINES ARE DONE, FINISH THE PAINTING AT HOME (YOU MAY WANT SOME HELP, IN THE FORM OF A REFERENCE PHOTO, WHICH NEEDS TO BE FLOPPED). LEAVE THE SKY AREA UNPAINTED SO THAT THAT THE MIRROR REFLECTS THE REAL SKY.

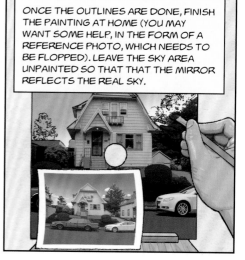

NOW, GET OUT THE SMALLER MIRROR.

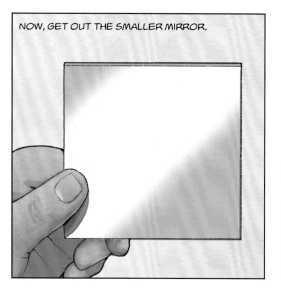

PLACE THE SMALLER MIRROR HALFWAY BETWEEN YOUR PANEL AND THE NOTCH AT THE OTHER END OF THE BOARD. YOU SHOULD CONSTRUCT SOME KIND OF STAND FOR IT, POSSIBLY OUT OF A CUT-DOWN ROD.

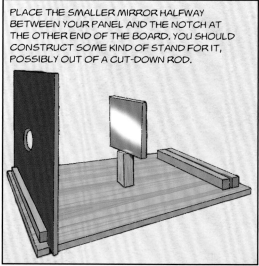

SET THE BOARD BACK DOWN ON THE STAND, WITH THE PANEL DIRECTLY IN FRONT OF THE SCENE. NOW LOOK THROUGH THE PEEPHOLE AT THE MIRROR.

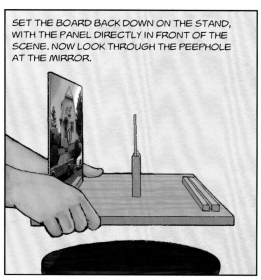

It works!

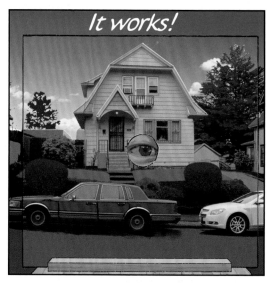

VERY IMPORTANT: GROUND ZERO, THE POINT THAT MUST REMAIN FIXED, IS THE SLOT AT THE FAR END OF THE BOARD (THE ONE THE MIRROR GOES IN WHEN YOU'RE SKETCHING).

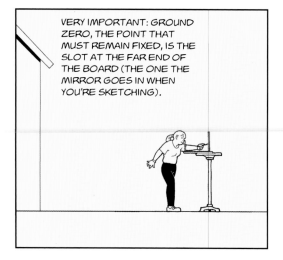

WHEN YOU SET THE DEVICE UP FOR VIEWING, THE DEVICE IS TURNED AROUND ON THE STAND. YOU ARE NOW FACING THE SCENE, AND THE REFLECTION OF THE PANEL APPEARS TO BE IN THAT FAR SLOT AT GROUND ZERO.

THE SECOND DEVICE FROM THE RENAISSANCE IS FAR SIMPLER THAN BRUNELLESCHI'S . . . THE ALBERTIAN VEIL.

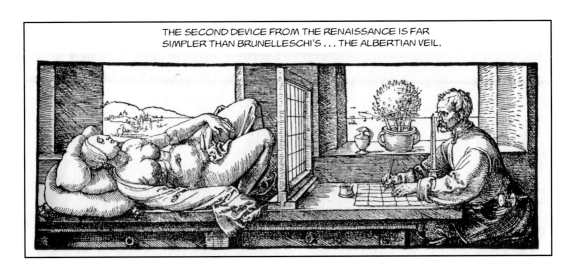

ARCHITECT LEON BATTISTA ALBERTI DESCRIBED IT IN HIS TREATISE *ON PAINTING*.

YOU CAN PROBABLY FIGURE OUT HOW TO MAKE ONE YOURSELF, BUT I'LL TELL YOU ANYWAY. HERE'S WHAT YOU'LL NEED:

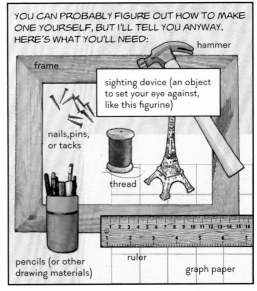

frame

hammer

sighting device (an object to set your eye against, like this figurine)

nails, pins, or tacks

thread

pencils (or other drawing materials)

ruler

graph paper

USE A RULER TO MARK REGULAR DIVISIONS ON THE FRAME.

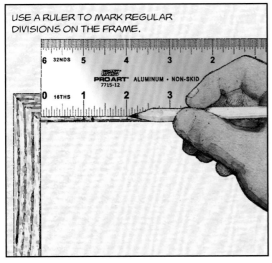

HAMMER IN NAILS AT EACH DIVISION.

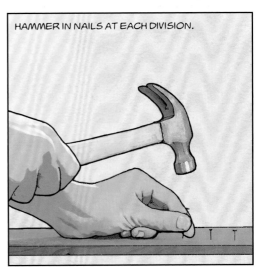

RUN THREAD BETWEEN THE NAILS TO DIVIDE UP THE PICTURE AREA.

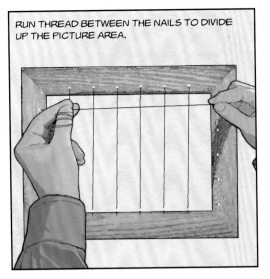

THEN, SET THE FRAME UP IN FRONT OF YOUR SCENE. USE THE SIGHTING DEVICE TO KEEP YOUR EYE FIXED AT ONE POINT IN SPACE.

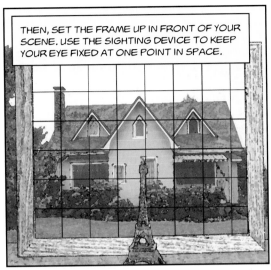

COPY WHAT YOU SEE THROUGH THE "VEIL" ONTO YOUR GRAPH PAPER, SQUARE BY SQUARE.

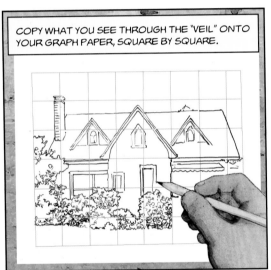

SHEET GLASS DID NOT EXIST DURING THE RENAISSANCE, BUT NOWADAYS YOU CAN MAKE AN ALBERTIAN VEIL BY SIMPLY DRAWING LINES ON A PANE OF GLASS, OR A PIECE OF TRANSPARENT PLASTIC.

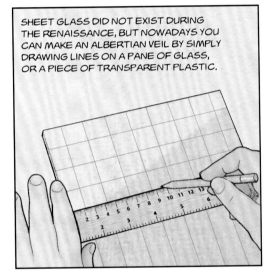

YOU CAN EVEN CUT OUT THE MIDDLE STAGE, AND PAINT DIRECTLY ON THE GLASS!

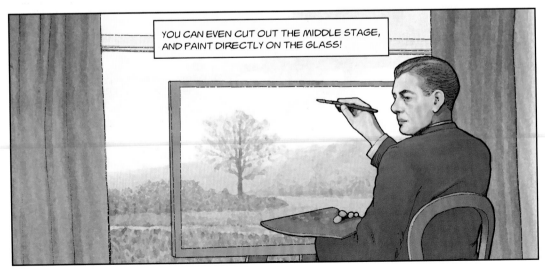

ARTIST DAVID HOCKNEY CREATED CONTROVERSY WITHIN THE ART WORLD IN THE EARLY 2000s, WITH HIS THEORY THAT ARTISTS IN THE RENAISSANCE ESSENTIALLY TRACED THEIR IMAGES.

BASED ON HIS ANALYSIS OF PAINTINGS BY RENAISSANCE ARTISTS SUCH JAN VAN EYCK, CARAVAGGIO, AND HANS HOLBEIN THE YOUNGER, HOCKNEY SURMISED THAT THEY HAD TRACED IMAGES CAST BY OPTICAL DEVICES SUCH AS LENSES, CONCAVE MIRRORS, AND THE CAMERA OBSCURA.

LET'S START WITH A CAMERA OBSCURA:

black paper

bedsheet

pushpins

drawing paper

hole punch or pin

thin metal (heavy foil or shim stock)

black tape

candle

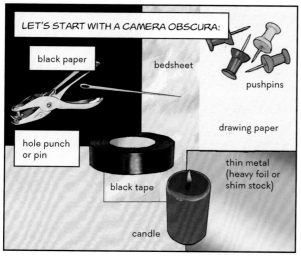

FIRST, FIND A ROOM IN YOUR HOUSE WITH JUST ONE WINDOW (IF YOU DON'T HAVE ONE, YOU WILL HAVE TO COVER ALL THE OTHER WINDOWS). I HAPPEN TO HAVE A ONE-TOILET BATHROOM IN THE HALL.

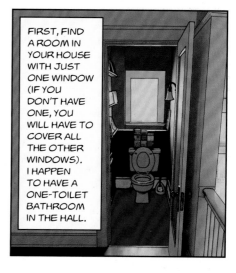

CUT A ROUND HOLE IN A SHEET OF BLACK PAPER. A HOLE PUNCH IS ONE EASY WAY, OR YOU CAN POKE THE HOLE WITH A PIN.

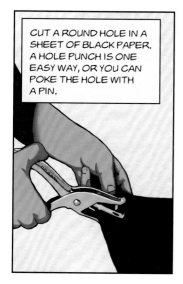

THEN, TAPE THE PAPER OVER THE WINDOW, MAKING SURE TO LEAVE NO AREAS WHERE LIGHT LEAKS.

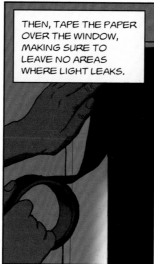

PIN THE BEDSHEET ON THE WALL DIRECTLY OPPOSITE THE TAPED-OVER WINDOW. IF THE WALL IS WHITE OR LIGHT-COLORED, YOU CAN SKIP THIS STEP.

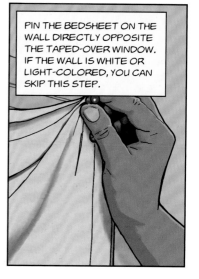

CLOSE THE DOOR, AND YOU SHOULD SEE AN UPSIDE-DOWN IMAGE OF THE SCENE OUTSIDE THE WINDOW PROJECTED ON THE WALL. YOU CAN THEN TRACE IT ONTO A PIECE OF PAPER.

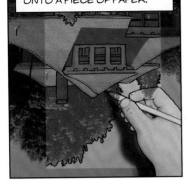

FOR A SHARPER IMAGE, TAPE A SECTION OF FOIL OR SHIM STOCK IN THE MIDDLE OF YOUR PAPER. A PINHOLE IN METAL IS LESS RAGGED THAN ONE IN BLACK PAPER.

TO GET THE ROUNDEST POSSIBLE HOLE, HEAT YOUR PIN OVER A FLAME BEFORE POKING IT THROUGH THE METAL, AND SAND DOWN ANY RAGGED EDGES AFTERWARD. THEN, BLACKEN THE METAL WITH SOOT BY HOLDING IT OVER A CANDLE FLAME.

IF YOU WOULD LIKE THE SHARPEST POSSIBLE IMAGE, FOLLOW THE EQUATION BELOW TO DETERMINE THE BEST DIAMETER PINHOLE FOR THE DISTANCE BETWEEN PINHOLE AND WALL SURFACE. SINCE MY BATHROOM IS 6 FEET DEEP, THE OPTIMUM PINHOLE WIDTH IS APPROXIMATELY 1.5 MM.

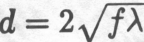

$$d = 2\sqrt{f\lambda}$$

(D IS PINHOLE DIAMETER, F IS FOCAL LENGTH OR DISTANCE FROM PINHOLE TO IMAGE PLANE, AND λ IS THE WAVELENGTH OF LIGHT.)

TO TAKE THINGS FURTHER, BUILD A PINHOLE CAMERA OBSCURA, WITH FILM OR A DIGITAL BACK TO PERMANENTLY RECORD THE IMAGE.

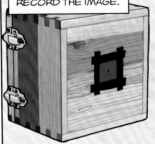

SUBSTITUTE A LENS FOR THE PINHOLE TO FOCUS THE LIGHT AND YOU HAVE . . . A CAMERA!

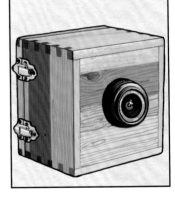

ONE ARTIST WHOSE WORK WAS LONG BELIEVED TO SHOW SIGNS OF OPTICAL TRACING WAS JAN VERMEER. ART HISTORIANS, WHO GENERALLY DO NOT HAVE A BACKGROUND IN OPTICS, TENDED TO SPEAK VAGUELY OF "A DEVICE LIKE A CAMERA OBSCURA" THAT VERMEER MAY HAVE USED, BUT NO ONE KNEW PRECISELY WHAT SORT OF DEVICE THAT MAY HAVE BEEN.

ONE FILM ABOUT VERMEER HAD HIM SHOWING A CURIOUS SERVANT A BOX CAMERA OBSCURA, ABOUT THE SIZE OF A CHILD'S COFFIN. HOWEVER, THE FILM DID NOT SHOW VERMEER TRACING OR OTHERWISE USING IT IN PAINTING.

INSPIRED BY HOCKNEY'S THEORIES, INVENTOR AND SOFTWARE DESIGNER TIM JENISON DECIDED TO TRY TO REPRODUCE ONE OF VERMEER'S MOST FAMILIAR PAINTINGS, *THE MUSIC LESSON*.

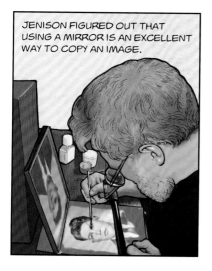

THE FILM *TIM'S VERMEER* RECOUNTS HIS EFFORT.

JENISON FIGURED OUT THAT USING A MIRROR IS AN EXCELLENT WAY TO COPY AN IMAGE.

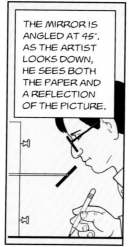

THE MIRROR IS ANGLED AT 45°. AS THE ARTIST LOOKS DOWN, HE SEES BOTH THE PAPER AND A REFLECTION OF THE PICTURE.

HERE IS MY OWN VERSION OF JENISON'S SETUP:

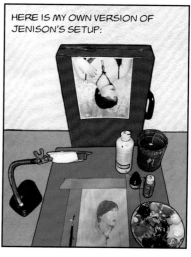

JENISON USED A DENTAL MIRROR. SINCE I DIDN'T HAVE ONE, I IMPROVISED BY TAPING A HAND MIRROR OVER A GOOSENECKED MAGNIFYING GLASS.

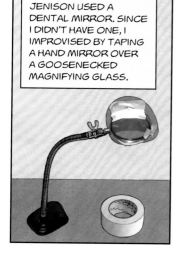

BY MATCHING THE TONES IN THE PAINTING TO THOSE IN THE PHOTOGRAPH EXACTLY, YOU CAN MAKE THE EDGE OF THE MIRROR VIRTUALLY DISAPPEAR.

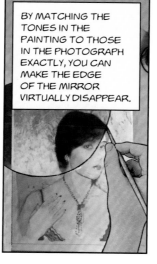

HERE'S THE FINAL RESULT SIDE BY SIDE WITH THE ORIGINAL. NOT A BAD MATCH!

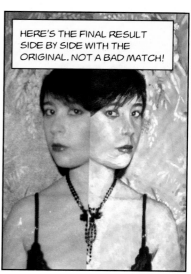

VERMEER, OF COURSE, DID NOT HAVE A PHOTOGRAPH TO COPY. HOWEVER, JENISON REASONED THAT VERMEER USED SOME COMBINATION OF MIRRORS AND LENSES TO PROJECT AN IMAGE SUITABLE FOR TRACING.

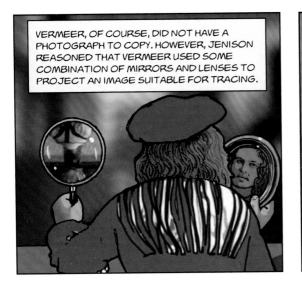

BEFORE HE BEGAN PAINTING, JENISON ENTIRELY RE-CREATED THE ROOM IN *THE MUSIC LESSON*, GOING SO FAR AS TO BUILD A REPLICA OF THE HARPSICHORD. HE ALSO GROUND THE LENSES AND MIRRORS NEEDED FOR THE PROJECT, AND MIXED HIS OWN PAINT.

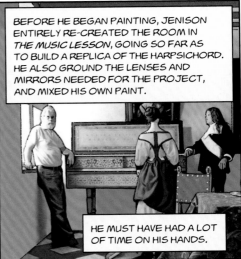

HE MUST HAVE HAD A LOT OF TIME ON HIS HANDS.

THIS PANEL SHOWS JENISON'S METHOD. THE VIEW THROUGH A MAGNIFYING GLASS IS REFLECTED IN A CONCAVE MIRROR, WHICH IS IN TURN REFLECTED IN THE SMALL ANGLED MIRROR IN FRONT OF JENISON. IN ORDER FOR HIS HEAD NOT TO BLOCK THE VIEW, JENISON HAD TO WORK SIDEWAYS.

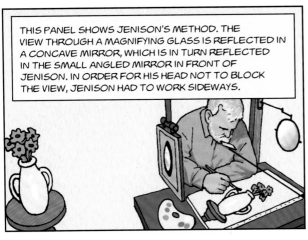

COMPLETING THE PAINTING TOOK JENISON SEVEN MONTHS OF PAINSTAKING WORK, BUT THE END RESULT CLOSELY RESEMBLES THE ORIGINAL PAINTING.

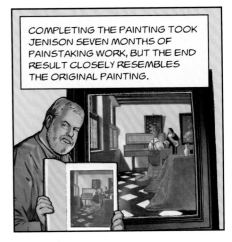

FOR THIS DEMONSTRATION, YOU WILL ONLY CONCERN YOURSELF WITH TRYING TO REPRODUCE JENISON'S OPTICAL METHOD, USING MIRRORS AND LENSES BOUGHT AT THE STORE, WITHOUT GRINDING THEM YOURSELF, OR MAKING YOUR OWN PAINT.

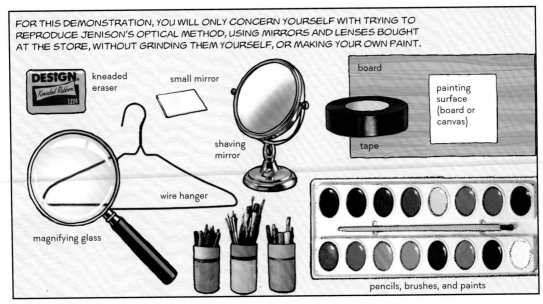

kneaded eraser

small mirror

board

painting surface (board or canvas)

shaving mirror

tape

wire hanger

magnifying glass

pencils, brushes, and paints

HERE IS MY LOW-COST REPLICA OF JENISON'S DEVICE. THE MAGNIFYING GLASS IS FROM AN OLD LAMP I SALVAGED, AND THE SMALL MIRROR IS STUCK WITH KNEADED ERASER TO A MOUNTING MADE OF TWISTED HANGER WIRE.

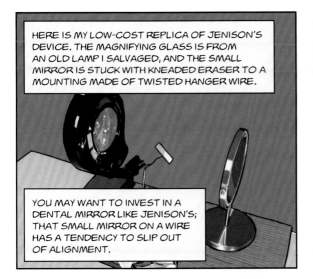

YOU MAY WANT TO INVEST IN A DENTAL MIRROR LIKE JENISON'S; THAT SMALL MIRROR ON A WIRE HAS A TENDENCY TO SLIP OUT OF ALIGNMENT.

THE ANGLED MIRROR SHOULD BE AS SMALL AS POSSIBLE BECAUSE ITS REFLECTION WILL APPEAR IN YOUR VIEW, AND YOU WANT TO BLOCK AS LITTLE OF THE SCENE AS POSSIBLE.

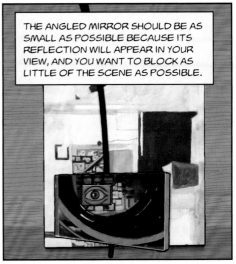

UNLESS YOU HAVE A HUGE MAGNIFYING GLASS, THE IMAGE AREA WILL BE TINY, SO YOU WILL NEED TO KEEP SHIFTING THE MAGNIFYING GLASS UP, DOWN, AND SIDEWAYS TO FILL UP YOUR PICTURE.

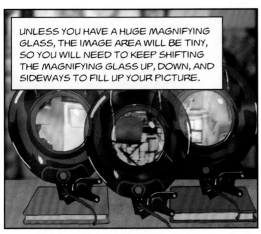

ONCE YOU HAVE YOUR SCENE SET UP, THE REST IS PAINSTAKINGLY FILLING IN AREAS TO MATCH THE IMAGE. TAKE FREQUENT BREAKS. JENISON SAYS HIS WORK GAVE HIM A TERRIBLE BACKACHE!

NOT HAVING JENISON'S RESOURCES, I DECIDED TO PAINT A CORNER OF MY STUDIO, RATHER THAN REBUILD A VERMEER ROOM. HERE IS MY FINISHED PAINTING, NEXT TO A PHOTOGRAPH OF THE SCENE. THIS PAINTING TOOK LESS TIME TO COMPLETE THAN JENISON'S, ABOUT 24 HOURS.

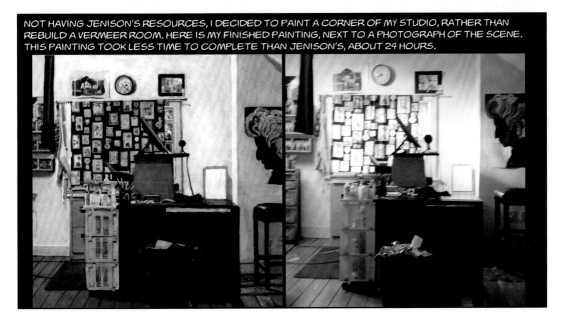

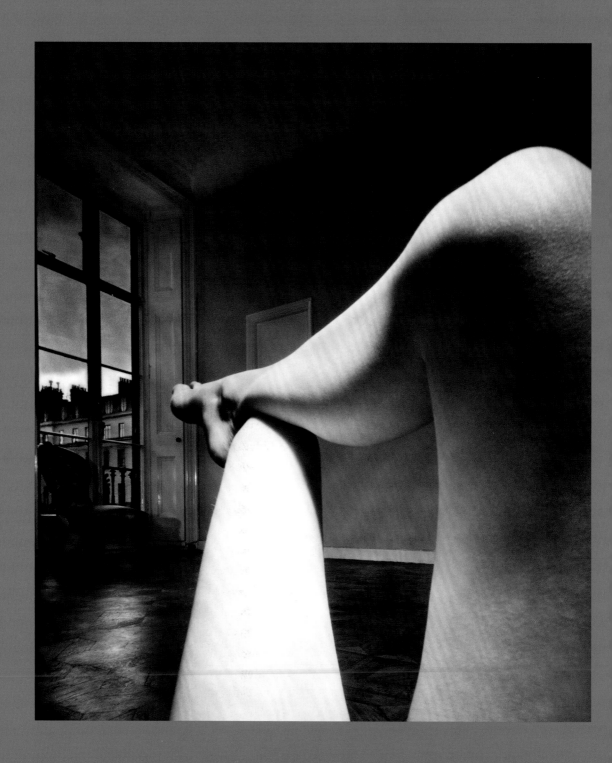

3
ANAMORPHOSIS

Anamorphosis is perspective on steroids. Unlike the routine application of perspective, which we have become used to in art, this distorted form of image making, which requires the viewer to use special devices or to occupy a specific vantage point to reconstitute the image, still has the power to startle.

It does so by following the rules of perspective to an absurd extreme. Classical perspective has a pristine purity: the image is drawn on a flat surface that an observer views from a fixed point. Any distortion required by the perspective method is exactly canceled out by the effect of foreshortening.

The first surviving painting in classical perspective, Masaccio's *Holy Trinity*, from 1427, is painted as if seen from a low-angle viewpoint corresponding to the spot where an observer would be standing. But the artists deviated from strict perspective almost immediately. Less than a decade later, Uccello painted *Funerary Monument to Sir John Hawkwood* with its vanishing point located close to the base of the picture even though the painting is set high up on a wall, meaning a viewer would need to mount a ladder to see it correctly.

By contrast, anamorphosis only truly works when viewed from the station point. It almost never depicts the kind of objects that you typically use perspective to draw: rectilinear forms like houses, other buildings, and furniture. Instead, the typical anamorphosis depicts a human or animal figure or face. We seem to notice and object to distortions of rounded, organic forms far more than we do boxy forms. Distortions of the human face and form are particularly jarring. A bit of a piece of furniture drawn in anamorphosis only appears to be the work of someone who has set their vanishing points too closely. But a portrait drawn by the same method appears monstrous. The modernist photographer Bill Brandt cultivates anamorphic distortion as a deliberate effect, though he falls short of the robust grotesquerie of a true anamorphosis viewed frontally.

Because an anamorphosis is meant to be viewed from a single, fixed point, the artist must learn to honestly simulate the effect of anamorphic distortion, lest the image appear imperfect to the observer. This effect is very difficult to get right except by scrupulous construction (or by slavish tracing of a projected image), which makes anamorphosis the least intuitive form of art.

Bill Brandt, *Nude*, 1951. Belgravia London.

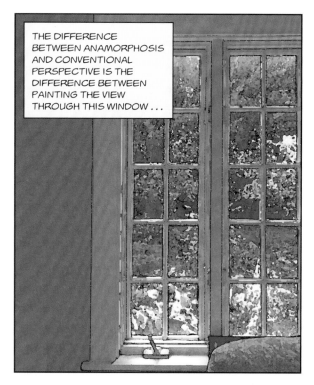

THE DIFFERENCE BETWEEN ANAMORPHOSIS AND CONVENTIONAL PERSPECTIVE IS THE DIFFERENCE BETWEEN PAINTING THE VIEW THROUGH THIS WINDOW . . .

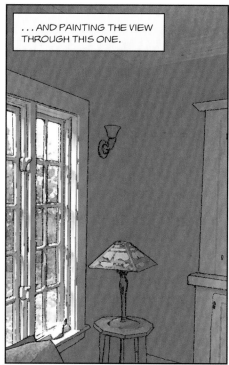

. . . AND PAINTING THE VIEW THROUGH THIS ONE.

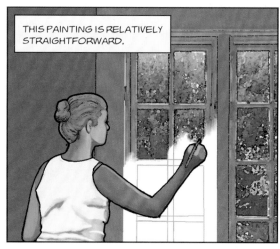

THIS PAINTING IS RELATIVELY STRAIGHTFORWARD.

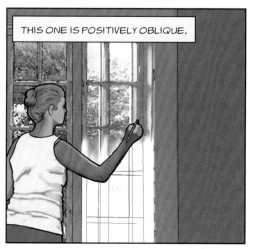

THIS ONE IS POSITIVELY OBLIQUE.

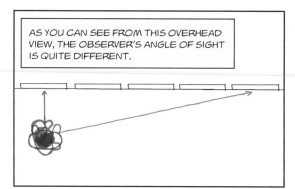

AS YOU CAN SEE FROM THIS OVERHEAD VIEW, THE OBSERVER'S ANGLE OF SIGHT IS QUITE DIFFERENT.

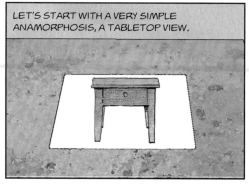

LET'S START WITH A VERY SIMPLE ANAMORPHOSIS, A TABLETOP VIEW.

CONSTRUCTING THE PERSPECTIVE OF A DRAWING IN ANAMORPHOSIS THE CONVENTIONAL WAY, WITH VANISHING POINTS, REQUIRES A HUGE PIECE OF PAPER.

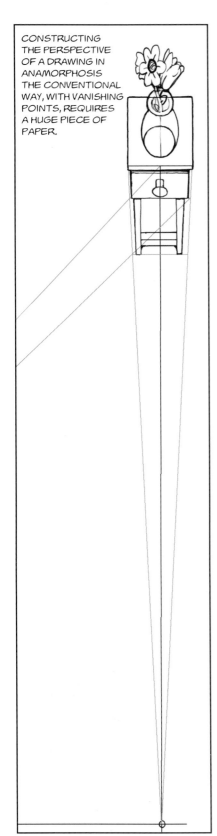

IF YOU WANT TO USE A DIAGONAL VANISHING POINT FOR MEASUREMENT, THE PAPER GETS EVEN BIGGER.

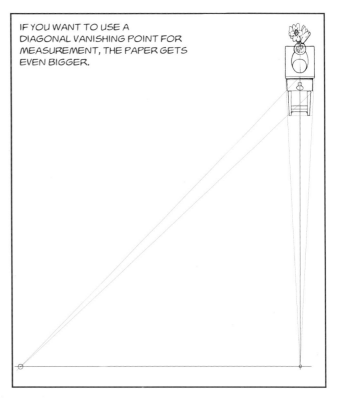

AFTER CUTTING AWAY THE PARTS OUTSIDE YOUR DRAWING . . .

. . . YOU ARE LEFT WITH RATHER A LOT OF WASTE PAPER.

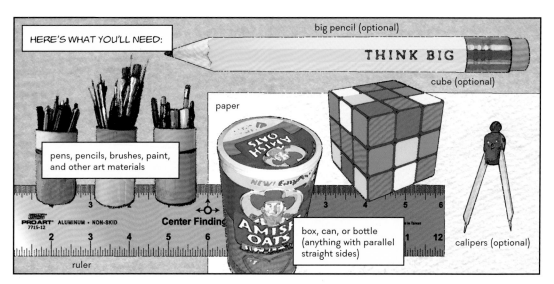

HERE'S WHAT YOU'LL NEED:

big pencil (optional)

THINK BIG

cube (optional)

paper

pens, pencils, brushes, paint, and other art materials

box, can, or bottle (anything with parallel straight sides)

calipers (optional)

ruler

FIRST, DRAW A STRAIGHT LINE DIVIDING YOUR PAPER IN HALF.

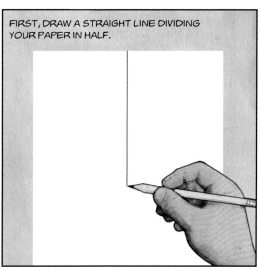

PLACE THE PAPER ON THE TABLE AND STAND EXACTLY IN FRONT OF THE CENTRAL LINE, SO THAT IT APPEARS VERTICAL.

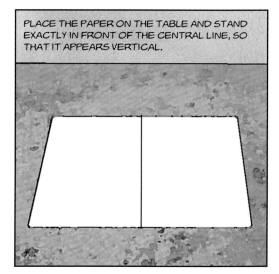

PLACE YOUR STRAIGHT-SIDED OBJECT ON THE PAPER SO THAT ONE SIDE LINES UP EXACTLY WITH THE CENTRAL LINE.

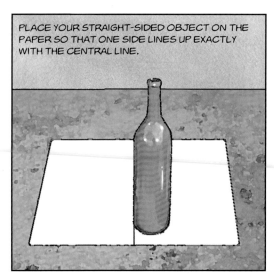

WITHOUT MOVING YOUR EYE, PLACE A RULER ON THE PAPER SO IT APPEARS TO TOUCH THE OBJECT ALONG ITS OTHER SIDE.

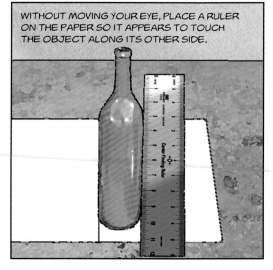

REMOVE YOUR OBJECT, AND TRACE A LINE ALONG THE EDGE OF THE RULER.

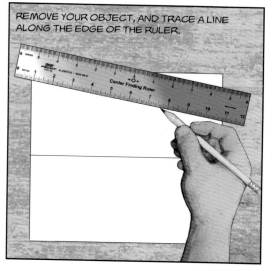

YOU WILL WIND UP WITH A LINE NOT QUITE PARALLEL TO THE CENTRAL LINE.

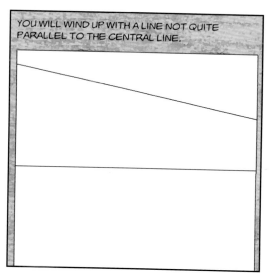

USE CALIPERS TO MEASURE THE DISTANCE BETWEEN THE LINES ON BOTH EDGES OF THE PAPER AND ADD POINTS THE SAME DISTANCE AWAY ON THE OTHER SIDE OF THE CENTRAL LINE.

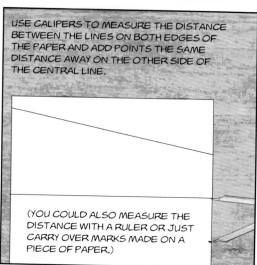

(YOU COULD ALSO MEASURE THE DISTANCE WITH A RULER OR JUST CARRY OVER MARKS MADE ON A PIECE OF PAPER.)

LINK THOSE POINTS UP, AND YOU NOW HAVE THREE LINES THAT MEET AT THE VANISHING POINT UNDER THE OBSERVER'S EYE.

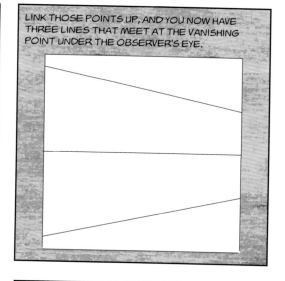

ADD MORE LINES GOING IN THE SAME DIRECTION EITHER BY DIVIDING THE AREAS UP WITH A RULER OR BY USING DIAGONALS TO SUBDIVIDE THE SPACE.

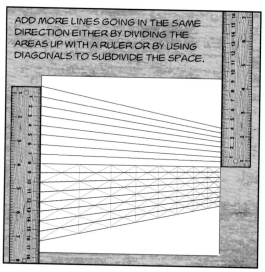

NOW YOU HAVE A REGULARLY SPACED SERIES OF LINES THAT ALL APPEAR VERTICAL WHEN SEEN FROM THE OBSERVER'S VIEWPOINT.

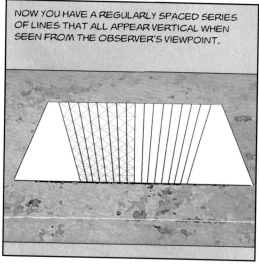

LINES DRAWN PARALLEL TO THE EDGE OF THE PAPER WILL READ AS HORIZONTAL, OR RECEDING IN PERSPECTIVE.

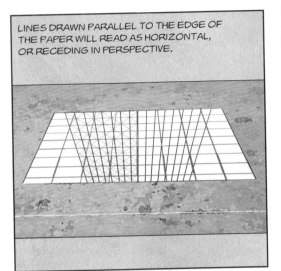

ALL THOSE LINES TOGETHER WILL GIVE YOU ENOUGH GUIDANCE TO DRAW AN OBJECT IN CORRECT PERSPECTIVE. (THOUGH TO GET YOUR PROPORTIONS RIGHT, IT WILL HELP TO DRAW YOUR PICTURE WHILE VIEWING IT FROM AS OBLIQUE AN ANGLE AS POSSIBLE.) THIS MAY BE A JOB FOR THE BIG PENCIL.

MAKING DIVISIONS WITH DIAGONAL LINES WILL HELP YOU ACCURATELY DRAW OBJECTS WITH REGULARLY SPACED SEGMENTS, LIKE A LADDER.

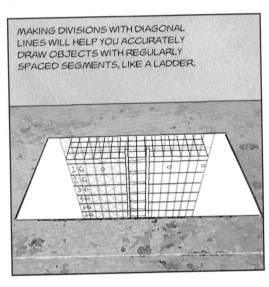

TO DRAW AN OBJECT WITH CONSISTENT MEASUREMENTS IN ALL THREE PLANES, LIKE A CUBE, YOU'LL HAVE TO UP YOUR GAME.

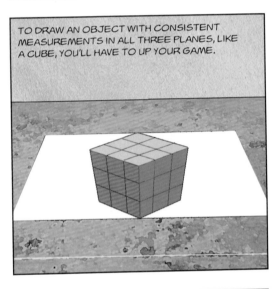

FORTUNATELY, I HAVE A SHORTCUT. YOU WILL NEED AN OBJECT YOU KNOW TO BE A CUBE--THAT IS, A BOX WITH ALL ITS EDGES PRECISELY THE SAME LENGTH--LIKE THIS BLOCK.

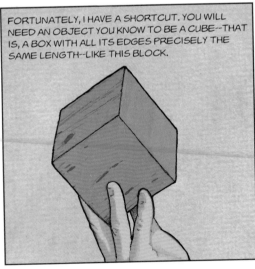

FIRST, PLACE THE CUBE ALONG A LINE DIVIDING YOUR PAPER IN HALF, AND TRACE THE SQUARE FACE THAT TOUCHES THE PAPER.

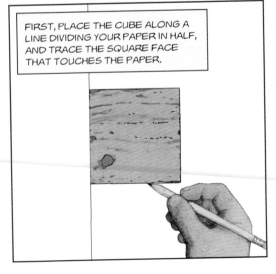

NOW, WITHOUT MOVING THE CUBE OFF THE SQUARE, STAND AT THE POINT FROM WHICH YOU WANT TO VIEW THE DRAWING, WITH THE CUBE'S LEFT EDGE TOUCHING THE CENTER LINE.

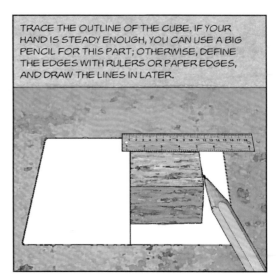

TRACE THE OUTLINE OF THE CUBE. IF YOUR HAND IS STEADY ENOUGH, YOU CAN USE A BIG PENCIL FOR THIS PART; OTHERWISE, DEFINE THE EDGES WITH RULERS OR PAPER EDGES, AND DRAW THE LINES IN LATER.

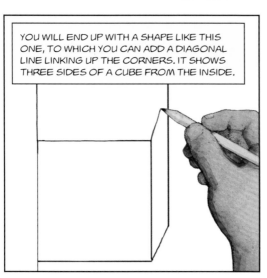

YOU WILL END UP WITH A SHAPE LIKE THIS ONE, TO WHICH YOU CAN ADD A DIAGONAL LINE LINKING UP THE CORNERS. IT SHOWS THREE SIDES OF A CUBE FROM THE INSIDE.

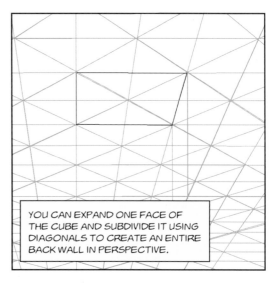

YOU CAN EXPAND ONE FACE OF THE CUBE AND SUBDIVIDE IT USING DIAGONALS TO CREATE AN ENTIRE BACK WALL IN PERSPECTIVE.

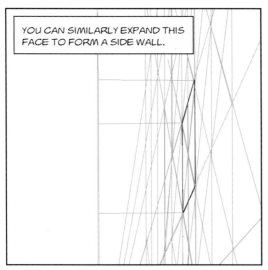

YOU CAN SIMILARLY EXPAND THIS FACE TO FORM A SIDE WALL.

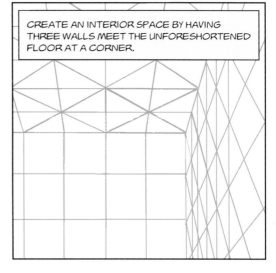

CREATE AN INTERIOR SPACE BY HAVING THREE WALLS MEET THE UNFORESHORTENED FLOOR AT A CORNER.

AN UNNATURALLY DISTENDED OBJECT DRAWN IN ANAMORPHOSIS WILL LOOK NATURALLY FORESHORTENED WHEN VIEWED FROM THE STATION POINT.

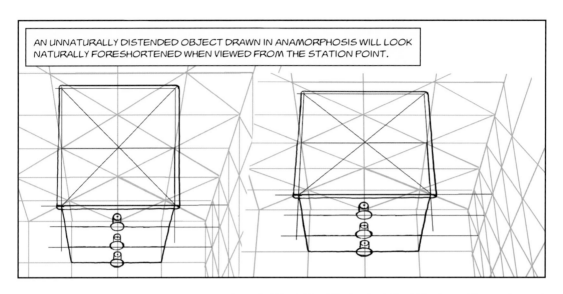

YOU CAN ROTATE THE OBJECT WITHOUT HAVING TO ADD ANY VANISHING POINTS. ALL LINES ON THE TOP PLANE WILL STILL BE PARALLEL, AND YOU CAN STILL BUILD A HEIGHT MEASUREMENT OFF THE SIDE WALL.

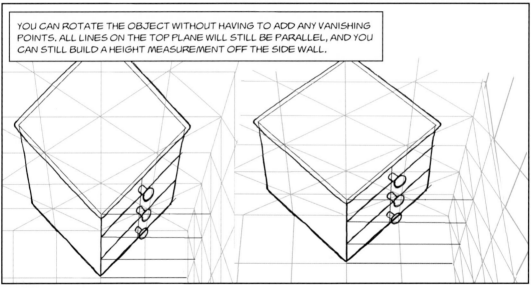

NOW IF YOU DON'T HAPPEN TO HAVE A CUBE HANDY, OR IF YOU JUST WANT TO UNDERSTAND THE PROCESS BETTER, YOU COULD USE . . . MATHEMATICAL REASONING.

START BY ASSUMING THAT THE OBSERVER IS STANDING A SPECIFIC DISTANCE FROM YOUR DRAWING--LIKE, SAY, 2 FEET.

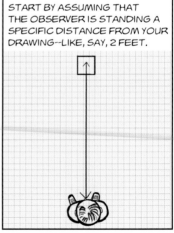

TWO INCHES IS ONE-TWELFTH OF THE DISTANCE TO THE VANISHING POINT. TO DRAW A LINE THAT WILL CROSS THE CENTRAL LINE AT THAT POINT, FIRST DRAW A HORIZONTAL LINE THAT YOU CAN EASILY DIVIDE INTO TWELVE PARTS--LIKE 6 INCHES IN LENGTH. THEN 2 INCHES BELOW THE LINE, DRAW ANOTHER LINE THAT IS ONE-TWELFTH SHORTER: IN THIS CASE, 5.5 INCHES LONG. DO THE SAME ON THE OTHER SIDE OF THE CENTER LINE.

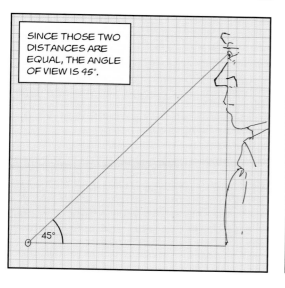

LINK UP THE POINTS YOU HAVE JUST DRAWN TO FORM LINES IN PERSPECTIVE. DIVIDE EACH HORIZONTAL LINE IN EVEN SEGMENTS TO MAKE MORE LINES IN PERSPECTIVE.

NEXT, YOU NEED TO FIGURE OUT HOW TO MAKE REGULAR DIVISIONS IN PERSPECTIVE, WHICH MEANS DRAWING A DIAGONAL LINE TO THE 45° VANISHING POINT. HOW DO YOU DO THAT?

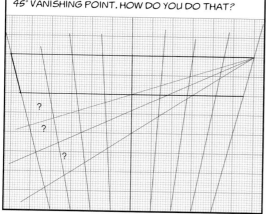

BEGIN BY SETTING A HEIGHT FOR YOUR OBSERVER'S EYE ABOVE THE SURFACE OF THE DRAWING. LET'S MAKE IT 2 FEET, THE SAME AS THE HORIZONTAL DISTANCE FROM THE OBSERVER TO THE DRAWING.

SINCE THOSE TWO DISTANCES ARE EQUAL, THE ANGLE OF VIEW IS 45°.

45°

TO HELP YOU WITH THE NEXT STEP, I'LL LET YOU IN ON A LITTLE SECRET:

IN ONE-POINT PERSPECTIVE, THE DISTANCE FROM THE CENTRAL VANISHING POINT TO THE DIAGONAL VANISHING POINT IS EXACTLY EQUAL TO THE DISTANCE FROM THE CENTRAL VANISHING POINT TO THE OBSERVER'S EYE.

WHAT DOES THIS TELL YOU? BECAUSE THE HORIZONTAL DISTANCE TO THE OBSERVER'S EYE IS EQUAL TO THE HEIGHT OF THE OBSERVER'S EYE ABOVE THE PICTURE SURFACE, WHICH IN TURN IS EQUAL TO THE DISTANCE FROM THE CENTRAL VANISHING POINT TO THE DIAGONAL VANISHING POINT . . .

. . . THE ANGLE OF VIEW FROM THE OBSERVER'S EYE TO THE CENTER OF THE PICTURE IS EQUAL TO THE ANGLE OF A LINE DRAWN FROM THE CENTER OF THE PICTURE TO THE DIAGONAL VANISHING POINT (PHEW!): 45°.

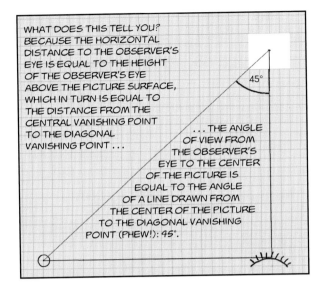

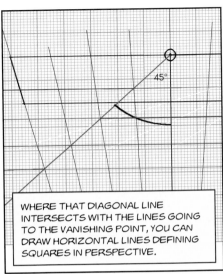

WHERE THAT DIAGONAL LINE INTERSECTS WITH THE LINES GOING TO THE VANISHING POINT, YOU CAN DRAW HORIZONTAL LINES DEFINING SQUARES IN PERSPECTIVE.

THE SAME BASIC PRINCIPLE APPLIES WHEN THE ANGLE OF VIEW IS SOMETHING OTHER THAN 45°. LET'S SAY THE DISTANCE FROM THE DRAWING TO THE OBSERVER IS 3 FEET, WHILE THE OBSERVER'S EYE IS STILL 2 FEET ABOVE THE PAPER. THE ANGLE THAT THE OBSERVER'S LINE OF SIGHT MAKES WITH THE PAPER IS APPROXIMATELY 33.6°.

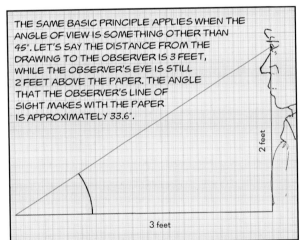

BECAUSE THE HEIGHT OF THE OBSERVER'S EYE EQUALS THE DISTANCE FROM THE VANISHING POINT TO THE 45° VANISHING POINT . . .

. . . THE ANGLE OF THE LINE FROM THE CENTER OF THE IMAGE TO THE DIAGONAL VANISHING POINT IS ALSO THE SAME: 33.6°.

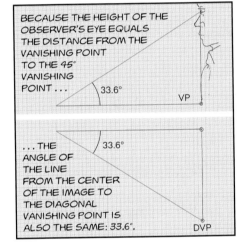

AS YOU DID WITH THE 45° LINE, USE THAT DIAGONAL LINE TO DRAW HORIZONTAL DIVISIONS RECEDING IN PERSPECTIVE.

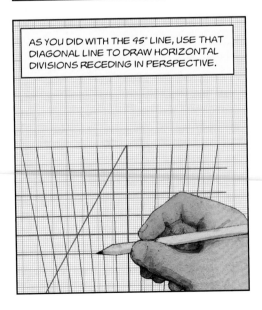

BEING ABLE TO DRAW EQUAL DIVISIONS IN DIFFERENT PLANES COMES IN HANDY WHEN YOU NEED TO DRAW IDENTICAL OBJECTS STANDING UP OR ON THE GROUND.

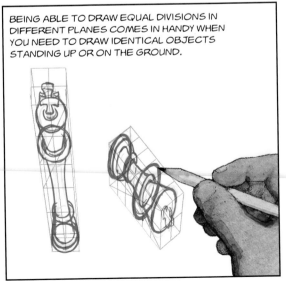

SO FAR, SO SIMPLE. NOW LET'S TRY SOMETHING NOT SO SIMPLE:

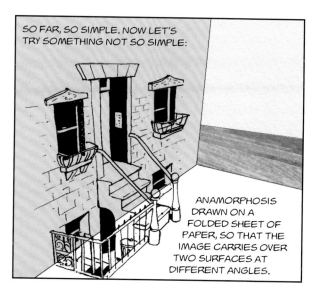

ANAMORPHOSIS DRAWN ON A FOLDED SHEET OF PAPER, SO THAT THE IMAGE CARRIES OVER TWO SURFACES AT DIFFERENT ANGLES.

START BY TRACING THE OUTLINE OF A CUBE ON THE PAPER. YOU MAY WANT THE BIG PENCIL FOR THIS ONE.

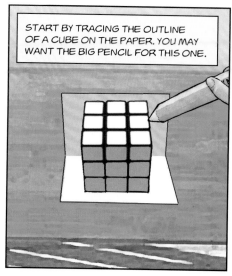

YOU WIND UP WITH A DIVIDED DRAWING. BOTH HALVES ARE IN ONE-POINT PERSPECTIVE. THE TOP HALF HAS LINES CONVERGING ON A VANISHING POINT DIRECTLY OPPOSITE THE OBSERVER'S EYE, AND THE BOTTOM HALF HAS THEM CONVERGING AT A POINT DIRECTLY UNDER THE OBSERVER'S EYE.

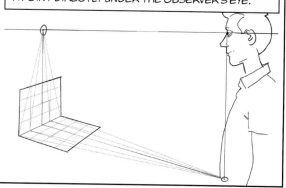

FIND ANGLES TO THE DIAGONAL VANISHING POINTS JUST AS YOU DID FOR A SIMPLE ANAMORPHOSIS. USE THE ANGLE OF SIGHT (TOP ONE FOR THE TOP IMAGE, BOTTOM ONE FOR THE BOTTOM IMAGE). THE TWO ANGLES ADDED TOGETHER WILL EQUAL 90°.

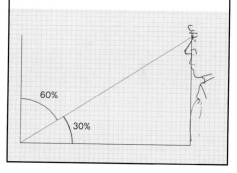

60%

30%

IT IS MORE COMPLICATED WHEN YOU'RE VIEWING AN ANAMORPHOSIS FROM THE SIDE. TRY TRACING THE CUBE THIS TIME.

WHEN YOU DO, YOU END UP WITH VANISHING POINTS OFF TO THE SIDE.

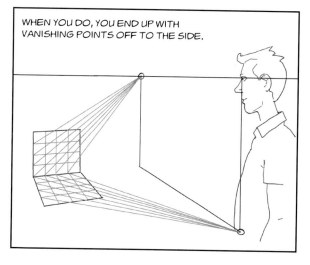

WHAT YOU WIND UP WITH IS A DRAWING OF THE CUBE THAT LOOKS LIKE THIS.

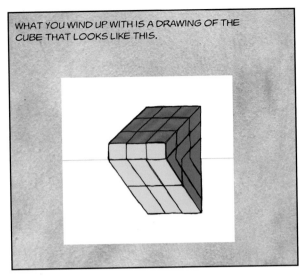

AND NOW FOR SOMETHING EVEN MORE CHALLENGING--ANAMORPHOSIS ON THREE PIECES OF PAPER MEETING AT A CORNER.

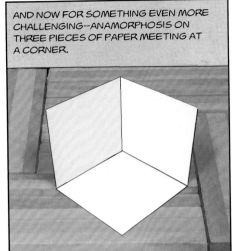

ALL THREE SIDES ARE THE SAME ON THIS ONE. FIRST, DRAW A DIAGONAL LINE BISECTING ONE SIDE, THEN DRAW THE OUTLINE OF A SQUARE.

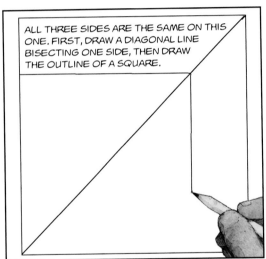

THEN, DIVIDE EACH SIDE OF THE SQUARE INTO THIRDS.

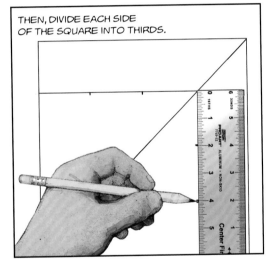

FIGURE THE DISTANCE ALONG THE DIAGONAL FROM THE FAR CORNER TO THE OBSERVER AS 36 INCHES . . .

. . . AND MARK A POINT ON THAT DIAGONAL AT 6 INCHES.

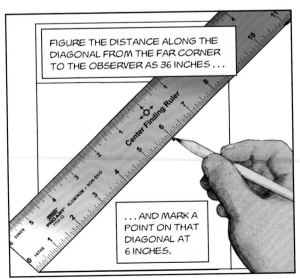

DRAW TWO LINES PERPENDICULAR TO THE DIAGONAL--ONE AT THE CORNER AND ONE AT THE 6-INCHES POINT. MAKE THE FAR ONE 6 INCHES WIDE AND THE NEARER ONE 5 INCHES WIDE.

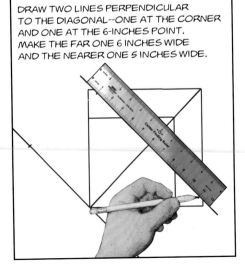

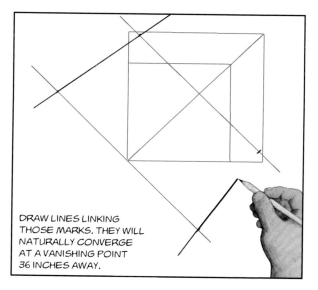

DRAW LINES LINKING THOSE MARKS. THEY WILL NATURALLY CONVERGE AT A VANISHING POINT 36 INCHES AWAY.

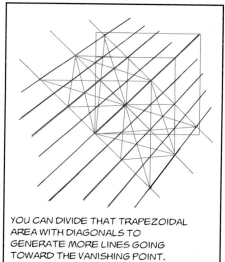

YOU CAN DIVIDE THAT TRAPEZOIDAL AREA WITH DIAGONALS TO GENERATE MORE LINES GOING TOWARD THE VANISHING POINT.

ONCE YOU HAVE A GENERAL IDEA OF THE DIRECTION OF THE LINES, YOU CAN DRAW THEM FROM THE ONE-THIRD DIVISIONS ON THE SQUARE GOING IN THAT DIRECTION.

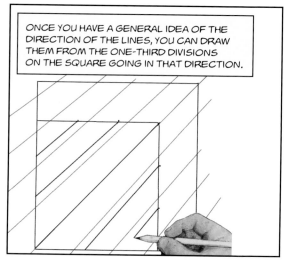

WHERE THOSE RECEDING LINES INTERSECT THE LEFT AND BOTTOM EDGES OF THE PAPER, DRAW OUT HORIZONTAL AND VERTICAL LINES.

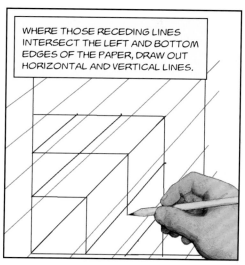

REPEAT THIS PROCESS THREE TIMES, AND YOU SHOULD HAVE A DESIGN LIKE THIS.

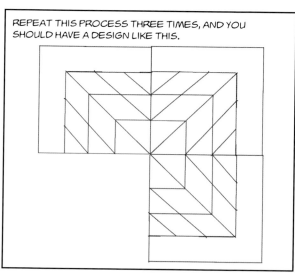

THINGS SHOULD BECOME A LITTLE CLEARER ONCE YOU START TO ADD COLOR.

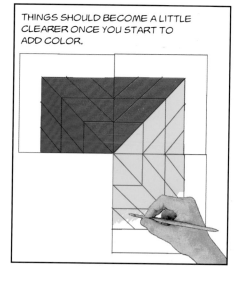

WHEN FOLDED UP AND VIEWED AT THE CORRECT DISTANCE AND ANGLE, YOUR DRAWING SHOULD LOOK LIKE THIS.

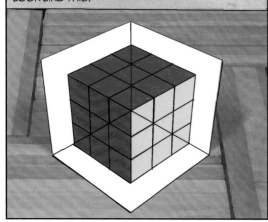

AFTER THAT EXERCISE, YOU MAY WANT TO TAKE ON SOMETHING MORE COMPLEX.

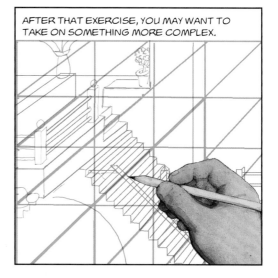

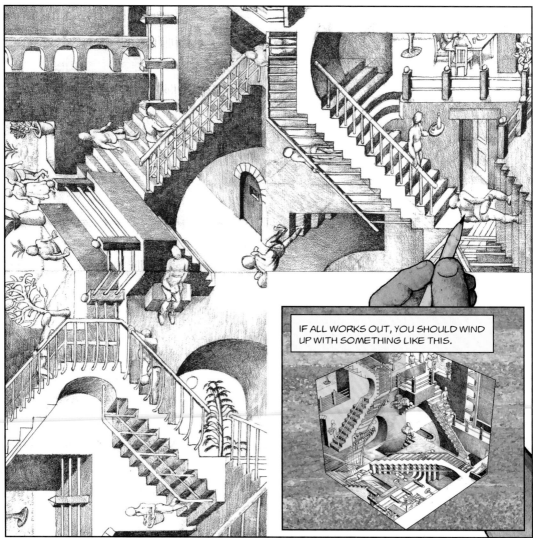

IF ALL WORKS OUT, YOU SHOULD WIND UP WITH SOMETHING LIKE THIS.

THAT SHOULD TELL YOU ENOUGH ABOUT RECTILINEAR OBJECTS IN PERSPECTIVE FOR NOW. BUT, OF COURSE, MOST OBJECTS AREN'T RECTILINEAR

FOR EXAMPLE, LOOK AT THIS OBJECT. HOW DO YOU GET THE ANAMORPHIC DISTORTION PRECISELY RIGHT FOR IT?

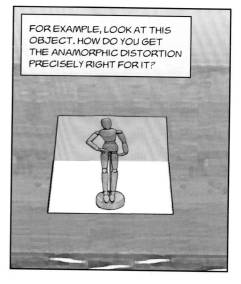

YOU CHEAT, OF COURSE. HOW ABOUT USING A SLIDE PROJECTOR . . .

. . . OR AN OPAQUE PROJECTOR, OR ONE OF THOSE NEWFANGLED COMPUTER PROJECTORS? WHATEVER THE MACHINE, THE METHOD IS THE SAME: PROJECT AN IMAGE ONTO THE PAPER AT AN OBLIQUE ANGLE AND TRACE IT.

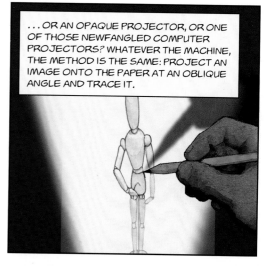

IF YOU DON'T HAPPEN TO HAVE A PROJECTOR HANDY, HERE'S SOMETHING ELSE YOU CAN TRY: FIRST, DRAW YOUR IMAGE ON A PIECE OF GLASS.

THEN, CAREFULLY TRACE THE IMAGE ONTO THE PAPER WHILE LOOKING THROUGH THE GLASS. (IT'S KIND OF AN ALBERTIAN VEIL IN REVERSE.)

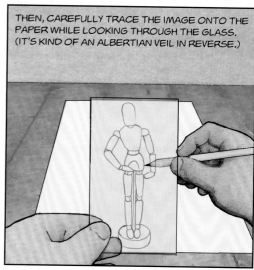

ANOTHER WAY OF COPYING IS TO USE A SMALL MIRROR OR PRISM.

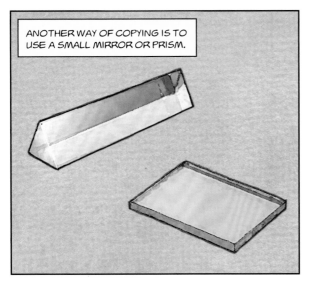

PLACE THE MIRROR OR PRISM IN FRONT OF THE PAPER, REFLECTING THE OBJECT, WHICH IS SET TO THE SIDE.

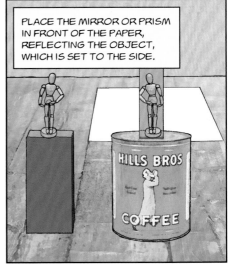

IF YOU KEEP YOUR HAND AND EYE STEADY, YOU SHOULD BE ABLE TO ACCURATELY COPY WHAT YOU SEE BY LINING UP THE EDGES.

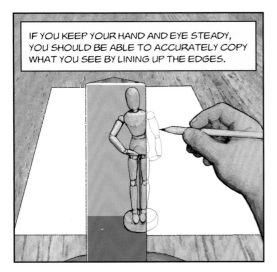

ANOTHER METHOD: TAKE A PICTURE.

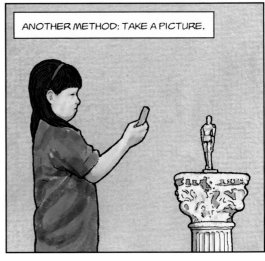

START BY PLACING THE OBJECT ON A SHEET OF PAPER. (YOU'LL MAKE YOUR WORK EASIER IF IT'S GRAPH PAPER.)

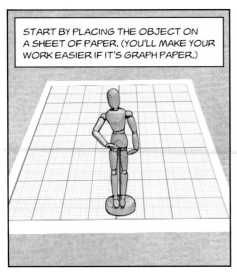

YOU CAN TRANSFER THE IMAGE IN THE PHOTOGRAPH SQUARE BY SQUARE ONTO AN UNDISTORTED SHEET OF GRAPH PAPER.

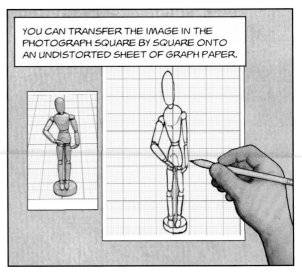

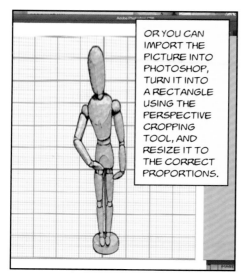

OR YOU CAN IMPORT THE PICTURE INTO PHOTOSHOP, TURN IT INTO A RECTANGLE USING THE PERSPECTIVE CROPPING TOOL, AND RESIZE IT TO THE CORRECT PROPORTIONS.

ACTUALLY, ONCE YOU PRINT OUT THE ALTERED VERSION OF YOUR PHOTOGRAPH...

...YOU PRETTY MUCH DON'T NEED TO DO ANY DRAWING AT ALL.

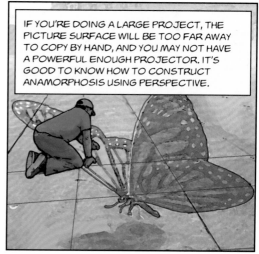

IF YOU'RE DOING A LARGE PROJECT, THE PICTURE SURFACE WILL BE TOO FAR AWAY TO COPY BY HAND, AND YOU MAY NOT HAVE A POWERFUL ENOUGH PROJECTOR. IT'S GOOD TO KNOW HOW TO CONSTRUCT ANAMORPHOSIS USING PERSPECTIVE.

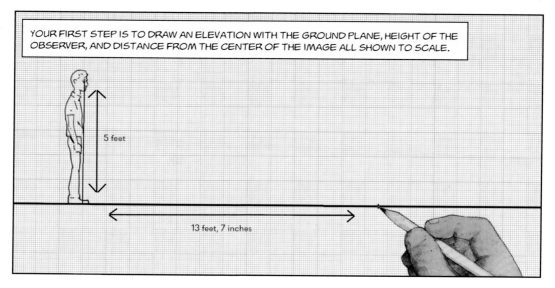

YOUR FIRST STEP IS TO DRAW AN ELEVATION WITH THE GROUND PLANE, HEIGHT OF THE OBSERVER, AND DISTANCE FROM THE CENTER OF THE IMAGE ALL SHOWN TO SCALE.

5 feet

13 feet, 7 inches

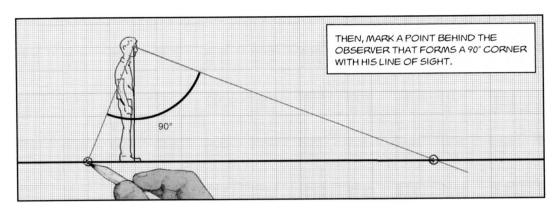

THEN, MARK A POINT BEHIND THE OBSERVER THAT FORMS A 90° CORNER WITH HIS LINE OF SIGHT.

90°

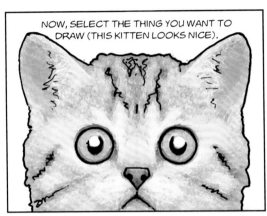

NOW, SELECT THE THING YOU WANT TO DRAW (THIS KITTEN LOOKS NICE).

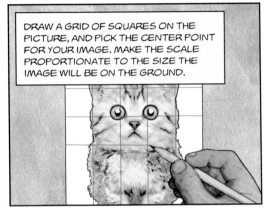

DRAW A GRID OF SQUARES ON THE PICTURE, AND PICK THE CENTER POINT FOR YOUR IMAGE. MAKE THE SCALE PROPORTIONATE TO THE SIZE THE IMAGE WILL BE ON THE GROUND.

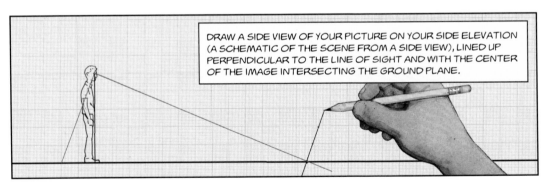

DRAW A SIDE VIEW OF YOUR PICTURE ON YOUR SIDE ELEVATION (A SCHEMATIC OF THE SCENE FROM A SIDE VIEW), LINED UP PERPENDICULAR TO THE LINE OF SIGHT AND WITH THE CENTER OF THE IMAGE INTERSECTING THE GROUND PLANE.

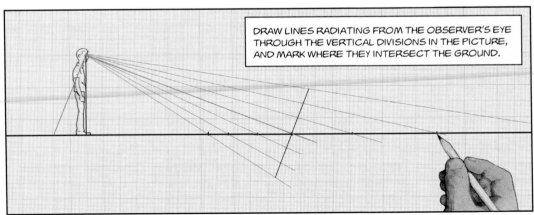

DRAW LINES RADIATING FROM THE OBSERVER'S EYE THROUGH THE VERTICAL DIVISIONS IN THE PICTURE, AND MARK WHERE THEY INTERSECT THE GROUND.

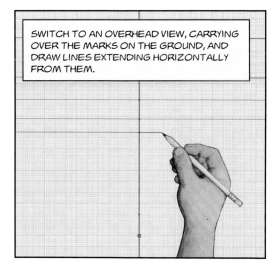

SWITCH TO AN OVERHEAD VIEW, CARRYING OVER THE MARKS ON THE GROUND, AND DRAW LINES EXTENDING HORIZONTALLY FROM THEM.

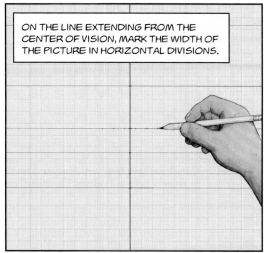

ON THE LINE EXTENDING FROM THE CENTER OF VISION, MARK THE WIDTH OF THE PICTURE IN HORIZONTAL DIVISIONS.

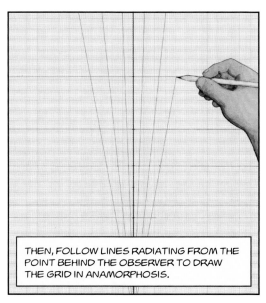

THEN, FOLLOW LINES RADIATING FROM THE POINT BEHIND THE OBSERVER TO DRAW THE GRID IN ANAMORPHOSIS.

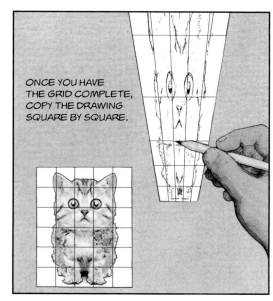

ONCE YOU HAVE THE GRID COMPLETE, COPY THE DRAWING SQUARE BY SQUARE.

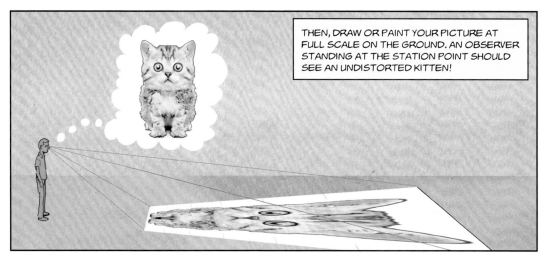

THEN, DRAW OR PAINT YOUR PICTURE AT FULL SCALE ON THE GROUND. AN OBSERVER STANDING AT THE STATION POINT SHOULD SEE AN UNDISTORTED KITTEN!

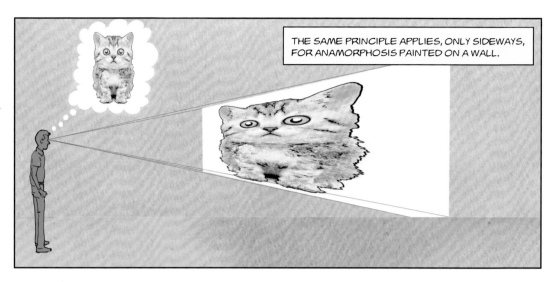

THE SAME PRINCIPLE APPLIES, ONLY SIDEWAYS, FOR ANAMORPHOSIS PAINTED ON A WALL.

IF YOU DON'T WANT TO DO ALL THAT PERSPECTIVE WORK, YOU CAN USE A CAMERA INSTEAD.

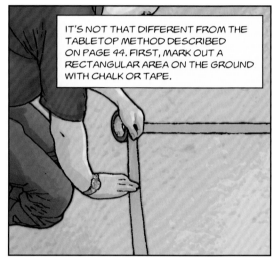

IT'S NOT THAT DIFFERENT FROM THE TABLETOP METHOD DESCRIBED ON PAGE 44. FIRST, MARK OUT A RECTANGULAR AREA ON THE GROUND WITH CHALK OR TAPE.

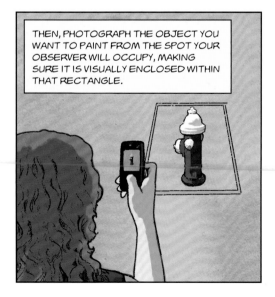

THEN, PHOTOGRAPH THE OBJECT YOU WANT TO PAINT FROM THE SPOT YOUR OBSERVER WILL OCCUPY, MAKING SURE IT IS VISUALLY ENCLOSED WITHIN THAT RECTANGLE.

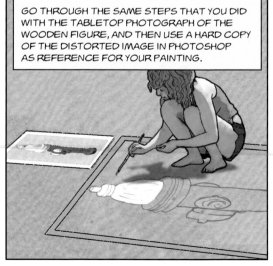

GO THROUGH THE SAME STEPS THAT YOU DID WITH THE TABLETOP PHOTOGRAPH OF THE WOODEN FIGURE, AND THEN USE A HARD COPY OF THE DISTORTED IMAGE IN PHOTOSHOP AS REFERENCE FOR YOUR PAINTING.

ANOTHER THING YOU CAN DO IS DRAW A DESIGN OF YOUR OWN ONTO A PHOTOGRAPH OF THE EMPTY RECTANGLE . . .

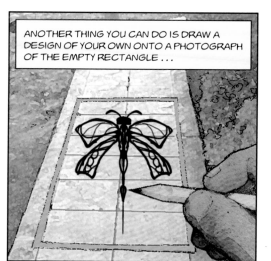

. . . THEN, APPLY ALL THE PERSPECTIVE DISTORTION IN PHOTOSHOP, AND USE A HARD COPY OF THE DISTORTED DESIGN AS REFERENCE FOR PAINTING IT IN ANAMORPHOSIS.

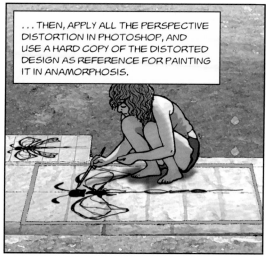

ANOTHER REALLY COOL THING YOU CAN DO, IF YOU'RE PAINTING A MURAL IN ANAMORPHOSIS, IS TO CONTINUE THE TILE PATTERN ON THE FLOOR IN THE ROOM. THE DIAGONAL VANISHING POINT COMES IN VERY HANDY HERE.

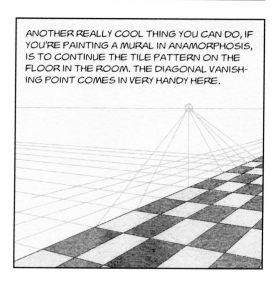

BUT WHAT IF THERE'S NO ROOM FOR THE DIAGONAL VANISHING POINT ON YOUR WALL?

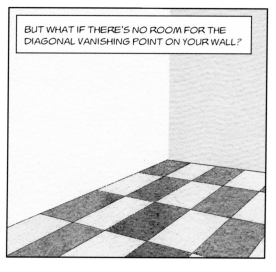

THEN, YOU HAVE TO FIND ANOTHER DIAGONAL VANISHING POINT--SAY, THE DIAGONAL OF TWO SQUARES TOGETHER--BY DRAWING A LINE FROM THE STATION POINT TO THE WALL, AND THEN CONTINUING THAT LINE VERTICALLY UNTIL IT CROSSES THE HORIZON. WHERE IT INTERSECTS THE HORIZON IS YOUR NEW DIAGONAL VANISHING POINT.

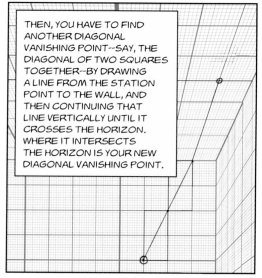

YOU NOW HAVE A MEANS OF FINDING EVERY SECOND LINE GOING BACK IN SPACE, AND YOU CAN USE THE X METHOD USED TO DIVIDE UP SQUARES INTO SMALLER SQUARES TO FIND THE LINES IN BETWEEN.

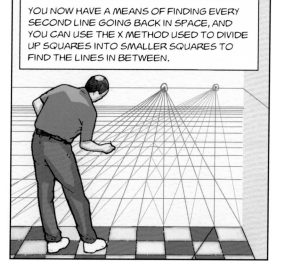

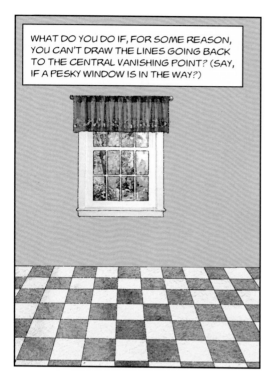

WHAT DO YOU DO IF, FOR SOME REASON, YOU CAN'T DRAW THE LINES GOING BACK TO THE CENTRAL VANISHING POINT? (SAY, IF A PESKY WINDOW IS IN THE WAY?)

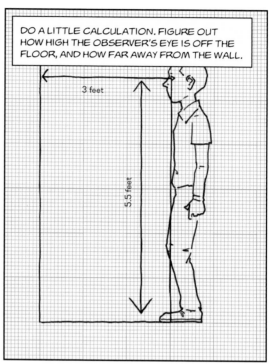

DO A LITTLE CALCULATION. FIGURE OUT HOW HIGH THE OBSERVER'S EYE IS OFF THE FLOOR, AND HOW FAR AWAY FROM THE WALL.

3 feet

5.5 feet

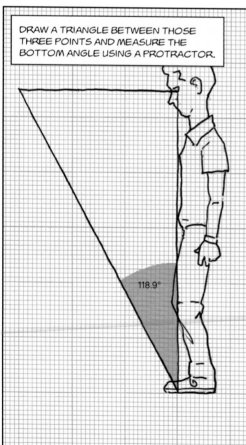

DRAW A TRIANGLE BETWEEN THOSE THREE POINTS AND MEASURE THE BOTTOM ANGLE USING A PROTRACTOR.

118.9°

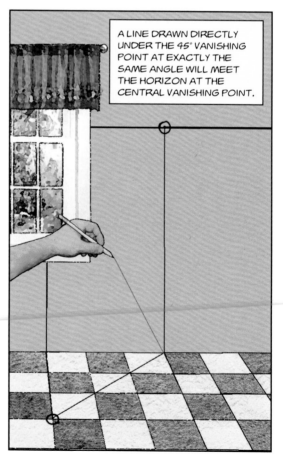

A LINE DRAWN DIRECTLY UNDER THE 45° VANISHING POINT AT EXACTLY THE SAME ANGLE WILL MEET THE HORIZON AT THE CENTRAL VANISHING POINT.

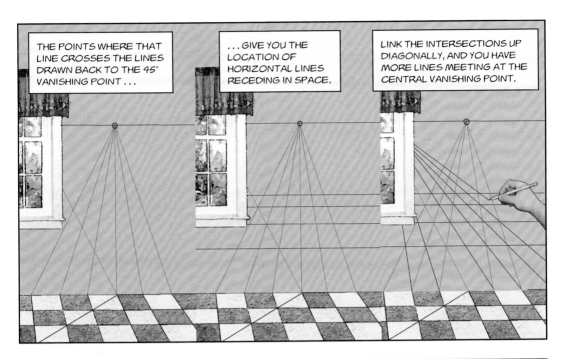

THE POINTS WHERE THAT LINE CROSSES THE LINES DRAWN BACK TO THE 45° VANISHING POINT . . .

. . . GIVE YOU THE LOCATION OF HORIZONTAL LINES RECEDING IN SPACE.

LINK THE INTERSECTIONS UP DIAGONALLY, AND YOU HAVE MORE LINES MEETING AT THE CENTRAL VANISHING POINT.

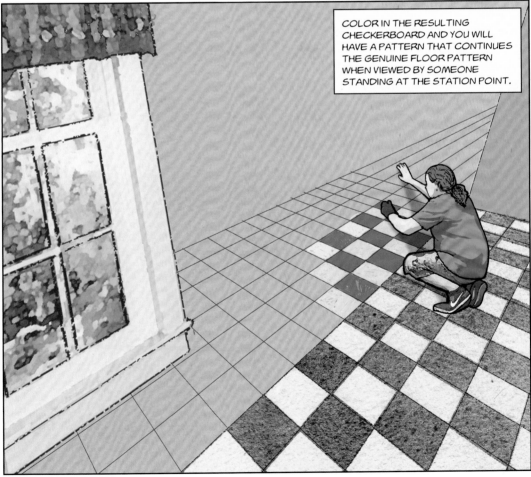

COLOR IN THE RESULTING CHECKERBOARD AND YOU WILL HAVE A PATTERN THAT CONTINUES THE GENUINE FLOOR PATTERN WHEN VIEWED BY SOMEONE STANDING AT THE STATION POINT.

ONE MORE TIP ABOUT LARGE-SCALE ANAMORPHOSIS:

IF YOU DON'T WANT TO WORK IT ALL OUT IN PERSPECTIVE, AND YOU DON'T HAVE A PROJECTOR, YOU CAN ALWAYS JUST TRACE THE SHADOW.

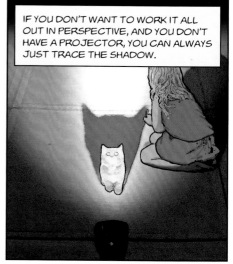

ONCE YOU HAVE THE SHADOW TRACED, IT'S UP TO YOU TO FILL IN THE OUTLINE.

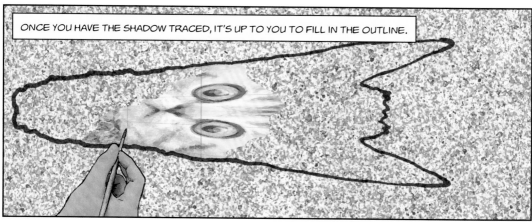

IT MAY MAKE SENSE TO ELEVATE YOUR MODEL, IF YOU DON'T WANT ITS FEET CUT OFF.

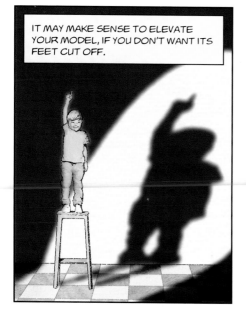

SINCE THE SHADOW GROWS AS IT GETS FARTHER FROM THE LIGHT SOURCE, IT MAY MAKE SENSE TO START WITH A MINIATURE MODEL.

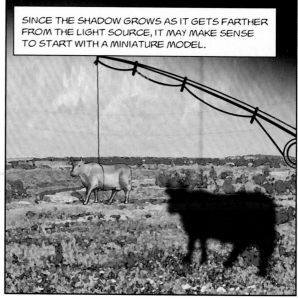

WANT TO TRY ANOTHER KIND OF ANAMORPHOSIS? THIS KIND, DONE WITH A *CYLINDRICAL MIRROR*, HAS BEEN POPULAR SINCE THE 1600s.

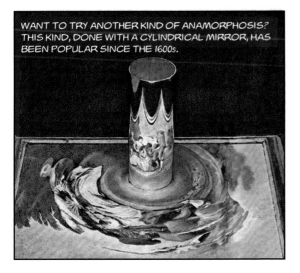

YOUR FIRST STEP IS TO GET A CYLINDRICAL MIRROR. THEY ARE NOT ACTUALLY THAT EASY TO FIND. YOU CAN SUBSTITUTE ANY REFLECTIVE OBJECT THAT IS ROUGHLY CYLINDRICAL: A METAL CUP, A PIPE FITTING, OR A VACUUM CLEANER HOSE EXTENSION.

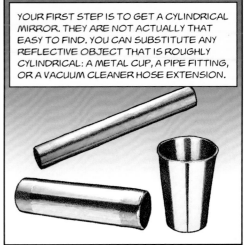

OR, YOU COULD MAKE YOUR OWN BY SILVERING A GLASS TUBE OR STRAIGHT-SIDED GLASS, BUT I DON'T RECOMMEND IT.

DOING SO REQUIRES HEATING (BUT NOT BOILING) A MIXTURE OF SILVER NITRATE, SODIUM HYDROXIDE, AMMONIA, AND SUGAR. IT SHOULD ONLY BE DONE IN A WELL-VENTILATED ROOM BECAUSE THE MIXTURE PRODUCES A TOXIC GAS.

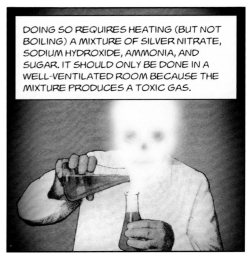

HERE IS A METHOD THAT INVOLVES A CYLINDRICAL MIRROR MADE FROM A TOILET PAPER ROLL AND A SHEET OF SILVERED MYLAR.

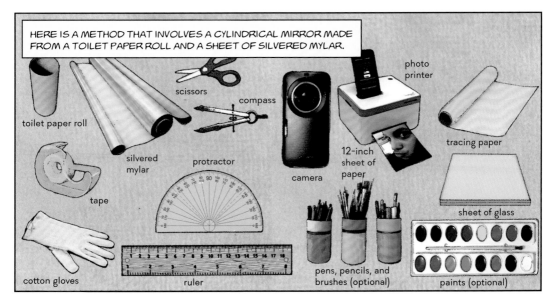

toilet paper roll

scissors

compass

photo printer

tracing paper

silvered mylar

protractor

camera

12-inch sheet of paper

tape

sheet of glass

cotton gloves

ruler

pens, pencils, and brushes (optional)

paints (optional)

START BY CUTTING OUT A STRIP OF SILVERED MYLAR THAT IS 4 INCHES TALL AND A LITTLE OVER 5½ INCHES WIDE.

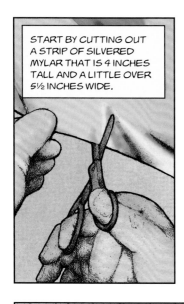

WRAP THE STRIP AROUND THE TOILET PAPER ROLL AND TAPE IT AT THE BACK. USE COTTON GLOVES TO AVOID LEAVING SMEARY FINGERPRINTS ON ITS SURFACE.

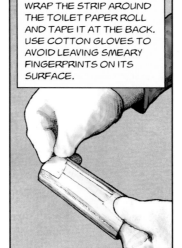

THEN, DRAW OR PRINT OUT A POLAR GRID LIKE THIS ONE. (A DIAMETER OF 12 INCHES IS A GOOD SIZE.)

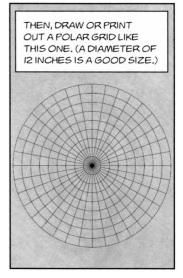

YOU CAN USE A PROTRACTOR, COMPASS, AND RULER TO MAKE DIVISIONS ON THE GRID 10° APART AND 1 INCH THICK EACH.

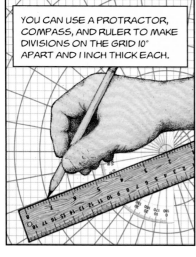

PLACING YOUR CYLINDRICAL MIRROR AT THE CENTER OF THE GRID, LOOK DOWN ON THE MIRROR AT SUCH AN ANGLE THAT THE REFLECTION OF THE GRID ENTIRELY FILLS THE MIRROR.

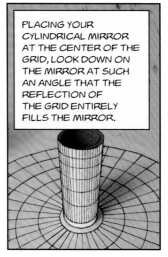

NOW, TAKE A PICTURE OF THE MIRROR ON THE GRID.

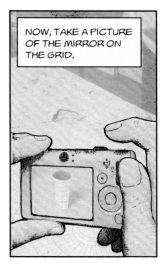

PRINT OUT YOUR PHOTOGRAPH OR DISPLAY IT ON YOUR COMPUTER SCREEN.

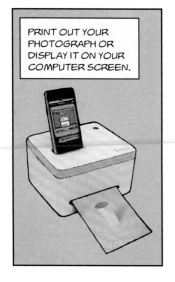

ON A SHEET OF TRACING PAPER (OR IN A DRAWING PROGRAM IF YOU ARE USING A COMPUTER), DRAW THE IMAGE THAT YOU WANT TO USE FOR YOUR ANAMORPHOSIS OVER THE AREA OF THE MIRROR.

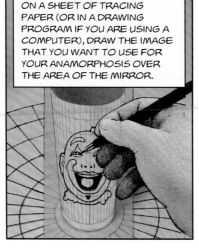

CAREFULLY NOTE HOW THE POLAR GRID PATTERN INTERSECTS WITH YOUR DRAWING.

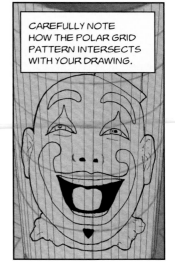

NOW, CAREFULLY TRANSFER YOUR DRAWING TO THE GRID, SECTION BY SECTION. BE AWARE THAT IF YOU DON'T REVERSE THE DRAWING, THE IMAGE REFLECTED IN THE MIRROR WILL BE A REVERSE OF YOUR ORIGINAL SKETCH.

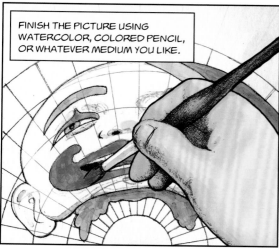

YOU WILL WIND UP WITH A VERY DISTORTED DRAWING ON YOUR GRID, BUT YOU SHOULD SEE AN UNDISTORTED REFLECTION IN THE MIRROR.

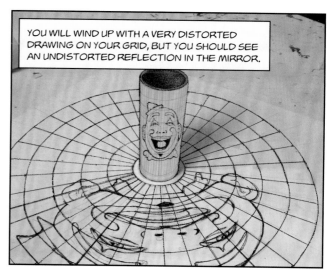

FINISH THE PICTURE USING WATERCOLOR, COLORED PENCIL, OR WHATEVER MEDIUM YOU LIKE.

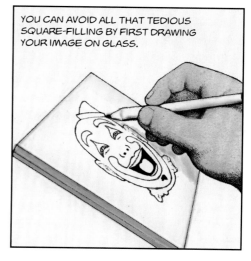

YOU CAN AVOID ALL THAT TEDIOUS SQUARE-FILLING BY FIRST DRAWING YOUR IMAGE ON GLASS.

NEXT, LOOK AT THE CYLINDRICAL MIRROR THROUGH THE GLASS AND ATTEMPT TO TRACE THE IMAGE ON THE PAPER SURFACE. YOU WILL NEED TO KEEP YOUR EYE FIXED WHILE HOLDING THE GLASS EXTREMELY STEADY AND HAVE GOOD HAND-EYE COORDINATION!

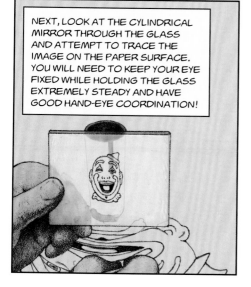

COLOR YOUR DRAWING AND-- VOILA--THE PIECE IS DONE!

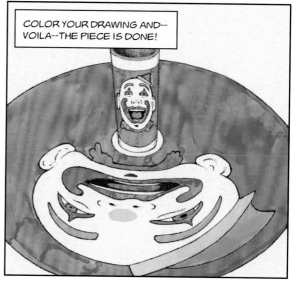

ANAMORPHOSIS 55

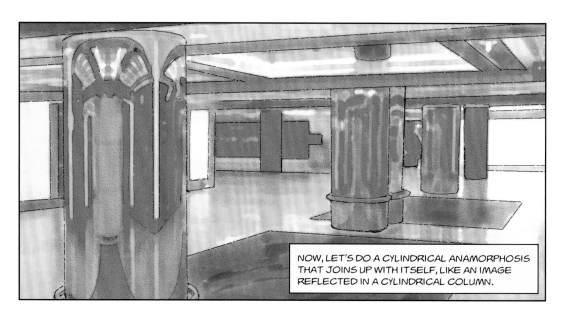

NOW, LET'S DO A CYLINDRICAL ANAMORPHOSIS THAT JOINS UP WITH ITSELF, LIKE AN IMAGE REFLECTED IN A CYLINDRICAL COLUMN.

THIS EXERCISE REQUIRES DISTORTING A CYLINDRICAL PERSPECTIVE GRID INTO A DOUGHNUT SHAPE. FORTUNATELY, I'VE ALREADY DONE THAT WORK FOR YOU.

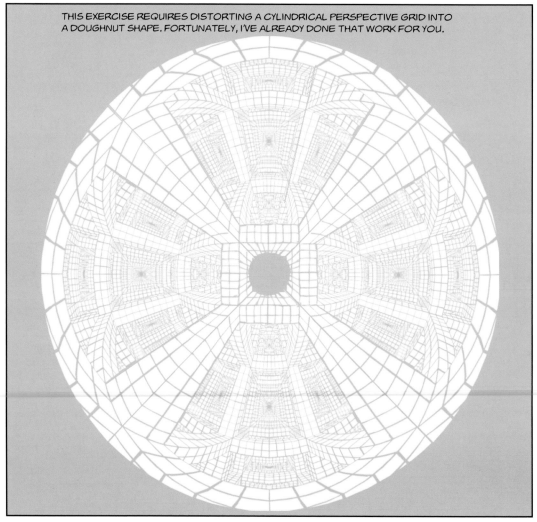

DRAW A PERSPECTIVE SCENE, FOLLOWING THE LINES ON THE GRID.

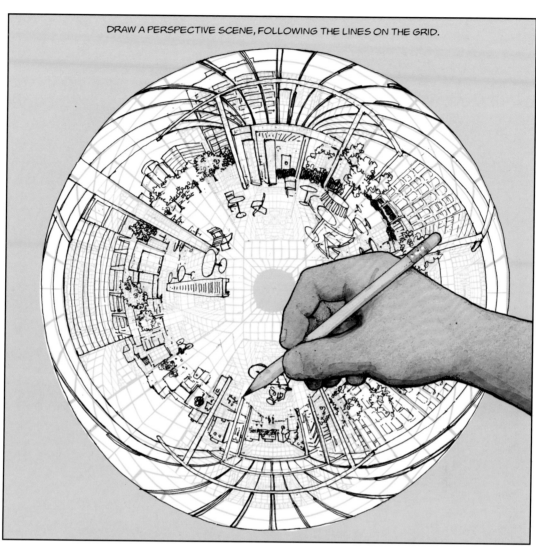

UNLIKE THE FIRST EXAMPLE, YOU CAN VIEW THIS DRAWING FROM ANY DIRECTION, AND CAN ROTATE IT 360° TO JOIN UP WITH ITSELF.

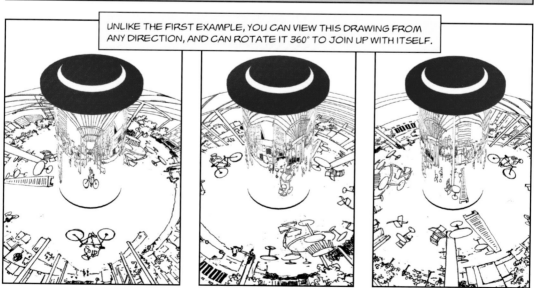

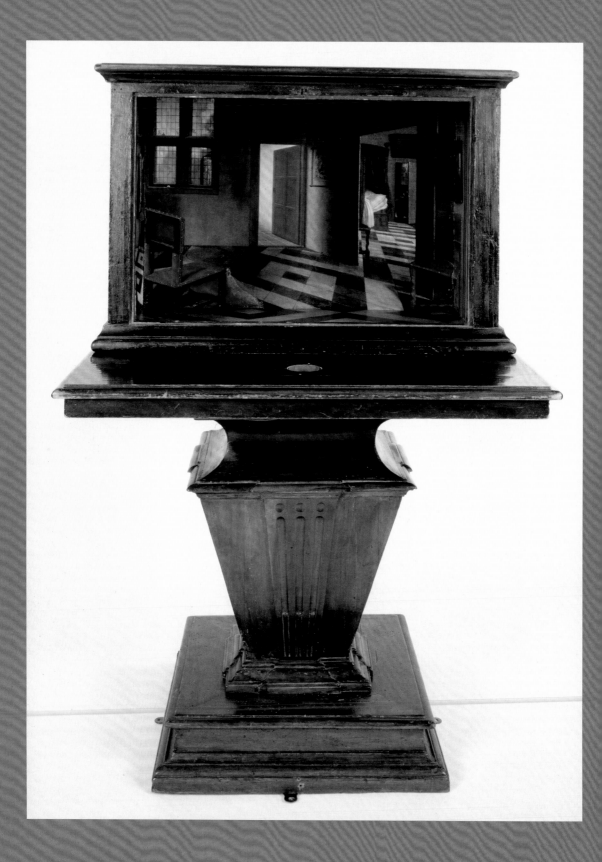

4
CABINETS OF WONDER

In this chapter, we'll look at a different type of anamorphosis—anamorphosis enclosed. Even though every correctly constructed perspective has an implied ideal viewing point, as I noted in the previous chapter, viewers tend to wander and occupy any old spot when looking at pieces. (To say nothing of those viewing reproductions in a book.) Photography and especially film have the same problem. The only person occupying the station point at a film or slideshow would have to have their eye on the lens of the projector. Anamorphosis depends on being seen from a fixed viewpoint. Sometimes the artist will thoughtfully mark the spot. But the makers of cabinet perspectives (or cabinets of wonder) leave nothing to chance. When your perspective scene is only visible through a tiny hole, it is impossible for it not be seen as it is meant to be seen. (Though for the illusion to be really appreciated, one really must take the top off and view the image from another angle.)

The perspective cabinets produced during the Renaissance by Dutch artists like Samuel Hoogstraeten are among the highest form of this art. But nothing tops the Ames Room devised by ophthalmologist Adelbert Ames in the 1930s. In that clever optical illusion, a person standing in one corner appears to the observer to be a giant, while a person standing in the other corner appears to be a dwarf. The illusion is so convincing that a person walking back and forth from the left corner to the right corner appears to grow or shrink. The Ames Room has long been a popular exhibit at science museums, and it appears in films like *Willy Wonka & the Chocolate Factory* and *Temple Grandin*, as well as in music videos. Unfortunately, providing plans for a full-size room is beyond my skill set, but I'm sure your friends will be impressed with the miniature version I will show you how to build in this chapter.

Samuel van Hoogstraeten, *A Peepshow with Views of the Interior of a Dutch House*, c. 1655-60, oil and egg on wood, $22^{83}/_{100}$ x $34^{65}/_{100}$ x $23^{82}/_{100}$ inches (58 x 88 x 60.5 cm). Presented by Sir Robert and Lady Witt through The Art Fund, 1924 (NG3832). Photo Credit: © National Gallery, London/Art Resource, NY.

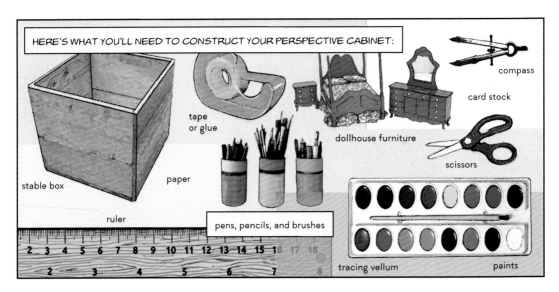

HERE'S WHAT YOU'LL NEED TO CONSTRUCT YOUR PERSPECTIVE CABINET:

compass

card stock

dollhouse furniture

scissors

tape or glue

paper

stable box

ruler

pens, pencils, and brushes

tracing vellum

paints

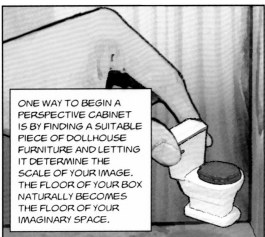

ONE WAY TO BEGIN A PERSPECTIVE CABINET IS BY FINDING A SUITABLE PIECE OF DOLLHOUSE FURNITURE AND LETTING IT DETERMINE THE SCALE OF YOUR IMAGE. THE FLOOR OF YOUR BOX NATURALLY BECOMES THE FLOOR OF YOUR IMAGINARY SPACE.

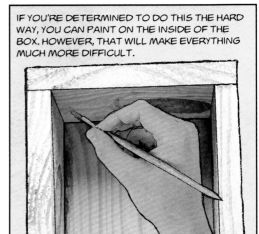

IF YOU'RE DETERMINED TO DO THIS THE HARD WAY, YOU CAN PAINT ON THE INSIDE OF THE BOX. HOWEVER, THAT WILL MAKE EVERYTHING MUCH MORE DIFFICULT.

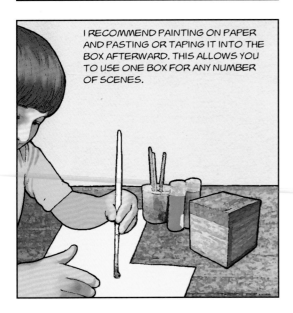

I RECOMMEND PAINTING ON PAPER AND PASTING OR TAPING IT INTO THE BOX AFTERWARD. THIS ALLOWS YOU TO USE ONE BOX FOR ANY NUMBER OF SCENES.

YOU MUST ESTABLISH A POINT WHERE THE SPECTATOR'S EYE WILL BE. THE TEMPTATION IS TO PLACE IT AT THE VERY EDGE OR CORNER OF YOUR BOX, BUT THAT WOULD BE A MISTAKE. THE SPECTATOR'S EYE WILL MOST LIKELY BE DIRECTLY OVER A POINT JUST INSIDE THE BOX AND SLIGHTLY HIGHER THAN THE LID.

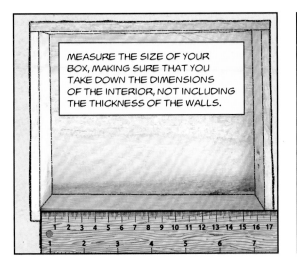

MEASURE THE SIZE OF YOUR BOX, MAKING SURE THAT YOU TAKE DOWN THE DIMENSIONS OF THE INTERIOR, NOT INCLUDING THE THICKNESS OF THE WALLS.

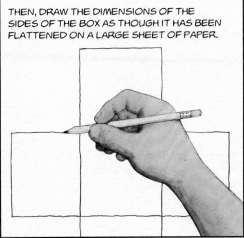

THEN, DRAW THE DIMENSIONS OF THE SIDES OF THE BOX AS THOUGH IT HAS BEEN FLATTENED ON A LARGE SHEET OF PAPER.

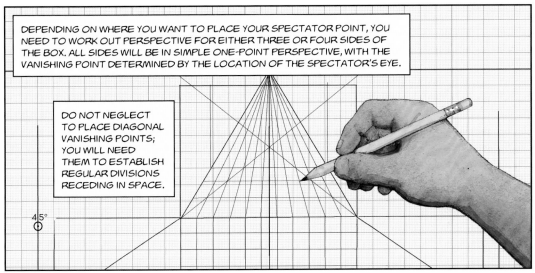

DEPENDING ON WHERE YOU WANT TO PLACE YOUR SPECTATOR POINT, YOU NEED TO WORK OUT PERSPECTIVE FOR EITHER THREE OR FOUR SIDES OF THE BOX. ALL SIDES WILL BE IN SIMPLE ONE-POINT PERSPECTIVE, WITH THE VANISHING POINT DETERMINED BY THE LOCATION OF THE SPECTATOR'S EYE.

DO NOT NEGLECT TO PLACE DIAGONAL VANISHING POINTS; YOU WILL NEED THEM TO ESTABLISH REGULAR DIVISIONS RECEDING IN SPACE.

45°

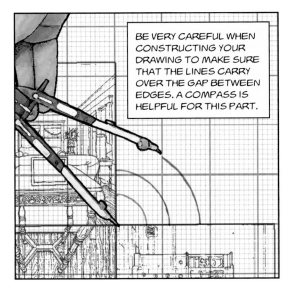

BE VERY CAREFUL WHEN CONSTRUCTING YOUR DRAWING TO MAKE SURE THAT THE LINES CARRY OVER THE GAP BETWEEN EDGES. A COMPASS IS HELPFUL FOR THIS PART.

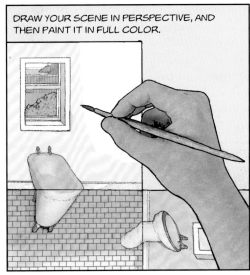

DRAW YOUR SCENE IN PERSPECTIVE, AND THEN PAINT IT IN FULL COLOR.

ONCE YOU ARE DONE, CUT THE SIDES OUT, FOLD AT THE EDGES, AND EITHER TAPE OR GLUE THE DRAWING INSIDE THE BOX.

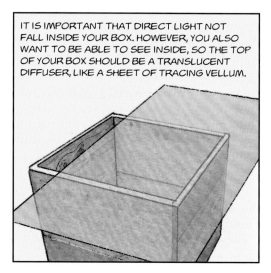

IT IS IMPORTANT THAT DIRECT LIGHT NOT FALL INSIDE YOUR BOX. HOWEVER, YOU ALSO WANT TO BE ABLE TO SEE INSIDE, SO THE TOP OF YOUR BOX SHOULD BE A TRANSLUCENT DIFFUSER, LIKE A SHEET OF TRACING VELLUM.

FOLD THE SHEET OF TRACING VELLUM AROUND THE TOP OF YOUR BOX TO FORM A LID. REINFORCE THE EDGES OF THE LID WITH CARD STOCK FOLDED AND TAPED. CUT A HOLE FOR VIEWING.

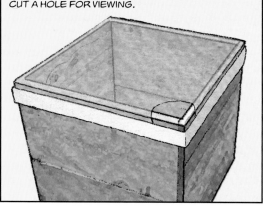

PLACE YOUR PIECE OF DOLLHOUSE FURNITURE FOR THAT EXTRA TOUCH OF VERISIMILITUDE. IF YOU'VE DONE YOUR WORK RIGHT, THE WALLS OF THE BOX SHOULD ENTIRELY DISAPPEAR.

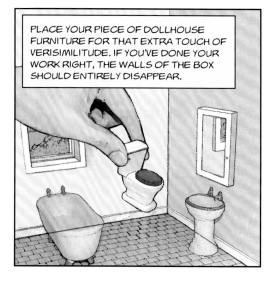

ADDING HUMAN OR ANIMAL FIGURES WILL REQUIRE EITHER CAREFUL CONSTRUCTION OR A FEEL FOR ANAMORPHOSIS, ESPECIALLY IF ONE NEEDS TO BE DRAWN ON MORE THAN ONE SIDE OF THE BOX.

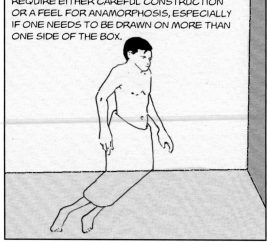

TRY DRAWING THE FIGURE ON GLASS FIRST, AND THEN TRACING THE OUTLINE ON THE WALLS.

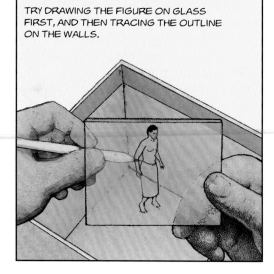

IF YOU WANT TO GET REALLY AMBITIOUS, YOU CAN TRY MAKING A PERSPECTIVE CABINET OUT OF A CYLINDRICAL BOX, LIKE THIS BOX OF OATMEAL.

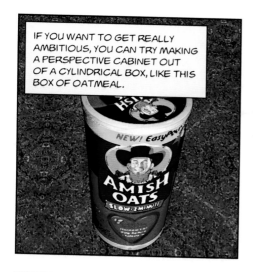

THE CIRCULAR FLOOR IS IN SIMPLE ONE-POINT PERSPECTIVE, BUT THE PERSPECTIVE OF THE WALLS IS FAR MORE COMPLICATED. TO RE-CREATE IT, YOU MUST COMBINE CYLINDRICAL PERSPECTIVE WITH ANAMORPHOSIS.

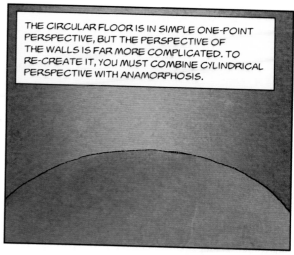

THE CALCULATIONS INVOLVED FOR WORKING OUT THE PERSPECTIVE ARE NOT FOR THE FAINT-HEARTED. FORTUNATELY, I HAVE DONE ALL THE WORK FOR YOU WITH THIS HANDY PERSPECTIVE GRID.

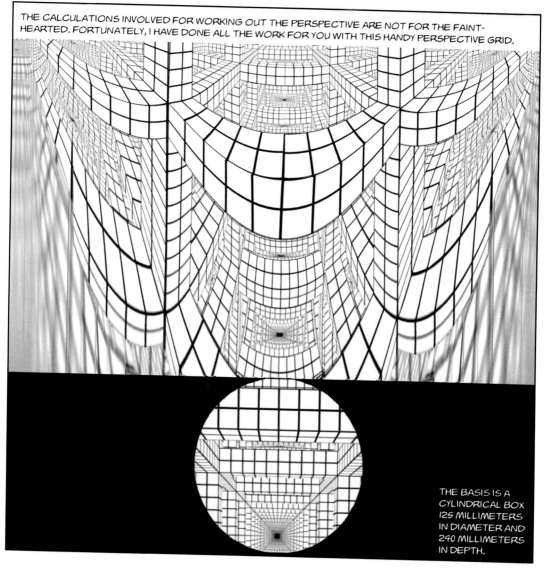

THE BASIS IS A CYLINDRICAL BOX 125 MILLIMETERS IN DIAMETER AND 240 MILLIMETERS IN DEPTH.

FOLLOW THE PERSPECTIVE LINES TO CREATE YOUR SCENE. IT MAKES SENSE TO FADE
OUT THE AREA NEAREST YOUR EYE, WHERE THE FORESHORTENING IS MOST EXTREME.

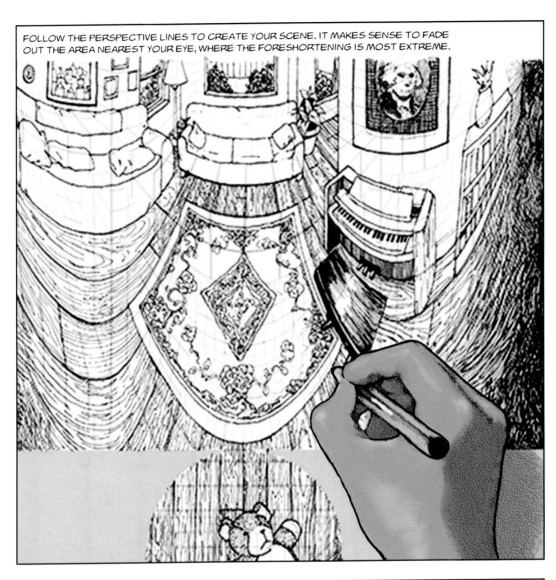

ONCE YOUR PAINTING IS DONE, ROLL
IT UP AND GLUE IT INSIDE THE BOX .

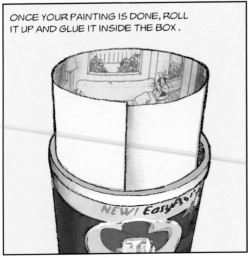

CONSTRUCT A VELLUM LID, AS YOU DID FOR THE
OTHER BOX, BUT MAKE IT CIRCULAR THIS TIME.

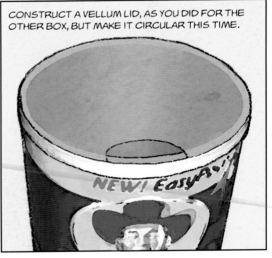

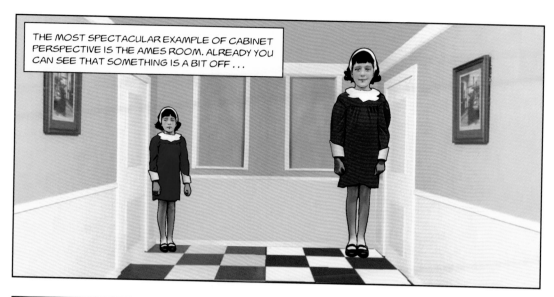

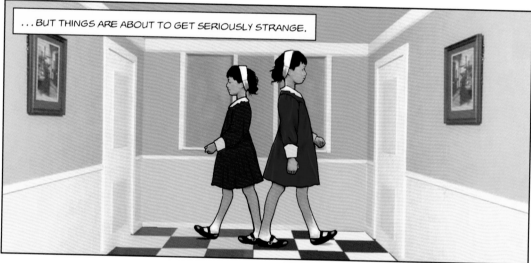

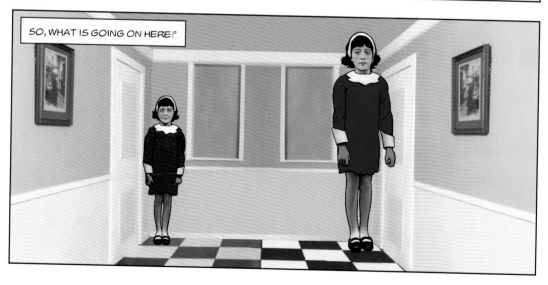

A VIEW FROM ANOTHER ANGLE MAKES THINGS A BIT MORE CLEAR.

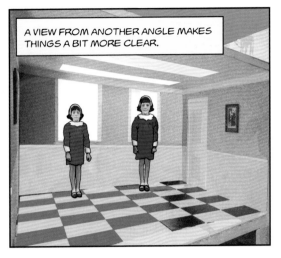

THE AMES ROOM WAS DEVISED IN 1934 BY AN OPHTHALMOLOGIST NAMED ADELBERT AMES, JR.

THE ILLUSION RELIES ON YOUR EYE'S INABILITY TO TELL THE DIFFERENCE BETWEEN A SMALL NEAR OBJECT AND A LARGE DISTANT OBJECT.

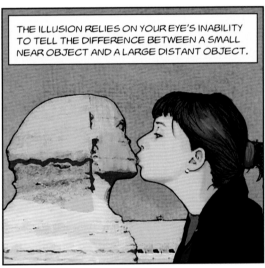

IN THIS CASE, THE BACKGROUND IS MANIPULATED TO MAKE TWO IDENTICAL OBJECTS APPEAR TO BE DIFFERENT SIZES.

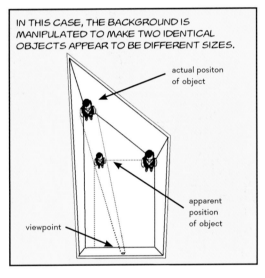

actual positon of object

apparent position of object

viewpoint

THERE IS NO ONE SINGLE SHAPE THAT AN AMES ROOM MUST HAVE. WHAT THEY ALL SHARE IS THAT THEY ARE MEANT TO BE VIEWED FROM ONE FIXED POINT AND THAT UNEQUALLY SIZED WALLS APPEAR TO BE IDENTICAL FROM THAT VIEWPOINT.

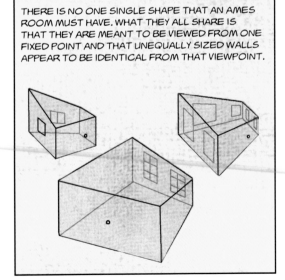

I AM GOING TO SHOW YOU HOW TO CREATE A ROOM WITH THE LEFT WALL EXACTLY TWICE THE SIZE OF THE RIGHT WALL.

THIS WILL BE A MINIATURE MODEL (250 MILLIMETERS, OR A LITTLE SHORT OF 10 INCHES IN HEIGHT, 300 MILLIMETERS IN WIDTH, AND 450 MILLIMETERS IN DEPTH).

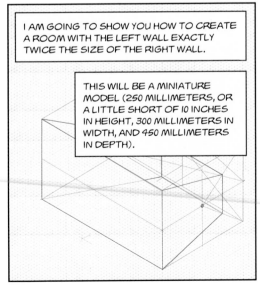

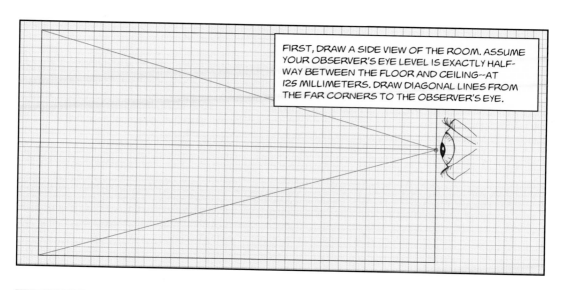

FIRST, DRAW A SIDE VIEW OF THE ROOM. ASSUME YOUR OBSERVER'S EYE LEVEL IS EXACTLY HALF-WAY BETWEEN THE FLOOR AND CEILING--AT 125 MILLIMETERS. DRAW DIAGONAL LINES FROM THE FAR CORNERS TO THE OBSERVER'S EYE.

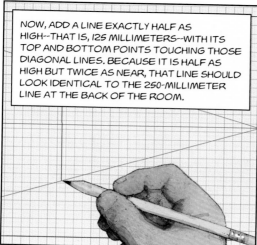

NOW, ADD A LINE EXACTLY HALF AS HIGH--THAT IS, 125 MILLIMETERS--WITH ITS TOP AND BOTTOM POINTS TOUCHING THOSE DIAGONAL LINES. BECAUSE IT IS HALF AS HIGH BUT TWICE AS NEAR, THAT LINE SHOULD LOOK IDENTICAL TO THE 250-MILLIMETER LINE AT THE BACK OF THE ROOM.

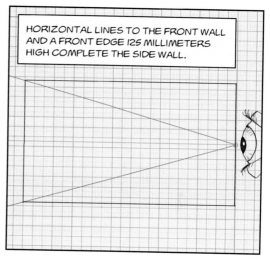

HORIZONTAL LINES TO THE FRONT WALL AND A FRONT EDGE 125 MILLIMETERS HIGH COMPLETE THE SIDE WALL.

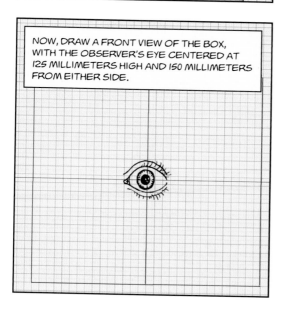

NOW, DRAW A FRONT VIEW OF THE BOX, WITH THE OBSERVER'S EYE CENTERED AT 125 MILLIMETERS HIGH AND 150 MILLIMETERS FROM EITHER SIDE.

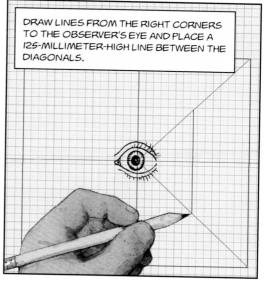

DRAW LINES FROM THE RIGHT CORNERS TO THE OBSERVER'S EYE AND PLACE A 125-MILLIMETER-HIGH LINE BETWEEN THE DIAGONALS.

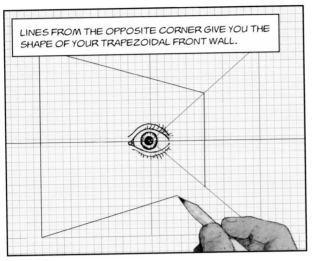

LINES FROM THE OPPOSITE CORNER GIVE YOU THE SHAPE OF YOUR TRAPEZOIDAL FRONT WALL.

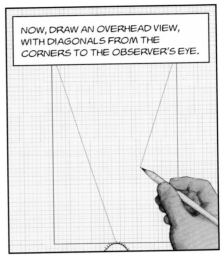

NOW, DRAW AN OVERHEAD VIEW, WITH DIAGONALS FROM THE CORNERS TO THE OBSERVER'S EYE.

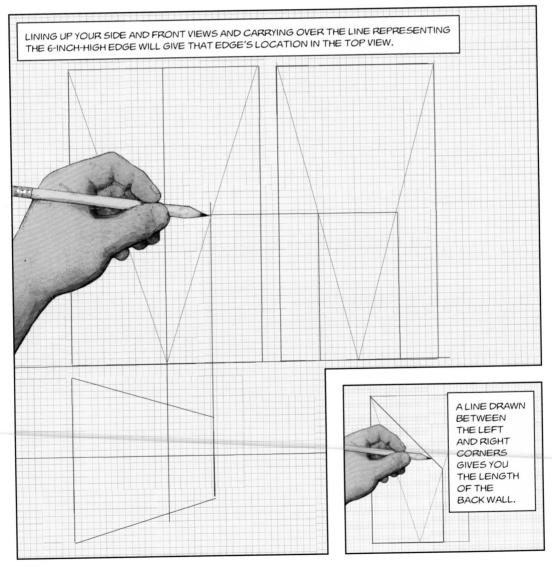

LINING UP YOUR SIDE AND FRONT VIEWS AND CARRYING OVER THE LINE REPRESENTING THE 6-INCH-HIGH EDGE WILL GIVE THAT EDGE'S LOCATION IN THE TOP VIEW.

A LINE DRAWN BETWEEN THE LEFT AND RIGHT CORNERS GIVES YOU THE LENGTH OF THE BACK WALL.

FROM THERE, IT'S EASY TO FIGURE OUT THE LENGTHS OF ALL THE WALLS, FLOOR, AND CEILING, AND TO DRAW THEM SO THAT THEY CAN ALL BE CUT OUT OF ONE SHEET OF CARDBOARD.

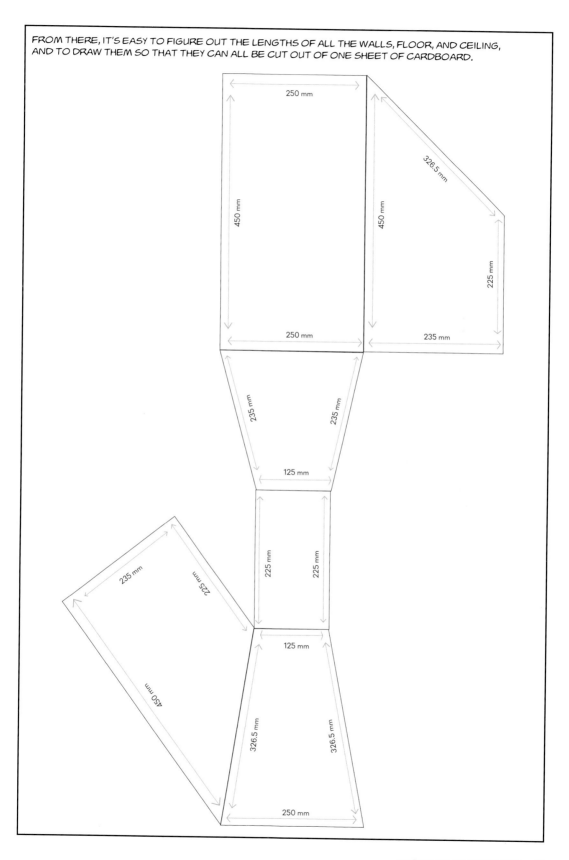

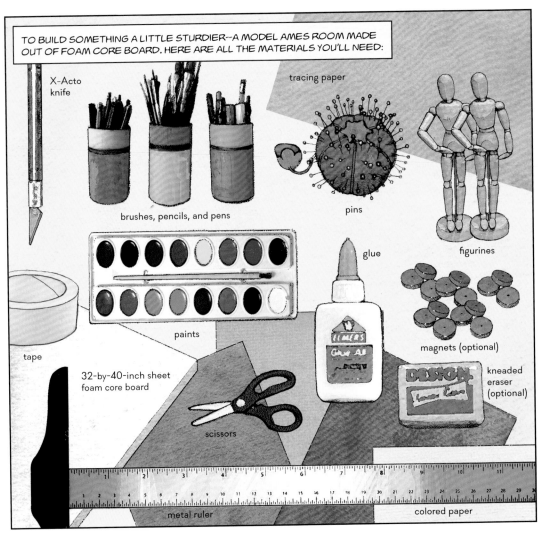

TO BUILD SOMETHING A LITTLE STURDIER--A MODEL AMES ROOM MADE OUT OF FOAM CORE BOARD. HERE ARE ALL THE MATERIALS YOU'LL NEED:

X-Acto knife

brushes, pencils, and pens

tracing paper

pins

figurines

glue

paints

magnets (optional)

tape

32-by-40-inch sheet foam core board

kneaded eraser (optional)

scissors

metal ruler

colored paper

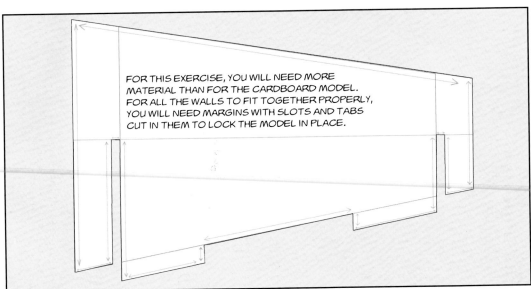

FOR THIS EXERCISE, YOU WILL NEED MORE MATERIAL THAN FOR THE CARDBOARD MODEL. FOR ALL THE WALLS TO FIT TOGETHER PROPERLY, YOU WILL NEED MARGINS WITH SLOTS AND TABS CUT IN THEM TO LOCK THE MODEL IN PLACE.

FORTUNATELY, I HAVE FIGURED OUT HOW TO FIT ALL THE SIDES ON ONE 32-BY-40-INCH SHEET OF FOAM CORE BOARD. I'VE WRITTEN ALL THE DIMENSIONS IN METRIC BECAUSE FOAM CORE SHEETS ARE TYPICALLY 5 MILLIMETERS THICK. (I ALSO DON'T LIKE ALL THE FRACTIONAL MEASURES YOU GET WITH ENGLISH STANDARD MEASUREMENTS.) HERE ARE THE DIMENSIONS FOR BOTH SIDES. BLACK LINES ARE CUTS, SOLID RED LINES ARE CONSTRUCTION LINES, AND BLUE LINES GIVE YOU THE MEASUREMENTS. THE DOTTED RED LINES ARE OUTLINES OF THE OPPOSITE SIDE SHOWING THROUGH.

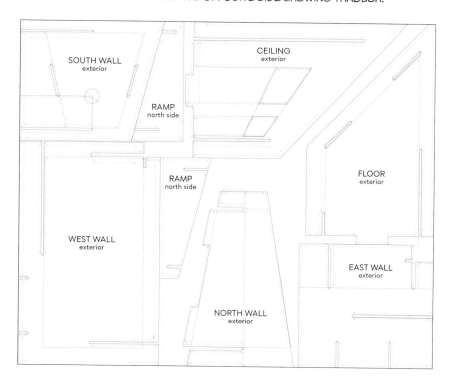

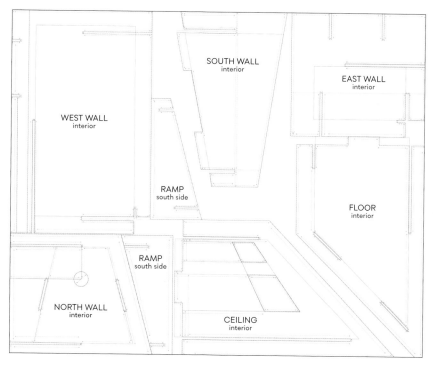

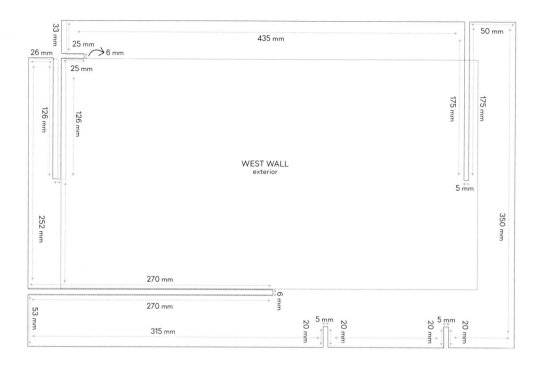

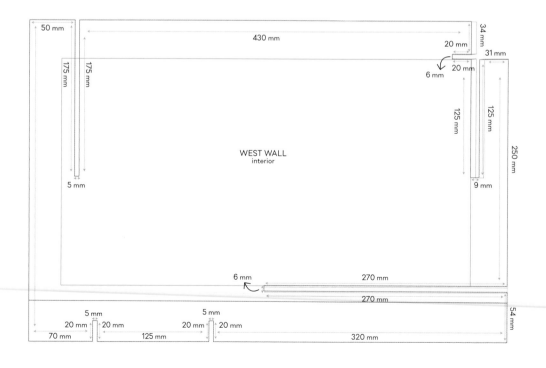

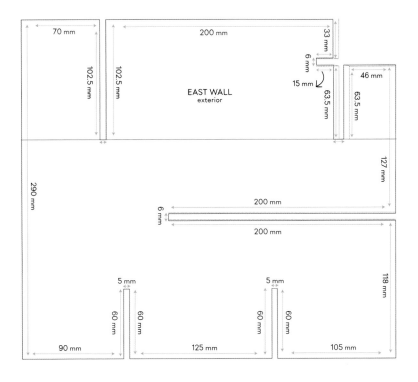

EAST WALL
exterior

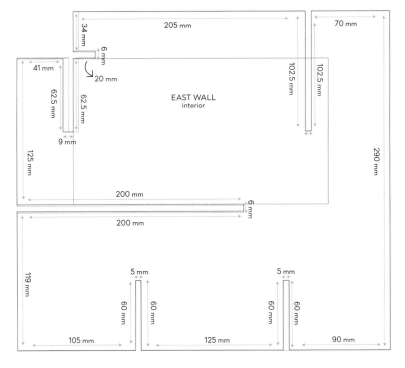

EAST WALL
interior

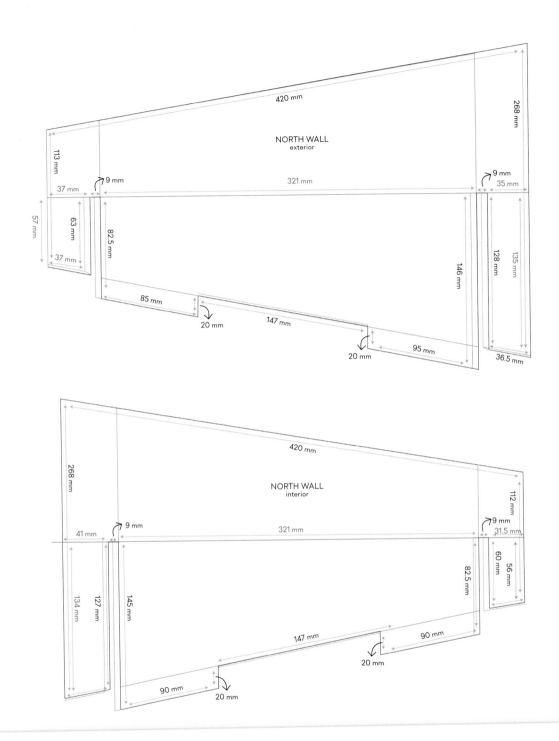

NORTH WALL
exterior

420 mm

268 mm

113 mm

9 mm

37 mm

321 mm

9 mm

35 mm

57 mm

63 mm

82.5 mm

128 mm

135 mm

146 mm

37 mm

85 mm

20 mm

147 mm

20 mm

95 mm

36.5 mm

NORTH WALL
interior

420 mm

268 mm

112 mm

9 mm

41 mm

321 mm

9 mm

31.5 mm

82.5 mm

60 mm

56 mm

145 mm

127 mm

134 mm

147 mm

90 mm

90 mm

20 mm

20 mm

20 mm

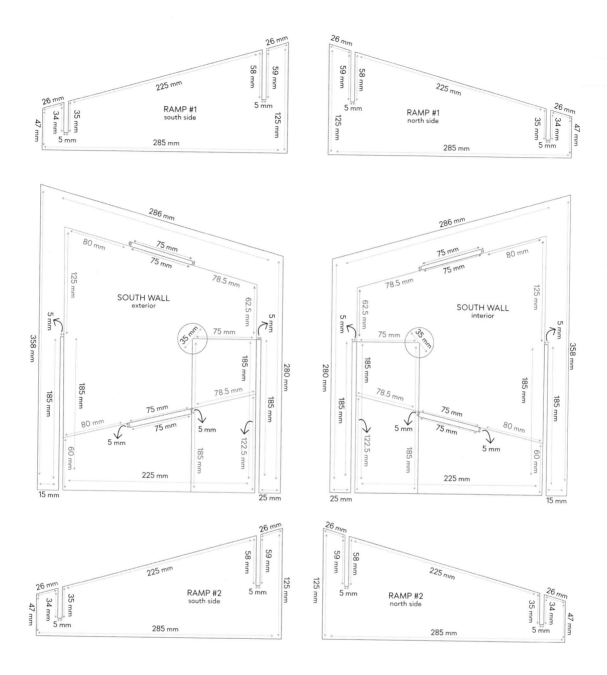

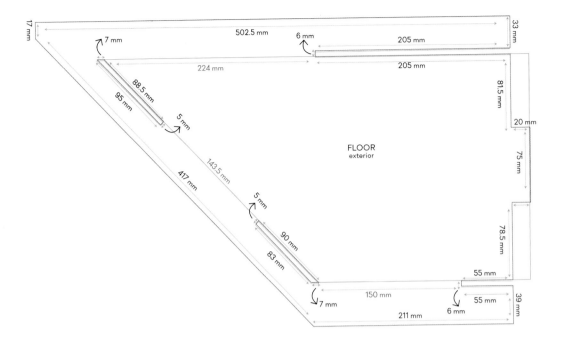

FLOOR
exterior

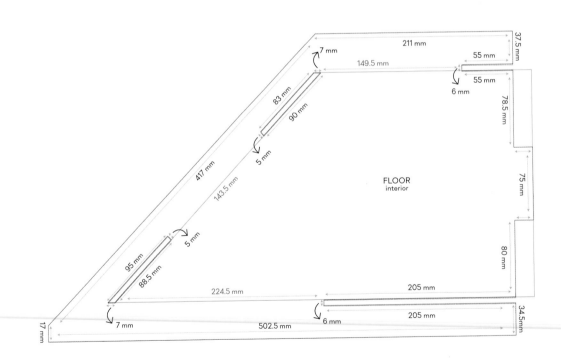

FLOOR
interior

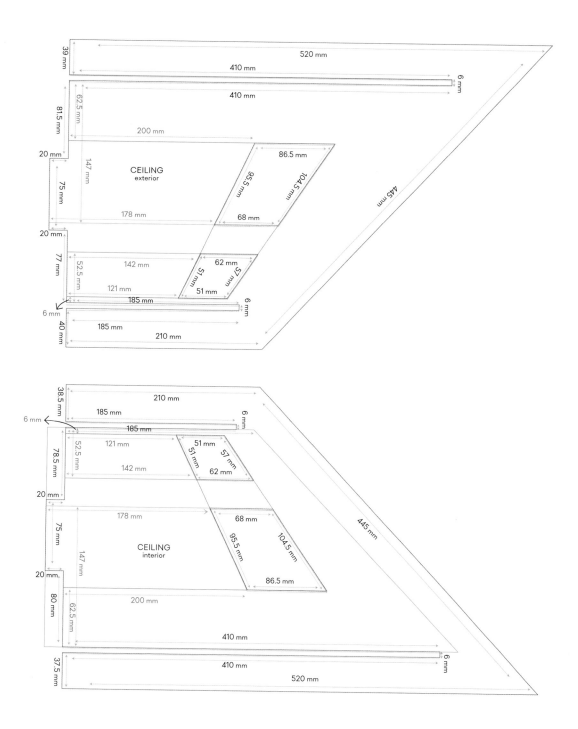

ABOUT THOSE ANGLED CUTS: IT IS DIFFICULT TO MAKE THEM CLEANLY THROUGH FOAM CORE BOARD, BUT HERE IS ONE METHOD. FIRST, CUT SHALLOW LINES THROUGH THE PAPER SURFACE ON BOTH SIDES, TAKING PARTICULAR CARE TO MAKE CLEAN, STRAIGHT CUTS ON THE INTERIOR SIDES.

NEXT, TAPE TWO METAL RULERS ALONG THE CUTS. POKE YOUR BLADE THROUGH TO THE OTHER SIDE, TRYING TO MAKE IT COME OUT JUST AT THE OPPOSITE RULER. THEN, HOLDING IT AT EXACTLY THAT ANGLE, CUT STRAIGHT THROUGH BETWEEN THE RULERS.

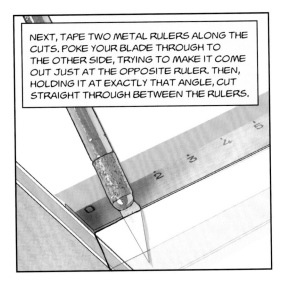

ONCE YOU HAVE ALL THE PIECES CUT OUT, YOU CAN BEGIN TO FIT THEM TOGETHER.

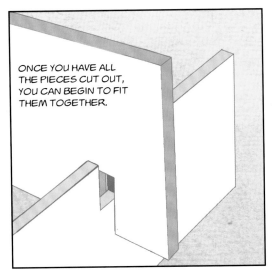

FIRST, THE TWO RAMPS . . .

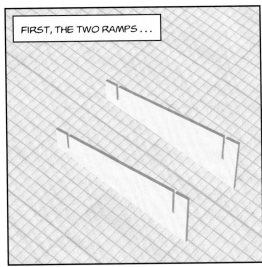

. . . THEN, THE WEST WALL ("WEST" BECAUSE WE'RE ARBITRARILY ASSUMING THE VIEWER IS FACING NORTH).

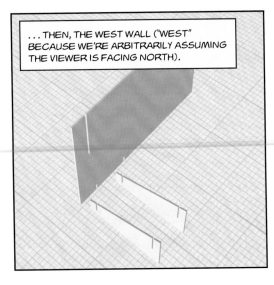

NEXT, THE EAST WALL.

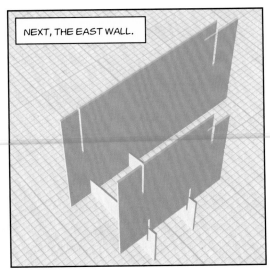

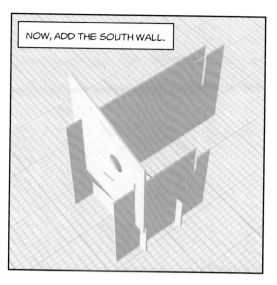

NOW, ADD THE SOUTH WALL.

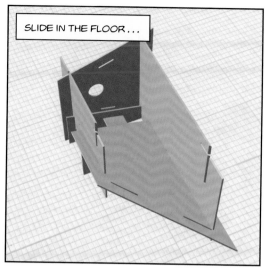

SLIDE IN THE FLOOR . . .

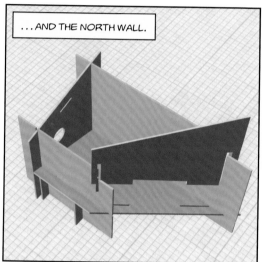

. . . AND THE NORTH WALL.

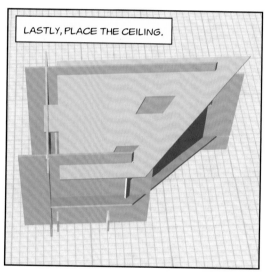

LASTLY, PLACE THE CEILING.

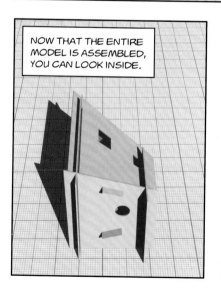

NOW THAT THE ENTIRE MODEL IS ASSEMBLED, YOU CAN LOOK INSIDE.

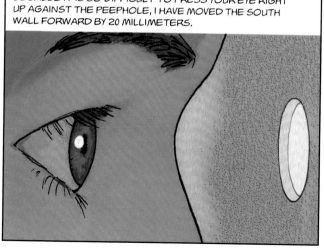

BECAUSE IT IS SO DIFFICULT TO PRESS YOUR EYE RIGHT UP AGAINST THE PEEPHOLE, I HAVE MOVED THE SOUTH WALL FORWARD BY 20 MILLIMETERS.

NOW, LOOK THROUGH THE PEEPHOLE. EVERYTHING LINES UP AS DESIGNED, BUT IT DOES LOOK EMPTY.

TWO IDENTICAL FIGURINES SHOULD PROVIDE A SENSE OF SCALE.

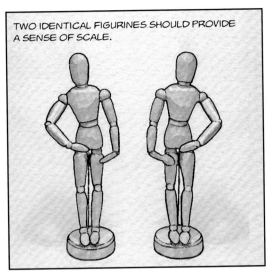

BECAUSE THE FLOOR IS SO SEVERELY TILTED, BOTH MANNEQUINS WILL WANT TO ROLL DOWNHILL. PIN THEM IN PLACE.

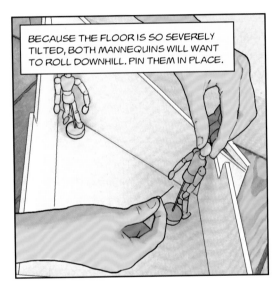

THAT LOOKS JUST ABOUT RIGHT, BUT IT WILL LOOK EVEN BETTER IF YOU DRESS THINGS UP A BIT.

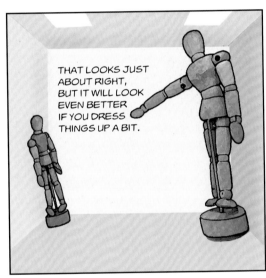

BEGIN WITH A TILE PATTERN ON THE FLOOR. START BY MARKING DIVISIONS ON THE LONG AND SHORT PARALLEL SIDES. CONVENIENTLY, THE LONG SIDE IS EXACTLY TWICE THE SCALE OF THE SHORT SIDE. I'M DIVIDING IT UP BY 25 MILLIMETERS ON THE LONG SIDE AND 12.5 MILLIMETERS ON THE SHORT SIDE, WHICH GIVES IT AN EVEN EIGHTEEN DIVISIONS ACROSS.

THE APPARENT PROPORTION OF THE FLOOR IS EIGHTEEN SQUARES DEEP AND TWELVE WIDE. DRAW A DIAGONAL LINE ACROSS TWELVE ROWS TO GIVE YOU THE INTERSECTIONS FOR THE RECEDING LINES, WHICH ARE ALL PARALLEL.

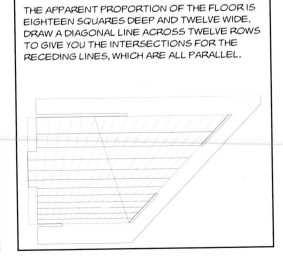

A DOOR, AND PERHAPS A FRAMED PICTURE, WILL HELP TO DRESS UP THE EAST AND WEST WALLS. THEY CAN BE MIRROR IMAGES OF EACH OTHER, JUST AT DIFFERENT SIZES. THE VANISHING POINT FOR RECEDING LINES IS ALL THE WAY AT THE NEAR END.

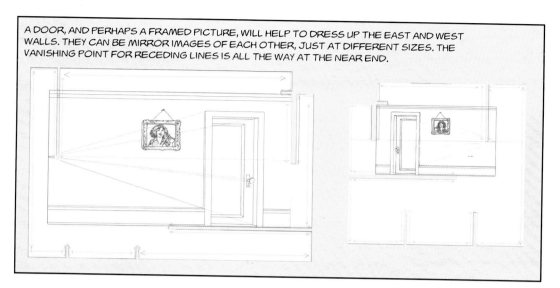

THE NORTH WALL, THE ONE YOU ARE FACING, HAS TO BE DRAWN IN SEVERELY EXAGGERATED PERSPECTIVE IN ORDER TO LOOK STRAIGHT WHEN VIEWED THROUGH THE PEEPHOLE.

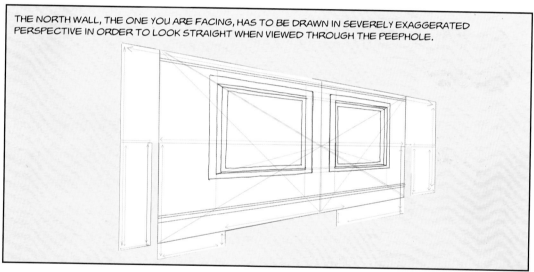

YOU CAN EITHER PAINT ALL OF THESE SURFACES OR CUT OUT COLORED PAPER AND GLUE IT DOWN OVER THEM. FOR A NICE DIFFUSED LIGHTING EFFECT, TAPE TRACING PAPER OVER THE WINDOWS IN THE CEILING.

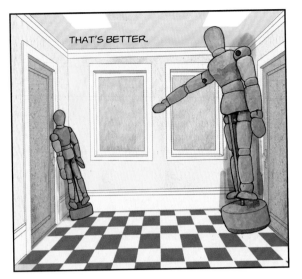

THAT'S BETTER.

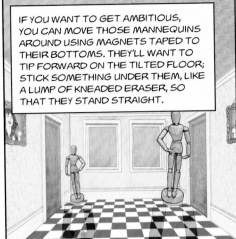

IF YOU WANT TO GET AMBITIOUS, YOU CAN MOVE THOSE MANNEQUINS AROUND USING MAGNETS TAPED TO THEIR BOTTOMS. THEY'LL WANT TO TIP FORWARD ON THE TILTED FLOOR; STICK SOMETHING UNDER THEM, LIKE A LUMP OF KNEADED ERASER, SO THAT THEY STAND STRAIGHT.

IF YOU WANT TO GET EVEN MORE AMBITIOUS, AND HAVE GENUINE CARPENTRY SKILLS, YOU CAN BUILD A FULL-SIZE VERSION OF THE AMES ROOM IN WHICH PEOPLE CAN STAND. HOWEVER, CARPENTRY INSTRUCTIONS ARE BEYOND THE SCOPE OF THIS BOOK. SORRY!

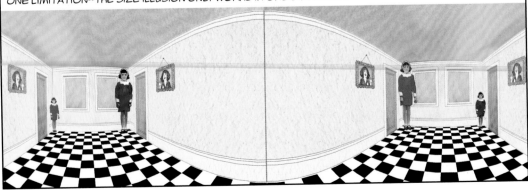

IF YOU DO BUILD A FULL-SIZE AMES ROOM, YOU CAN TAKE IT EVEN A STEP FURTHER, AND BUILD A VERSION IN WHICH THE ILLUSION FILLS YOUR ENTIRE FIELD OF VISION. JUST BUILD TWO AMES ROOMS THAT ARE MIRROR IMAGES OF EACH OTHER, AND JOIN THEM UP AT THE MIDPOINT. ONE LIMITATION--THE SIZE ILLUSION ONLY WORKS IN ONE DIRECTION.

HERE'S ONE LAST COOL THING YOU
CAN DO IN THE FULL-SIZE AMES ROOM.

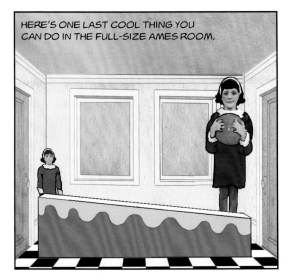

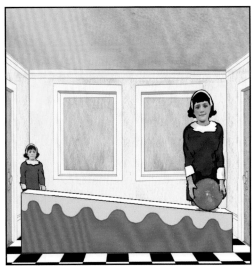

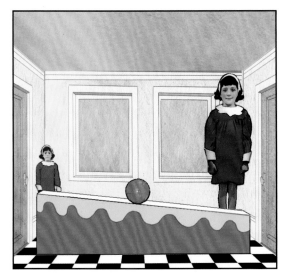

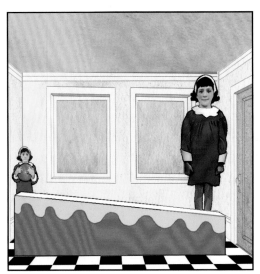

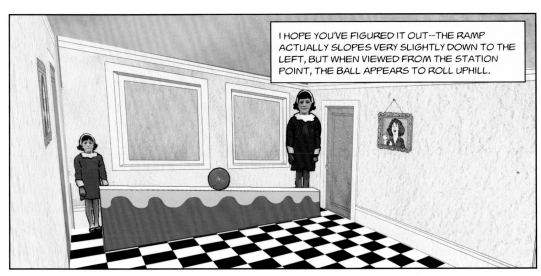

I HOPE YOU'VE FIGURED IT OUT--THE RAMP
ACTUALLY SLOPES VERY SLIGHTLY DOWN TO THE
LEFT, BUT WHEN VIEWED FROM THE STATION
POINT, THE BALL APPEARS TO ROLL UPHILL.

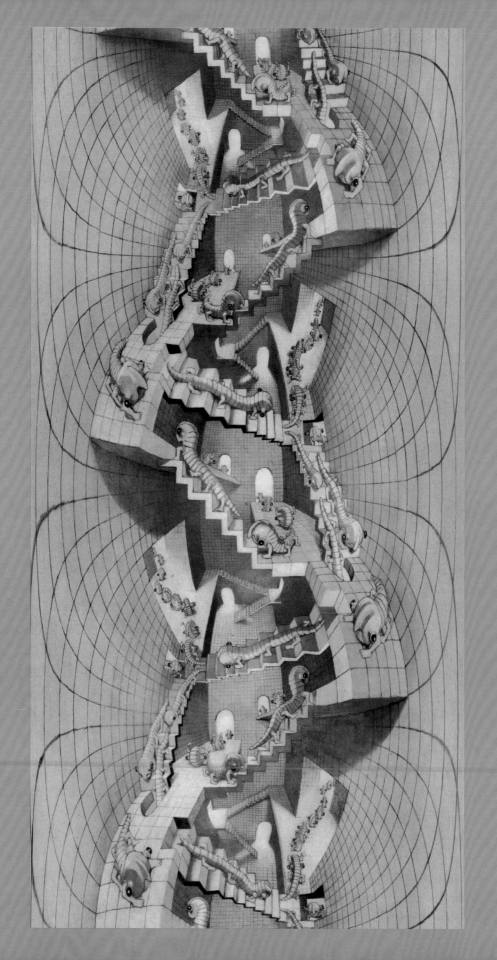

5
SIX-POINT PERSPECTIVE

Classical perspective has a great deal to recommend it; however, it opens a tiny, restrictive window on the world. Go much beyond a narrow area around the center of vision, and you wind up with severe anamorphic distortion (of course, that can be a cool effect; see the chapter on anamorphosis). Adventurous artists have not let themselves be limited by classical perspective, and have explored curvilinear perspective, such as in the Jean Fouquet miniature *Arrival of the Emperor Charles IV in front of Saint Denis* or Vincent van Gogh's famous painting of his room at Arles.

Other artists have wanted to take curvilinear perspective to its logical conclusion, depicting the entire visual field viewable from a single point on a continuous surface. This field would have six vanishing points, not the usual one, two, or three; four located on the horizon at each point of the compass, and one each directly overhead and directly below one's feet. A flat picture plane (the imaginary pane of glass on which an artist traces what he sees, in classical perspective theory) cannot show any more than half of what is visible from a given point, so in order to take in a wider view, we must warp it into a cone, a cylinder, or a sphere. The best way to do this is to paint on a sphere. The first artist to do so, using a systematic approach to perspective, was Dick Termes. Termes began painting his "Termespheres" in 1968. (Thirty years later, I came up with the same method independently. It is that method I share in this book.)

Another way to extend the limited window of classical perspective is to have not one picture plane, but many, forming a faceted polyhedron centered on the observer. I include a number of these exercises in the chapter as well.

David Chelsea, *House of Stairs*, after M.C. Escher, 2009.
An equirectangular projection of a spherical painting.

THE GOLD STANDARD FOR SIX-POINT PERSPECTIVE WOULD BE A SPHERE THAT YOU CAN PAINT FROM THE INSIDE AND VIEW FROM THE CENTER. IT'D BE DIFFICULT TO STORE. I FOR ONE COULDN'T GET IT OUT THE DOOR OF MY STUDIO.

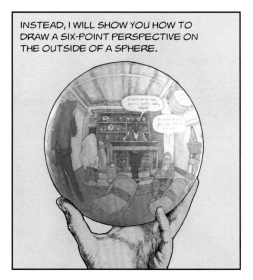

INSTEAD, I WILL SHOW YOU HOW TO DRAW A SIX-POINT PERSPECTIVE ON THE OUTSIDE OF A SPHERE.

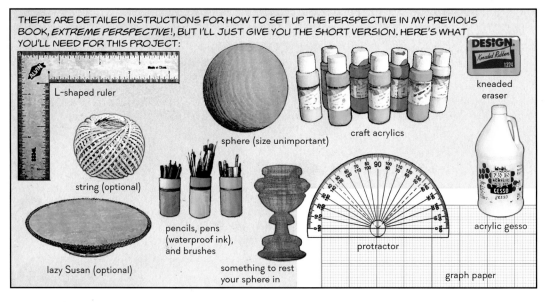

THERE ARE DETAILED INSTRUCTIONS FOR HOW TO SET UP THE PERSPECTIVE IN MY PREVIOUS BOOK, *EXTREME PERSPECTIVE!*, BUT I'LL JUST GIVE YOU THE SHORT VERSION. HERE'S WHAT YOU'LL NEED FOR THIS PROJECT:

L-shaped ruler

string (optional)

lazy Susan (optional)

sphere (size unimportant)

pencils, pens (waterproof ink), and brushes

something to rest your sphere in

craft acrylics

protractor

kneaded eraser

acrylic gesso

graph paper

DESIGN. Kneaded Rubber 1224

FIRST, PAINT YOUR SPHERE WITH ACRYLIC GESSO.

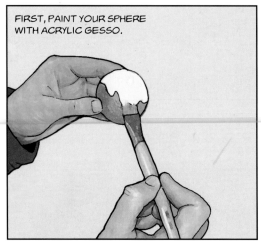

WHEN IT DRIES, PLACE AN L-SHAPED RULER ON THE SPHERE AND MARK THE TWO POINTS WHERE THE SPHERE TOUCHES THE RULER.

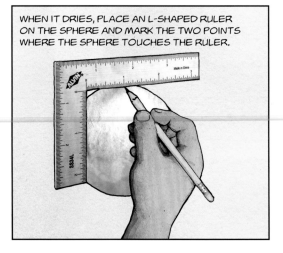

PIVOT ONE ARM OF THE RULER AROUND THE TOP POINT AND DRAW MARKS WHERE THE OTHER ARM TOUCHES THE SPHERE, DRAWING A LINE THAT CUTS THE SPHERE IN HALF.

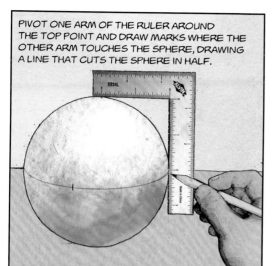

NOW, PIVOT THE RULER ON A POINT ON THE DIVIDING LINE. YOU SHOULD GET A SECOND LINE PERPENDICULAR TO THE FIRST.

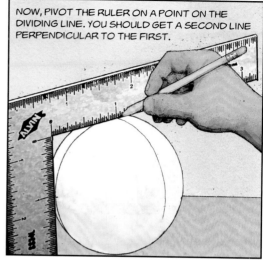

REPEATING THE PROCESS WITH THE RULER PIVOTING ON A POINT WHERE THE TWO LINES CROSS SHOULD GIVE YOU . . .

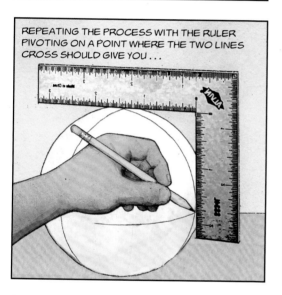

. . . A SPHERE DIVIDED INTO EIGHTHS.

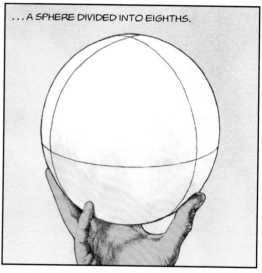

AT THE POINTS WHERE THE RINGS INTERSECT, ADD DIAGONAL LINES DIVIDING EACH QUARTER EXACTLY IN HALF.

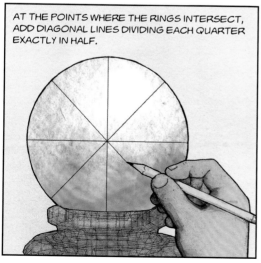

LINK THEM ALL UP AND YOU WIND UP WITH A PATTERN LIKE THIS.

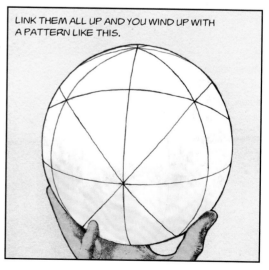

HEAVY-UP LINES AROUND EACH INTERSECTION TO FORM A SQUARE, AND YOU WILL END UP WITH A CUBE PATTERN DRAWN ON THE SPHERE.

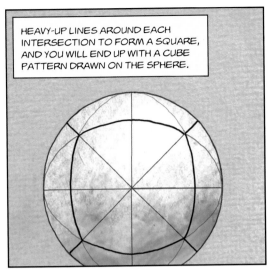

ADD SOME MORE DIAGONAL LINES LINKING UP THE MIDPOINTS OF THE EDGES. THEN USE THE INTERSECTIONS TO ROUGH OUT LINES SECTIONING THE SQUARE INTO SMALLER SQUARES.

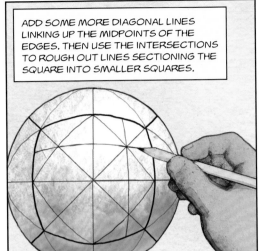

YOU WILL WIND UP WITH A CUBE CAGE PATTERN ON THE SURFACE OF THE SPHERE.

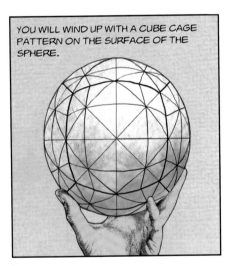

THE TRICK TO DRAWING SIX-POINT PERSPECTIVE IS TO IMAGINE YOURSELF INSIDE THE CAGE.

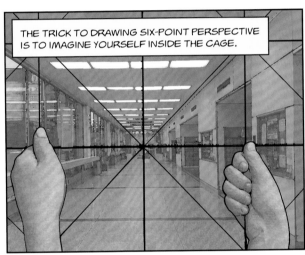

THE CENTER OF EACH SIDE OF THE CUBE IS A VANISHING POINT, AND THE EDGE BETWEEN SIDES IS EXACTLY HALFWAY BETWEEN THEM.

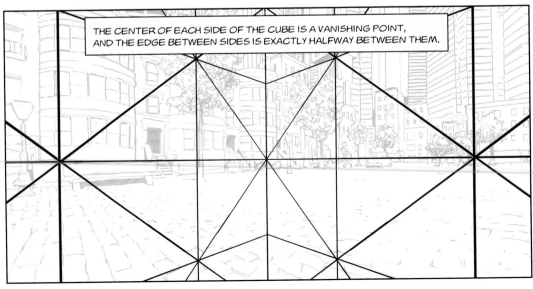

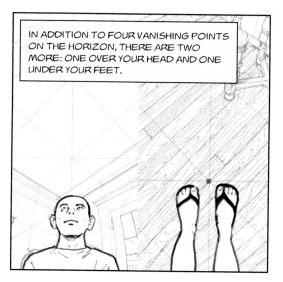

IN ADDITION TO FOUR VANISHING POINTS ON THE HORIZON, THERE ARE TWO MORE: ONE OVER YOUR HEAD AND ONE UNDER YOUR FEET.

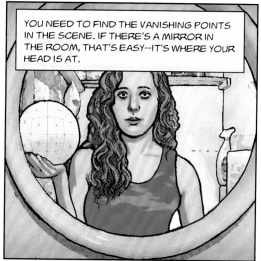

YOU NEED TO FIND THE VANISHING POINTS IN THE SCENE. IF THERE'S A MIRROR IN THE ROOM, THAT'S EASY--IT'S WHERE YOUR HEAD IS AT.

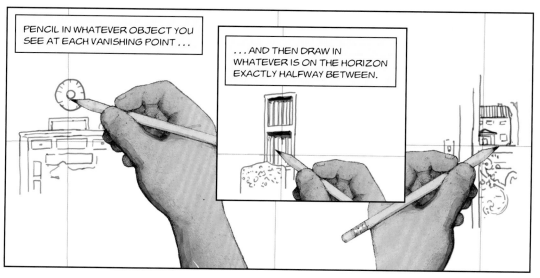

PENCIL IN WHATEVER OBJECT YOU SEE AT EACH VANISHING POINT . . .

. . . AND THEN DRAW IN WHATEVER IS ON THE HORIZON EXACTLY HALFWAY BETWEEN.

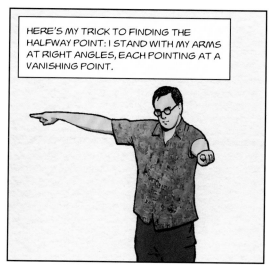

HERE'S MY TRICK TO FINDING THE HALFWAY POINT: I STAND WITH MY ARMS AT RIGHT ANGLES, EACH POINTING AT A VANISHING POINT.

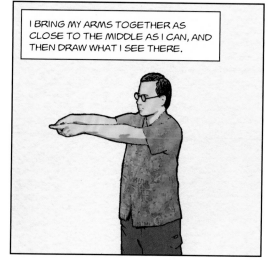

I BRING MY ARMS TOGETHER AS CLOSE TO THE MIDDLE AS I CAN, AND THEN DRAW WHAT I SEE THERE.

SIX-POINT PERSPECTIVE 89

THINK OF THE HORIZON AS A CLOTHESLINE AND THE OBJECTS ON IT AS THE LAUNDRY HANGING TO DRY. YOU SHOULD WIND UP WITH SOMETHING LIKE THIS.

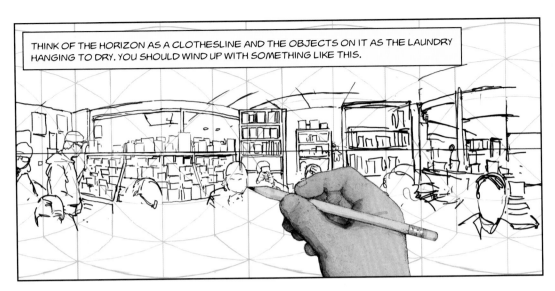

NOW, SHIFT YOUR ATTENTION TO THE VANISHING POINT DIRECTLY IN FRONT OF YOU, AND PENCIL IN EVERYTHING DIRECTLY ABOVE AND BELOW THAT POINT IN A VERTICAL LINE.

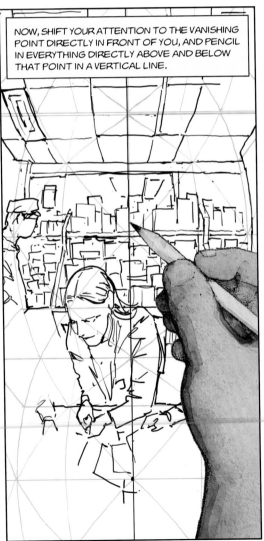

IF YOU HAVE BEEN SITTING, AT SOME POINT YOU WILL HAVE TO STAND UP AND DRAW YOUR CHAIR, BEING CAREFUL TO TRY AND PIVOT AROUND SO THAT YOUR EYE REMAINS EXACTLY AT THE SAME POINT IN SPACE.

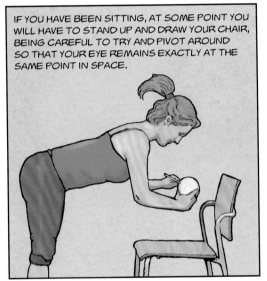

WHEN YOU'VE COMPLETED THE LINES ABOVE AND BELOW ALL THE VANISHING POINTS, YOU SHOULD HAVE A PATTERN ON YOUR SPHERE THAT LOOKS ROUGHLY LIKE THIS.

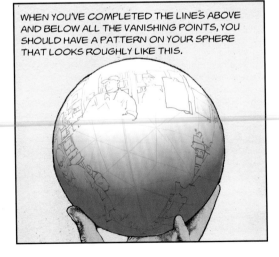

NOW, FILL IN THE REMAINING AREAS. THE BARS ON THE CAGE SHOULD HELP YOU ESTABLISH THE DIRECTION FOR ALL PERSPECTIVE LINES.

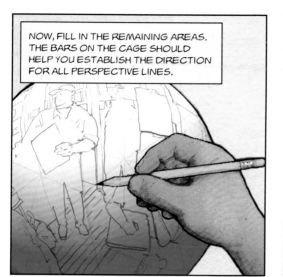

TRY TO BE ACCURATE ABOUT HOW MUCH SPACE EACH ELEMENT TAKES UP IN THE VISUAL FIELD. IF YOU DRAW SOMETHING THAT INTERESTS YOU BIGGER, SOMETHING ELSE WILL BE CROWDED OUT ENTIRELY. THINK OF THE DRAWING AS A JIGSAW PUZZLE IN WHICH EACH PIECE FITS EXACTLY.

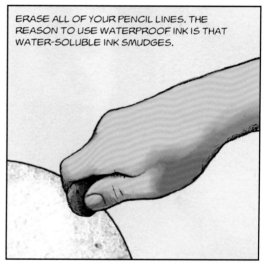

ONCE YOU FINISH YOUR PENCIL DRAWING, INK IN THE OUTLINES WITH WATERPROOF INK. A TECHNICAL PEN WORKS WELL FOR THIS PHASE.

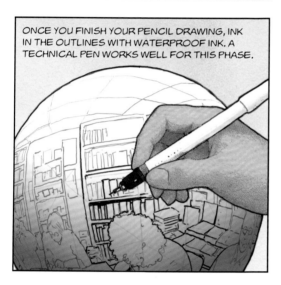

ERASE ALL OF YOUR PENCIL LINES. THE REASON TO USE WATERPROOF INK IS THAT WATER-SOLUBLE INK SMUDGES.

YOU CAN STOP HERE, BUT IT REALLY WOULD LOOK BETTER IN FULL COLOR.

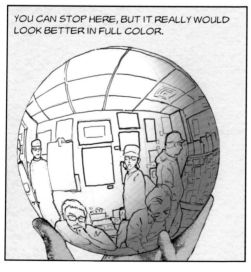

I LIKE CRAFT ACRYLICS FOR THIS PART. THEY'RE WATERPROOF, DRY QUICKLY, AND STAND UP TO HANDLING PRETTY WELL.

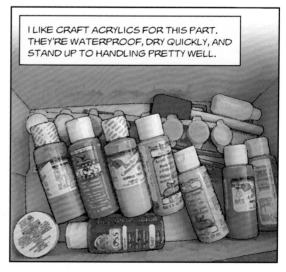

IF YOU DON'T WANT TO HANG AROUND YOUR LOCATION LONG ENOUGH TO COMPLETE A PAINTING, TAKE SOME PICTURES--THEY'LL LAST LONGER.

THE IDEA IS TO STAND IN ONE PLACE, AND TAKE PHOTOS IN ALL DIRECTIONS WHILE KEEPING YOUR CAMERA LENS BASICALLY AT THE SAME POINT IN SPACE. DEPENDING ON HOW WIDE YOUR ANGLE OF VIEW IS, YOU WILL NEED FORTY TO EIGHTY PICTURES TO COVER EVERYTHING (I ALMOST ALWAYS HAVE TO GO BACK BECAUSE I MISSED SOMETHING).

BACK IN THE DAY, I USED TO GET MY PHOTOS PRINTED OUT AND THEN LINK THEM IN PIECEMEAL PANORAMAS THAT I WOULD TRANSFER TO MY SPHERE BIT BY BIT . . .

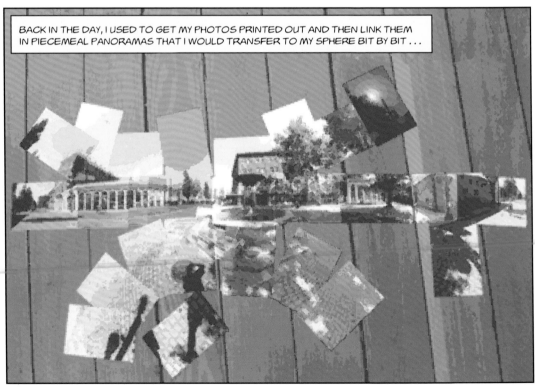

... BUT NOW THERE ARE SOFTWARE PROGRAMS THAT CAN PIECE TOGETHER PANORAMAS FROM YOUR DIGITAL PHOTOGRAPHS AUTOMATICALLY.

THERE IS A VERSION THAT COMES WITH PHOTOSHOP, AND THERE ARE ALSO STAND-ALONE VERSIONS THAT YOU CAN FIND ONLINE. THE FORMAT THEY ALL USE IS CALLED AN EQUIRECTANGULAR PROJECTION, WHICH LOOKS LIKE WHAT YOU SEE HERE.

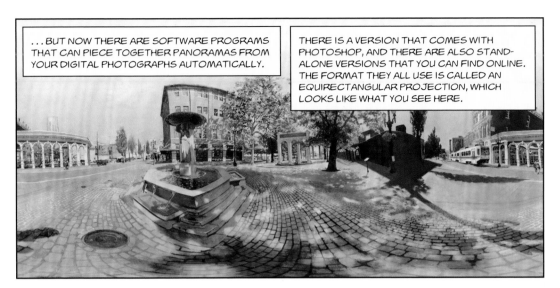

YOU DON'T EVEN HAVE TO KNOW PERSPECTIVE TO TRANSFER AN EQUIRECTANGULAR PANORAMA TO A SPHERE--JUST DRAW A SIMPLE SQUARE GRID ON A HARD COPY.

THE PANORAMA IS ALWAYS EXACTLY TWICE AS WIDE AS IT IS TALL. I USUALLY MAKE EIGHTEEN DIVISIONS VERTICALLY AND THIRTY-SIX HORIZONTALLY.

THOSE SQUARE DIVISIONS CORRESPOND TO LATITUDE AND LONGITUDE LINES ON A GLOBE.

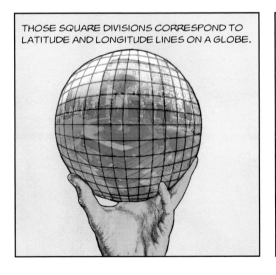

TO DRAW A GRID ON A SPHERE, BEGIN BY USING AN L-SHAPED RULER TO MARK THREE INTERSECTING CIRCLES ON THE SPHERE.

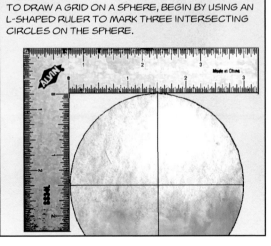

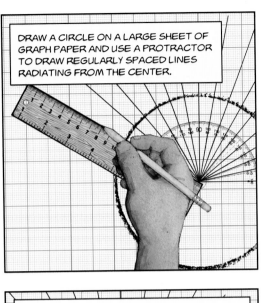

DRAW A CIRCLE ON A LARGE SHEET OF GRAPH PAPER AND USE A PROTRACTOR TO DRAW REGULARLY SPACED LINES RADIATING FROM THE CENTER.

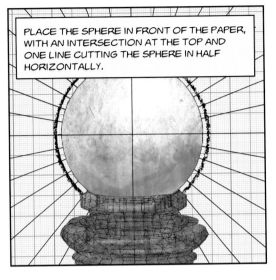

PLACE THE SPHERE IN FRONT OF THE PAPER, WITH AN INTERSECTION AT THE TOP AND ONE LINE CUTTING THE SPHERE IN HALF HORIZONTALLY.

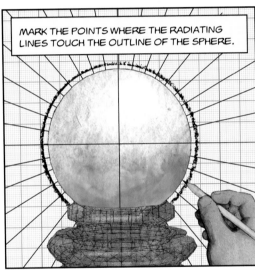

MARK THE POINTS WHERE THE RADIATING LINES TOUCH THE OUTLINE OF THE SPHERE.

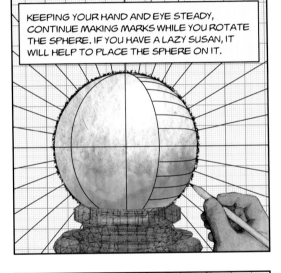

KEEPING YOUR HAND AND EYE STEADY, CONTINUE MAKING MARKS WHILE YOU ROTATE THE SPHERE. IF YOU HAVE A LAZY SUSAN, IT WILL HELP TO PLACE THE SPHERE ON IT.

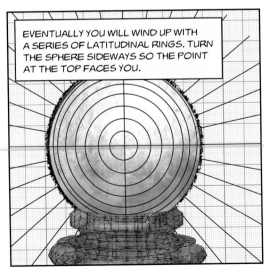

EVENTUALLY YOU WILL WIND UP WITH A SERIES OF LATITUDINAL RINGS. TURN THE SPHERE SIDEWAYS SO THE POINT AT THE TOP FACES YOU.

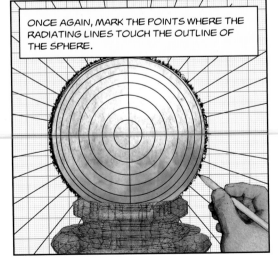

ONCE AGAIN, MARK THE POINTS WHERE THE RADIATING LINES TOUCH THE OUTLINE OF THE SPHERE.

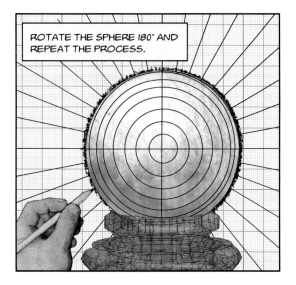

ROTATE THE SPHERE 180° AND REPEAT THE PROCESS.

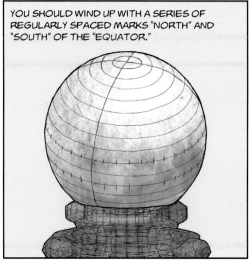

YOU SHOULD WIND UP WITH A SERIES OF REGULARLY SPACED MARKS "NORTH" AND "SOUTH" OF THE "EQUATOR."

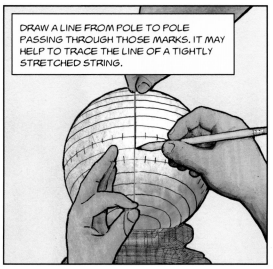

DRAW A LINE FROM POLE TO POLE PASSING THROUGH THOSE MARKS. IT MAY HELP TO TRACE THE LINE OF A TIGHTLY STRETCHED STRING.

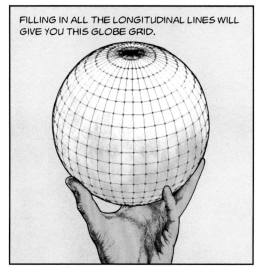

FILLING IN ALL THE LONGITUDINAL LINES WILL GIVE YOU THIS GLOBE GRID.

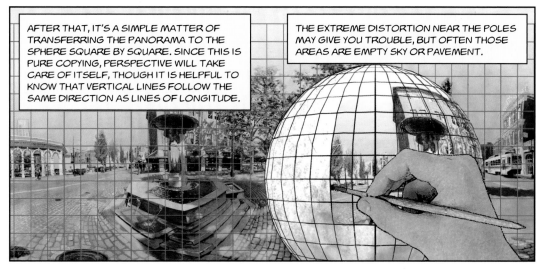

AFTER THAT, IT'S A SIMPLE MATTER OF TRANSFERRING THE PANORAMA TO THE SPHERE SQUARE BY SQUARE. SINCE THIS IS PURE COPYING, PERSPECTIVE WILL TAKE CARE OF ITSELF, THOUGH IT IS HELPFUL TO KNOW THAT VERTICAL LINES FOLLOW THE SAME DIRECTION AS LINES OF LONGITUDE.

THE EXTREME DISTORTION NEAR THE POLES MAY GIVE YOU TROUBLE, BUT OFTEN THOSE AREAS ARE EMPTY SKY OR PAVEMENT.

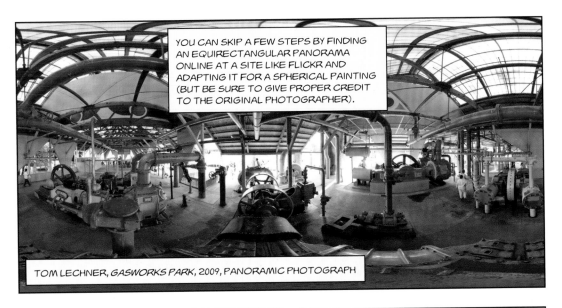

YOU CAN SKIP A FEW STEPS BY FINDING AN EQUIRECTANGULAR PANORAMA ONLINE AT A SITE LIKE FLICKR AND ADAPTING IT FOR A SPHERICAL PAINTING (BUT BE SURE TO GIVE PROPER CREDIT TO THE ORIGINAL PHOTOGRAPHER).

TOM LECHNER, *GASWORKS PARK*, 2009, PANORAMIC PHOTOGRAPH

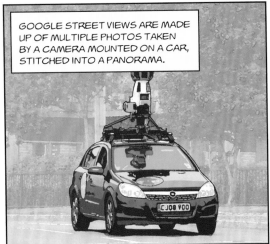

GOOGLE STREET VIEWS ARE MADE UP OF MULTIPLE PHOTOS TAKEN BY A CAMERA MOUNTED ON A CAR, STITCHED INTO A PANORAMA.

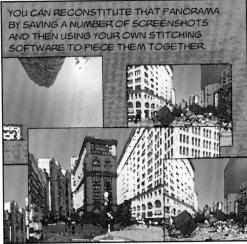

YOU CAN RECONSTITUTE THAT PANORAMA BY SAVING A NUMBER OF SCREENSHOTS AND THEN USING YOUR OWN STITCHING SOFTWARE TO PIECE THEM TOGETHER.

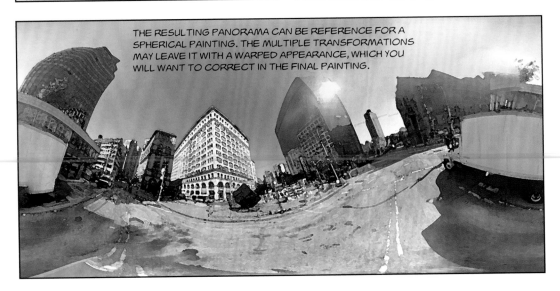

THE RESULTING PANORAMA CAN BE REFERENCE FOR A SPHERICAL PAINTING. THE MULTIPLE TRANSFORMATIONS MAY LEAVE IT WITH A WARPED APPEARANCE, WHICH YOU WILL WANT TO CORRECT IN THE FINAL PAINTING.

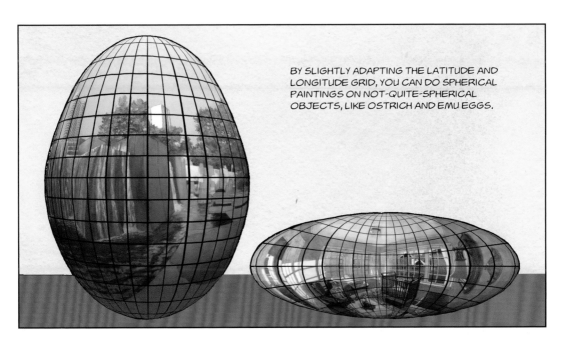

BY SLIGHTLY ADAPTING THE LATITUDE AND LONGITUDE GRID, YOU CAN DO SPHERICAL PAINTINGS ON NOT-QUITE-SPHERICAL OBJECTS, LIKE OSTRICH AND EMU EGGS.

USING MAP PROJECTIONS, YOU CAN ADAPT AN EQUIRECTANGULAR PANORAMA TO A FLAT PAINTING IN CURVILINEAR PERSPECTIVE.

I'M QUITE FOND OF THIS DOUBLE HEMISPHERE:

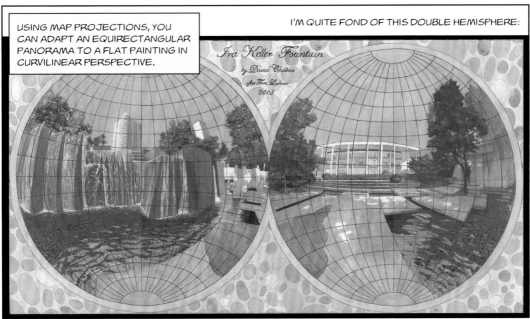

Ira Keller Fountain
by Daniel Chelsea
after Tom Lechner
2008

ANOTHER VARIANT: YOU CAN DRAW HALF OF A SIX-POINT PERSPECTIVE ON THE INSIDE OF A BOWL.

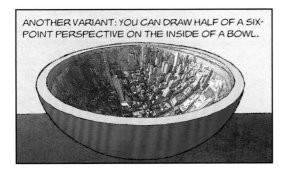

ESSENTIALLY, YOU'RE DRAWING A HALF-SPHERE TURNED INSIDE OUT. THERE ARE TWO WAYS YOU CAN APPROACH THIS EXERCISE: EITHER DRAW HALF A CUBE CAGE OR USE LATITUDE AND LONGITUDE.

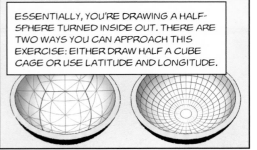

TO DRAW THE CUBE CAGE: FIRST, DRAW FOUR LINES BISECTING THE BOWL AND MEETING IN THE MIDDLE, DIVIDING IT INTO EIGHT SLICES.

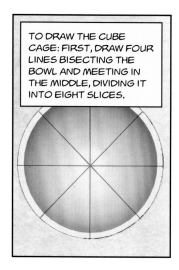

MARK THE MIDPOINTS ON THE HORIZONTAL AND VERTICAL LINES.

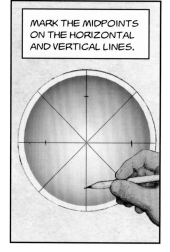

THE POINTS WHERE THESE LINES MEET THE RIM CAN BE TREATED AS VANISHING POINTS. DRAW GENTLY CURVING LINES FROM THESE VANISHING POINTS THROUGH THE MIDPOINTS.

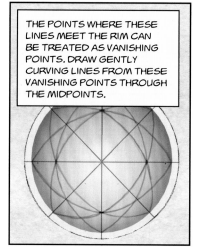

THESE CAN BE SELECTIVELY HEAVIED-UP TO DEFINE THE BARS OF THE CUBE CAGE.

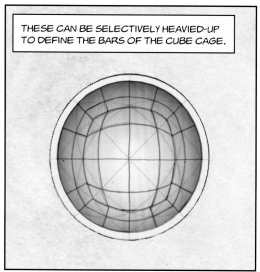

TO USE LATITUDE AND LONGITUDE: FIRST, LAY A CENTER-FINDING RULER DOWN, EXACTLY CENTERED, AND DIVIDE THE BOWL IN HALF.

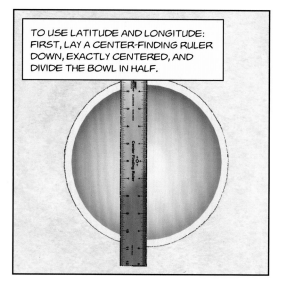

PLACE A PROTRACTOR WITH ITS CENTER ON THE CENTER OF THE RULER.

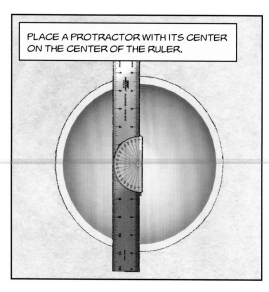

PLACE A SECOND RULER ON TOP OF THE PROTRACTOR, PASSING THROUGH THE CENTER, AND MARK TWO POINTS WHERE IT TOUCHES THE RIM.

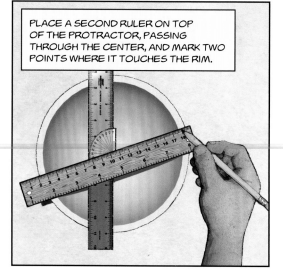

REPEAT THIS STEP, MOVING THE RULER 10° EACH TIME, UNTIL YOU HAVE MARKINGS ON THE RIM ALL AROUND THE CIRCLE.

LIKE THIS:

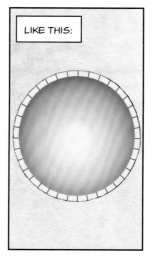

NOW, DRAW LINES PASSING THROUGH THE CENTER, LINKING THE MARKS ON THE RIM. ALTHOUGH CURVED, THEY SHOULD APPEAR STRAIGHT FROM ABOVE.

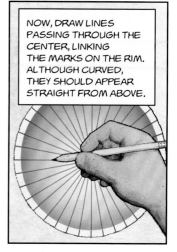

MARK EQUAL DIVISIONS ON ONE LINE, USING MEASURING TAPE OR A CURVED RULER.

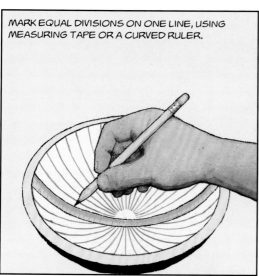

THEN, DRAW CIRCULAR LINES AROUND THE INSIDE OF THE BOWL. IT MAY BE USEFUL TO ROTATE THE BOWL ON A LAZY SUSAN.

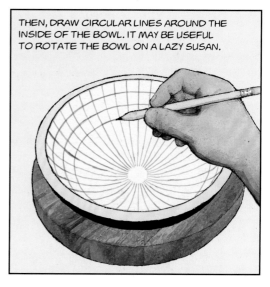

DEPENDING ON THE IMAGE YOU WANT TO TRANSFER, YOU MAY PREFER TO DRAW A SIDE VIEW OF THE GLOBE, WITH THE POLES AT EITHER END AND THE EQUATOR RUNNING DOWN THE MIDDLE.

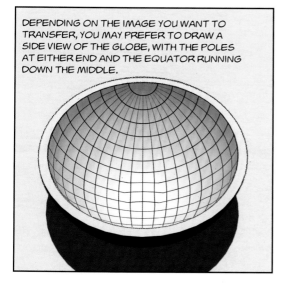

IN THAT CASE, YOU WOULD START BY PLACING THOSE SAME MARKS AROUND THE RIM.

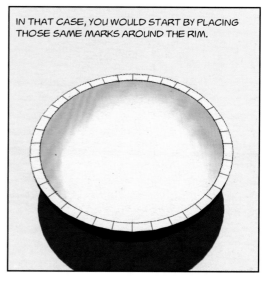

ADD THE EQUAL DIVISION MARKS TO TWO CENTRAL LINES CROSSING AT RIGHT ANGLES.

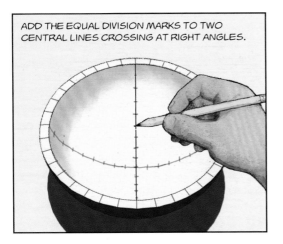

LINK THEM WITH GENTLY CURVING LINES RUNNING FROM POLE TO POLE.

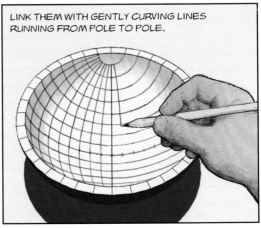

ONCE YOU HAVE THE PATTERN DRAWN, YOU CAN TRANSFER THE IMAGE FROM AN EQUIRECTANGULAR PANORAMA TO THE BOWL, SQUARE BY SQUARE.

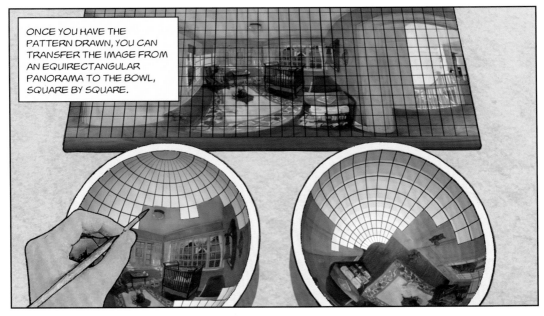

I'M ASSUMING THAT YOU WILL BE PAINTING IN OIL OR ACRYLICS ON A WOODEN BOWL, BUT YOU COULD ALSO WORK IN GLAZE ON A CERAMIC BOWL.

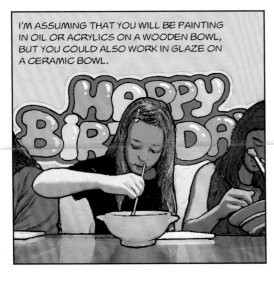

IT'S A VERY COOL THING TO EAT YOUR SOUP OUT OF!

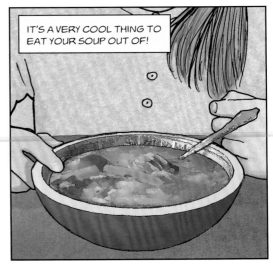

THINKING BACK TO THE CUBE CAGE, IT IS NATURAL TO THINK OF PAINTING PERSPECTIVE ON THE WALLS OF A CUBE.

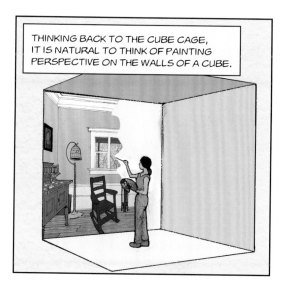

YOU WOULD WIND UP WITH A ROOM PAINTED IN ANAMORPHOSIS. LOVELY, BUT DIFFICULT TO STORE IN YOUR HOUSE.

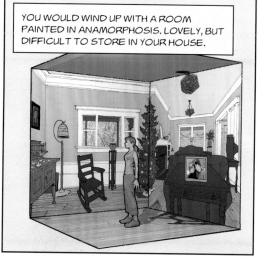

SOMETHING MORE MANAGEABLE WOULD BE A CUBE YOU CAN HOLD IN YOUR HAND, PAINTED ON ITS OUTSIDE.

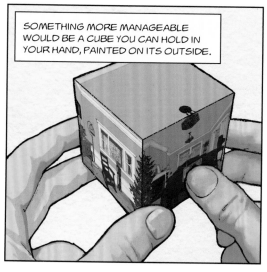

THE KINKS BETWEEN SIDES ARE KIND OF JARRING. YOU GET A MORE COHERENT SCENE WITH A GEOMETRIC SOLID WITH MORE SIDES, LIKE THIS OCTAHEDRON . . .

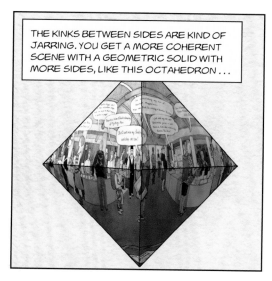

. . . OR THIS DODECAHEDRON (WITH TWELVE SIDES).

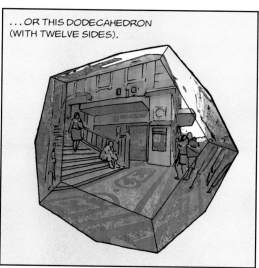

A RHOMBIC DODECAHEDRON ALSO HAS TWELVE SIDES, EACH CENTERED ON AN EDGE OF THE CUBE.

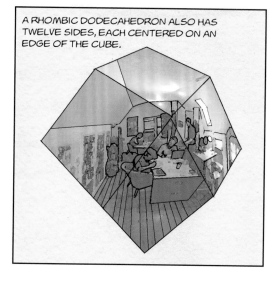

AN ICOSAHEDRON HAS TWENTY SIDES, AND APPROXIMATES A SPHERE PRETTY CLOSELY.

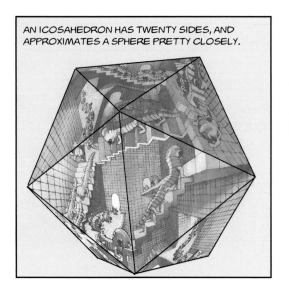

A CUBOCTAHEDRON, WHICH YOU GET BY CHOPPING THE CORNERS OFF A CUBE TO CREATE TRIANGULAR FACES THAT TOUCH AT THE TIPS, HAS SIX SQUARES FACES TILTED 45° AND EIGHT TRIANGULAR FACES.

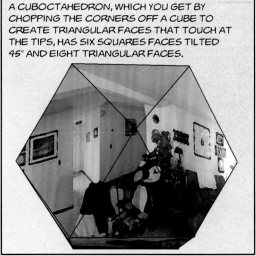

HERE IS A PERSPECTIVE DIAGRAM FOR THE CUBE.

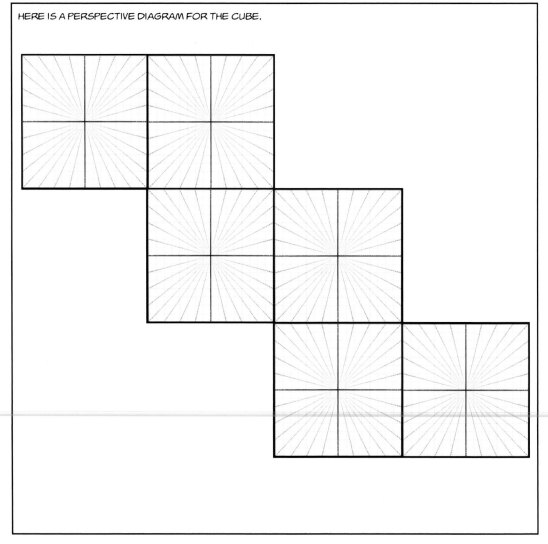

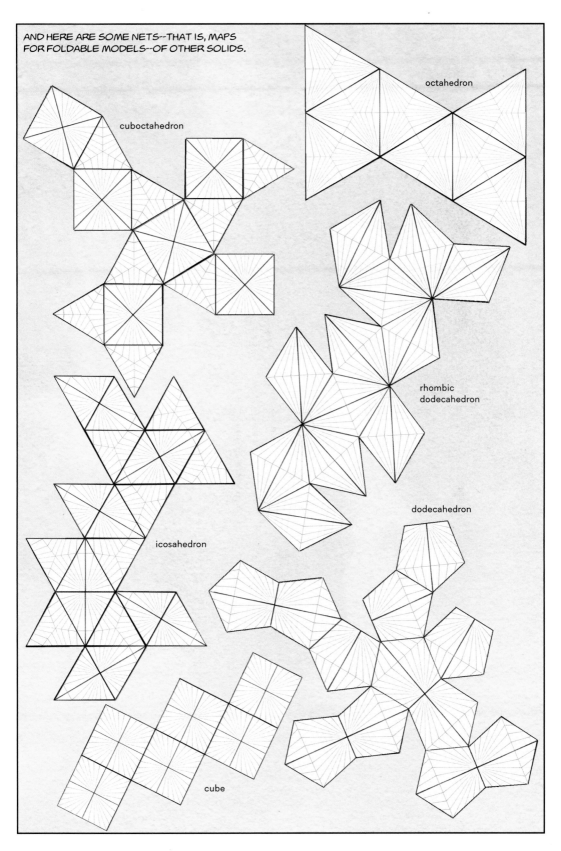

AND HERE ARE SOME NETS--THAT IS, MAPS FOR FOLDABLE MODELS--OF OTHER SOLIDS.

octahedron

cuboctahedron

rhombic dodecahedron

dodecahedron

icosahedron

cube

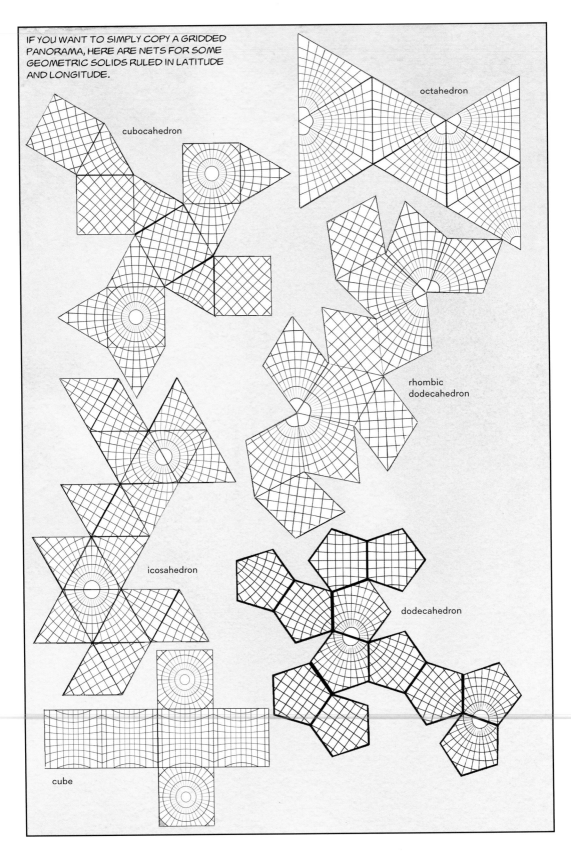

IF YOU WANT TO SIMPLY COPY A GRIDDED PANORAMA, HERE ARE NETS FOR SOME GEOMETRIC SOLIDS RULED IN LATITUDE AND LONGITUDE.

octahedron

cubocahedron

rhombic dodecahedron

icosahedron

dodecahedron

cube

YOU MAY WANT TO DRAW ONE OF THOSE POLYHEDRAL PERSPECTIVES BY DIRECT OBSERVATION, IN WHICH CASE IT WILL BE USEFUL TO BUILD A MODEL YOU CAN SIT INSIDE, LIKE THIS CUBE.

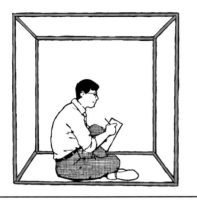

THE UNFORTUNATE THING ABOUT A CUBE IS THAT IT IS LIABLE TO FLOP OVER.

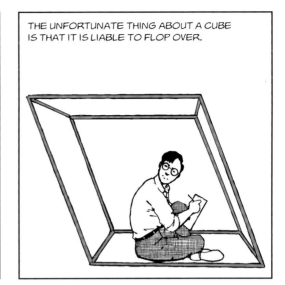

A MODEL WITH DIAGONAL BRACES WILL BE MORE STABLE . . .

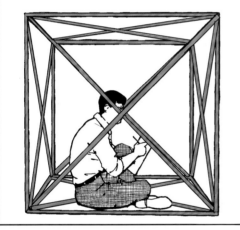

. . . IN WHICH CASE YOU'RE REALLY CONSTRUCTING A MODEL OUT OF RIGHT TRIANGLES. YOU'LL NEED TO CUT TUBING TO PRECISE LENGTHS . . .

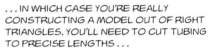

. . . FORM THE TUBES INTO TRIANGLES AND RUN TWINE THROUGH THEM . . .

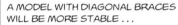

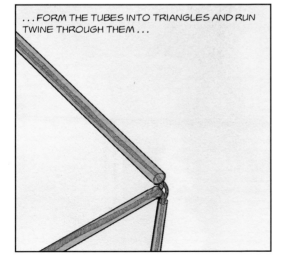

. . . AND THEN JOIN THE CORNERS UP WITH WIRE.

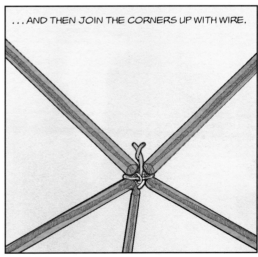

THE OCTAHEDRON IS SIMPLE TO CONSTRUCT. EACH OF ITS TWELVE EDGES IS THE SAME LENGTH AND ITS TRIANGULAR FACES MAKE IT SELF-BRACING.

IT HAS A RELATION TO PERSPECTIVE THAT IS EASY TO UNDERSTAND: EACH CORNER IS CENTERED ON A VANISHING POINT.

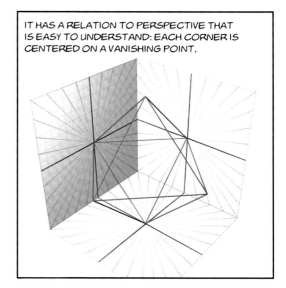

UNFORTUNATELY, AN OCTAHEDRON WON'T BALANCE EASILY ON A POINT. WHEN IT RESTS ON A FACE, THE TOP AND BOTTOM WILL BE IN ONE-POINT PERSPECTIVE, AND THE OTHER SIDES WILL BE IN EITHER TWO- OR THREE-POINT PERSPECTIVE.

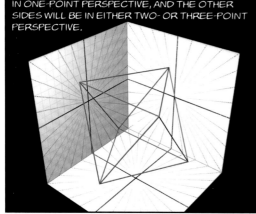

A COMPLETED DRAWING WILL LOOK LIKE THIS.

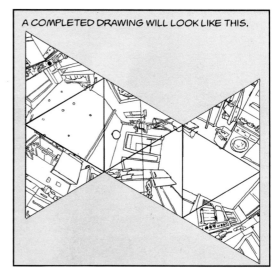

A VERY ELEGANT MODEL CAN BE CONSTRUCTED FOR THE ICOSAHEDRON. EACH OF ITS THIRTY EDGES IS THE SAME LENGTH.

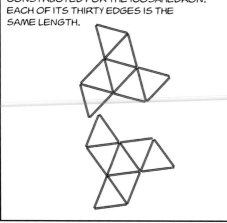

THE TUBES CAN BE ARRANGED INTO TWO IRREGULAR SHAPES WITH TWINE RUNNING THROUGH THEM . . .

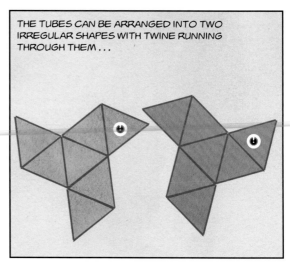

...WHICH THEN LINK UP TO FORM AN ICOSAHEDRON.

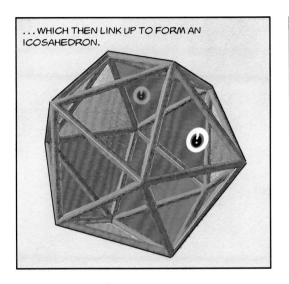

THE MOST SYMMETRICAL RELATION OF AN ICOSAHEDRON TO PERSPECTIVE IS FOR IT TO BALANCE ON AN EDGE, SO THAT EACH VANISHING POINT SITS AT THE MIDPOINT OF AN EDGE.

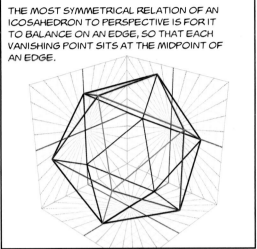

IN THE REAL WORLD, HOWEVER, AN ICOSAHEDRON WON'T BALANCE ON AN EDGE. IT WILL HAVE TO SIT ON ONE OF ITS FACES.

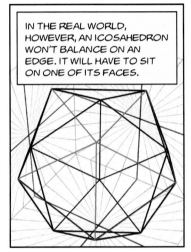

VIEWED FROM INSIDE, THE HORIZON CUTS ACROSS TWELVE FACES, AND IS DIVIDED INTO TWELVE EQUAL PIECES.

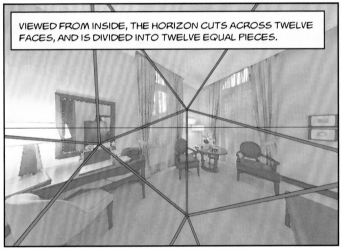

THE RESULTING DRAWING WILL LOOK LIKE THIS.

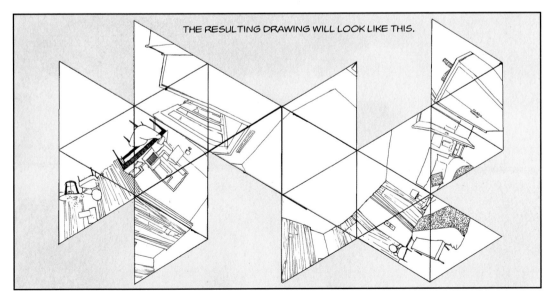

ONCE YOU'VE FINISHED, YOU CAN ASSEMBLE EACH OF THESE DRAWINGS INTO MODELS THAT CAN BE USED AS ORNAMENTS.

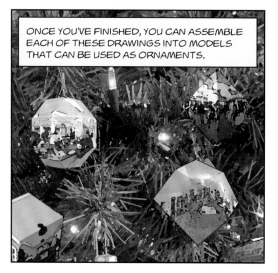

THE USUAL ASSEMBLY METHOD IS TO HAVE FOLDING TABS THAT GLUE TOGETHER.

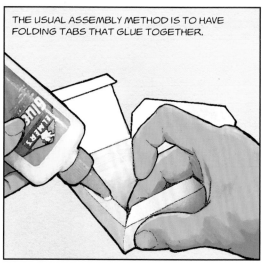

HOWEVER, THERE IS ANOTHER METHOD TO ASSEMBLE MODELS, CALLED PLAITING. IN THIS METHOD, CHAINS OF TRIANGLES OR SQUARES ARE BRAIDED TOGETHER . . .

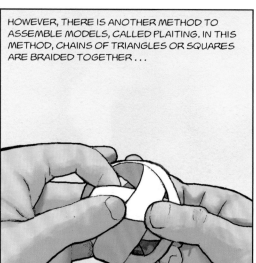

. . . TO FORM COMPLETE GEOMETRIC SOLIDS.

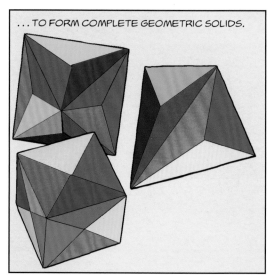

BECAUSE THE VISIBLE FACES IN THE FINAL MODEL ARE SEPARATED BY WIDE GAPS, IT IS BEST TO DRAW YOUR SCENE AS ONE CONNECTED DRAWING FIRST, THEN TRANSFER IT IN PIECES TO THE PLAITED MODEL. THIS CAN BE DONE EITHER WITH SCISSORS AND GLUE, OR DIGITALLY ON A COMPUTER.

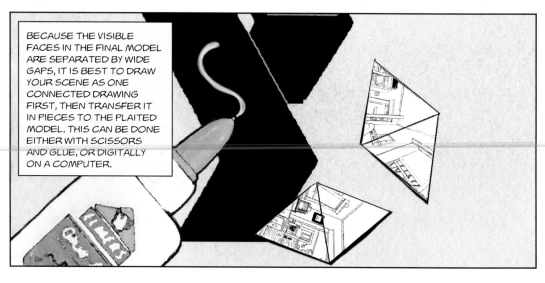

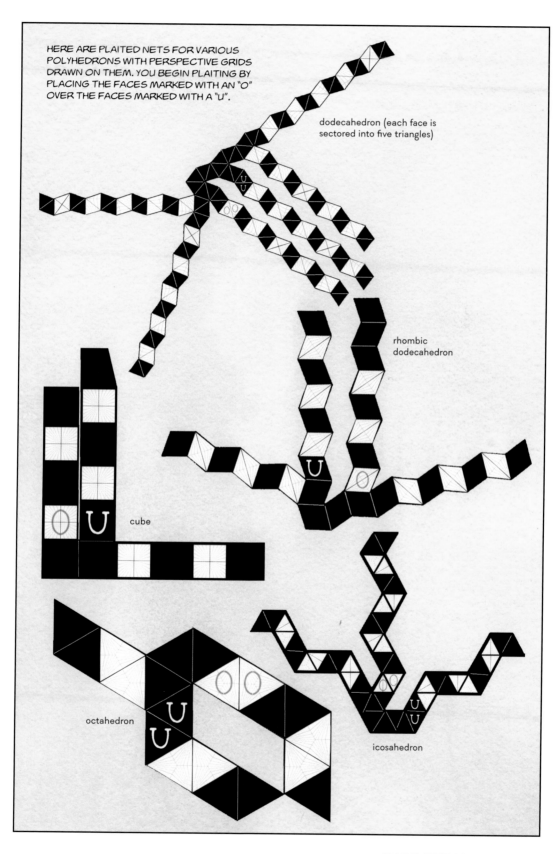

HERE ARE PLAITED NETS FOR VARIOUS
POLYHEDRONS WITH PERSPECTIVE GRIDS
DRAWN ON THEM. YOU BEGIN PLAITING BY
PLACING THE FACES MARKED WITH AN "O"
OVER THE FACES MARKED WITH A "U".

dodecahedron (each face is
sectored into five triangles)

rhombic
dodecahedron

cube

octahedron

icosahedron

TO AVOID WASTING PAPER, CHAINS OF TRIANGLES OR QUADRILATERALS CAN BE RULED ONTO PAPER (NOT CARD STOCK) IN STACKS . . .

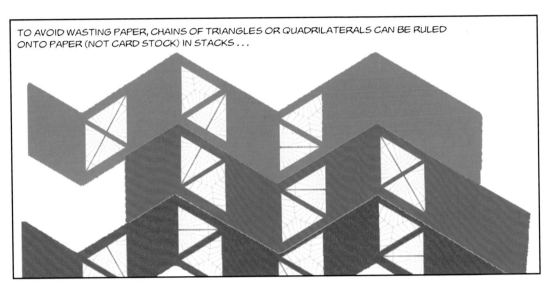

. . . THEN CUT OUT WITH SCISSORS . . .

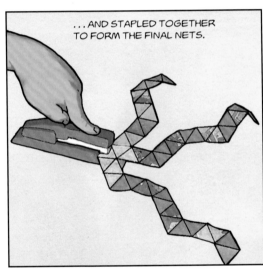

. . . AND STAPLED TOGETHER TO FORM THE FINAL NETS.

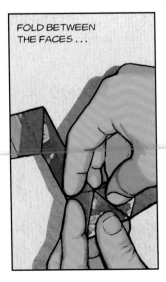

FOLD BETWEEN THE FACES . . .

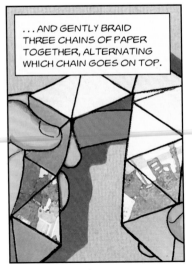

. . . AND GENTLY BRAID THREE CHAINS OF PAPER TOGETHER, ALTERNATING WHICH CHAIN GOES ON TOP.

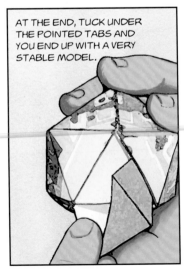

AT THE END, TUCK UNDER THE POINTED TABS AND YOU END UP WITH A VERY STABLE MODEL.

SOME OTHER POSSIBILITIES FOR POLYHEDRAL MODELS: DRAWING SEPARATE FACES ON A LARGE SCALE AND THEN ASSEMBLING THEM INTO AN ACTUAL MODEL THAT YOU CAN VIEW FROM INSIDE.

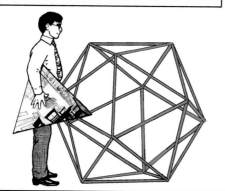

I GUESS YOU SHOULD LEAVE ONE FACE BLANK SO THAT YOU CAN CRAWL IN AND OUT. OH, AND BRING A FLASHLIGHT.

ANOTHER POSSIBILITY: CUT A BUNCH OF TRIANGLES, OR WHATEVER SHAPE YOU WANT, OUT OF MAGNETIC SHEETING AND PASTE THE FACES OF YOUR MODEL ON THE FRONT.

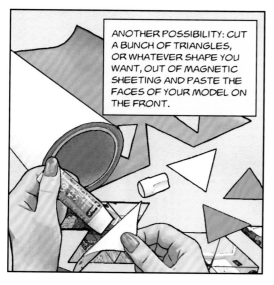

THERE ARE ALWAYS GAPS WHEN YOU LAY A POLYHEDRON PERSPECTIVE FLAT, BUT WITH FRIDGE MAGNETS YOU CAN MOVE THE FACES AROUND SO THAT DIFFERENT PARTS LINE UP.

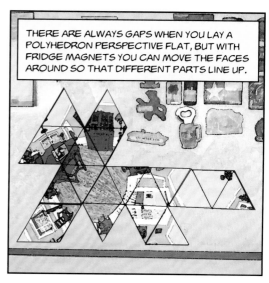

LIKE THIS . . .

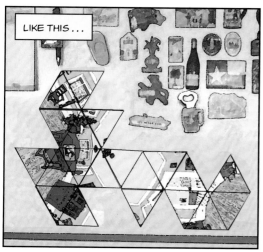

. . . OR THIS.

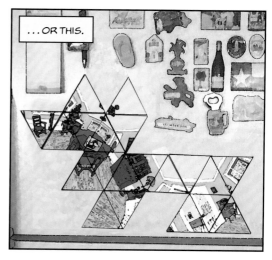

6
STEREO PERSPECTIVE

Drawing in stereo precedes photography in stereo, but just barely. The first examples were a series of geometric figures drawn by the English scientist and inventor Charles Wheatstone in the 1830s; they were never more than novelties, however. The true craze began with stereo photography, which placed exotic landscapes and uniquely lifelike portraits of luminaries like Abraham Lincoln in every Victorian parlor.

Artists have never entirely caught up, even though the rudiments of stereo perspective are easily grasped. An artist who attempts to work in 3-D has more than double the work to take on because the stereo image is extremely unforgiving of fudgy drawing and perspective mistakes, and to achieve the desired effect, one must think as much like a sculptor as a painter. Small wonder that most art created for the nineteenth-century stereo and the twentieth-century Viewmaster consisted of photographed sculpture. The 3-D comics that came along in the 1950s had more to do with aping the popularity of 3-D movies than any real desire to extend the reach of drawing.

As I demonstrate in this chapter, the effect 3-D comics achieved was closer to the flattened forms of the shooting gallery or pop-up book than the heightened reality they promised. However, today computer graphics make 3-D drawing more achievable. In this chapter, I show a few methods using Photoshop, Illustrator, and even a bit of computer modeling.

Page from *Destroy!* by Scott McCloud,
3-D conversion by Ray Zone, 1986, Eclipse Comics.

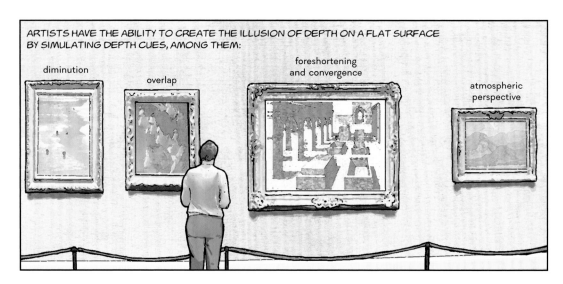

ARTISTS HAVE THE ABILITY TO CREATE THE ILLUSION OF DEPTH ON A FLAT SURFACE BY SIMULATING DEPTH CUES, AMONG THEM:

diminution

overlap

foreshortening and convergence

atmospheric perspective

THE DEPTH CUE THAT IS HARDEST FOR ARTISTS TO SIMULATE IS BINOCULAR VISION, THE ABILITY THAT TWO EYES HAVE TO SEE IN THREE DIMENSIONS.

EXCEPT FOR SCULPTORS, THEY HAVE IT ALL FIGURED OUT!

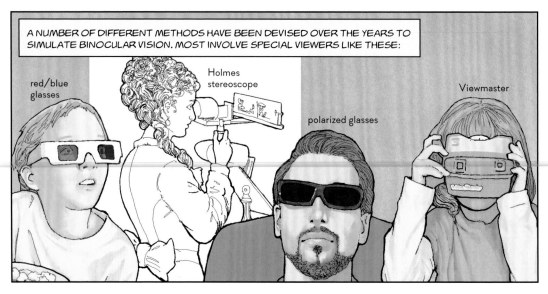

A NUMBER OF DIFFERENT METHODS HAVE BEEN DEVISED OVER THE YEARS TO SIMULATE BINOCULAR VISION. MOST INVOLVE SPECIAL VIEWERS LIKE THESE:

red/blue glasses

Holmes stereoscope

polarized glasses

Viewmaster

TWO METHODS THAT DON'T INVOLVE SPECIAL VIEWERS ARE LENTICULAR IMAGES AND HOLOGRAMS. BOTH ARE FASCINATING ... AND WAY TOO COMPLICATED TO COVER IN THIS BOOK!

THE SIMPLEST WAY TO VIEW A STEREO IMAGE IS TO CROSS YOUR EYES.

YOU MAY HAVE DONE THIS ALREADY: HELD UP TWO FINGERS AND CROSSED YOUR EYES UNTIL ...

... THEY FUSE INTO ONE.

I USED TO DO THAT CROSS-EYED TRICK A LOT WITH CYCLONE FENCES.

THAT MAY BE WHY I EVENTUALLY NEEDED GLASSES!

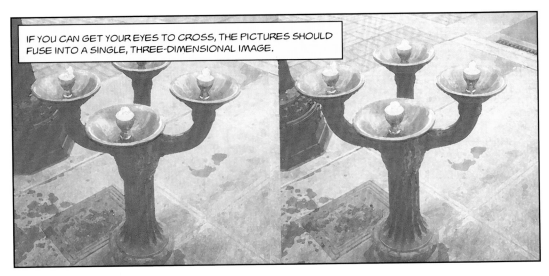

IF YOU CAN GET YOUR EYES TO CROSS, THE PICTURES SHOULD FUSE INTO A SINGLE, THREE-DIMENSIONAL IMAGE.

OF COURSE, IF YOU'RE NOT USED TO CROSS-EYED VIEWING, IT MAY GIVE YOU AN EYESTRAIN HEADACHE!

SOMEWHAT MORE DIFFICULT IS "FREE VIEWING," IN WHICH YOUR EYES SLIGHTLY DIVERGE.

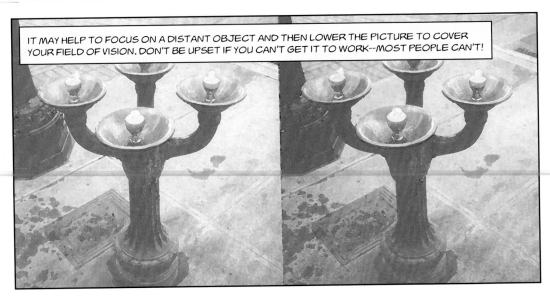

IT MAY HELP TO FOCUS ON A DISTANT OBJECT AND THEN LOWER THE PICTURE TO COVER YOUR FIELD OF VISION. DON'T BE UPSET IF YOU CAN'T GET IT TO WORK--MOST PEOPLE CAN'T!

TRYING MAY GIVE YOU AN EVEN MORE SEVERE EYESTRAIN HEADACHE!

HERE'S ANOTHER METHOD: VIEWING THE PICTURES WITH A SMALL MIRROR.

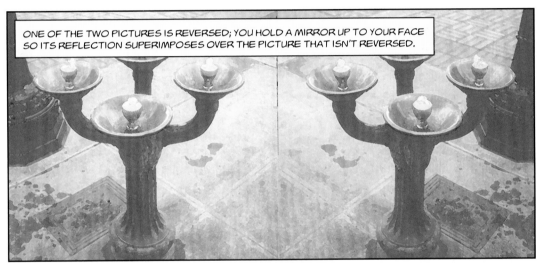

ONE OF THE TWO PICTURES IS REVERSED; YOU HOLD A MIRROR UP TO YOUR FACE SO ITS REFLECTION SUPERIMPOSES OVER THE PICTURE THAT ISN'T REVERSED.

THIS ONE PROBABLY WON'T GIVE YOU AN EYESTRAIN HEADACHE--IF YOU DON'T OVERDO IT.

ANOTHER COMMON TYPE OF 3-D IMAGE REQUIRES YOU TO WEAR GLASSES WITH RED AND BLUE GLASS OR PLASTIC GELS.

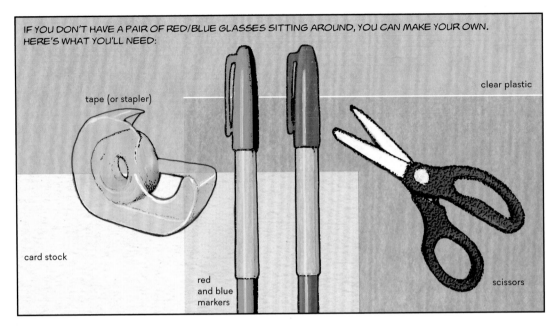

IF YOU DON'T HAVE A PAIR OF RED/BLUE GLASSES SITTING AROUND, YOU CAN MAKE YOUR OWN. HERE'S WHAT YOU'LL NEED:

tape (or stapler)

clear plastic

card stock

red and blue markers

scissors

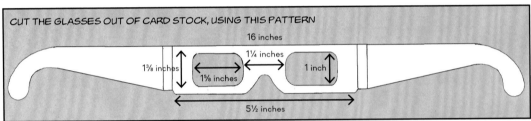

CUT THE GLASSES OUT OF CARD STOCK, USING THIS PATTERN

16 inches

1¼ inches

1⅜ inches

1⅝ inches

1 inch

5½ inches

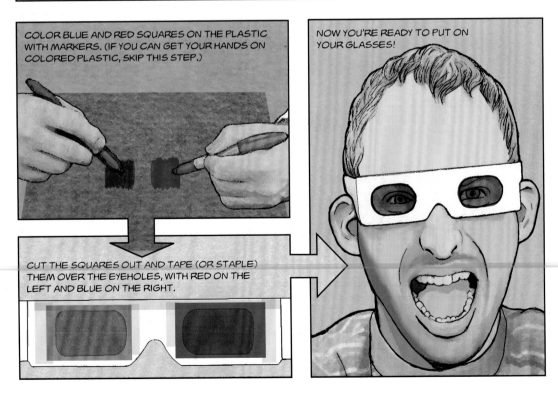

COLOR BLUE AND RED SQUARES ON THE PLASTIC WITH MARKERS. (IF YOU CAN GET YOUR HANDS ON COLORED PLASTIC, SKIP THIS STEP.)

NOW YOU'RE READY TO PUT ON YOUR GLASSES!

CUT THE SQUARES OUT AND TAPE (OR STAPLE) THEM OVER THE EYEHOLES, WITH RED ON THE LEFT AND BLUE ON THE RIGHT.

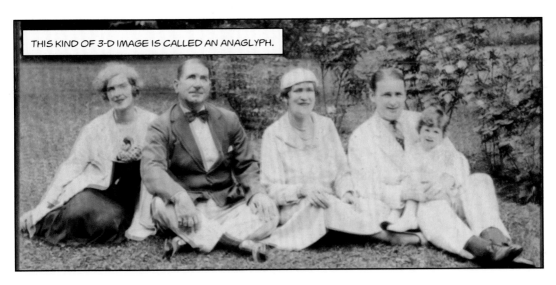

THIS KIND OF 3-D IMAGE IS CALLED AN ANAGLYPH.

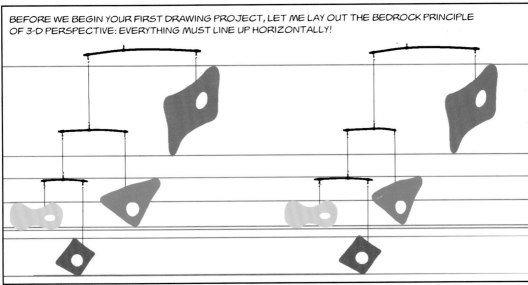

BEFORE WE BEGIN YOUR FIRST DRAWING PROJECT, LET ME LAY OUT THE BEDROCK PRINCIPLE OF 3-D PERSPECTIVE: EVERYTHING MUST LINE UP HORIZONTALLY!

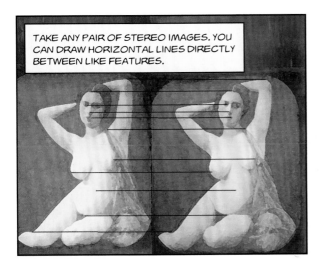

TAKE ANY PAIR OF STEREO IMAGES. YOU CAN DRAW HORIZONTAL LINES DIRECTLY BETWEEN LIKE FEATURES.

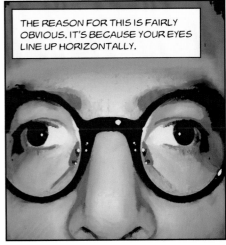

THE REASON FOR THIS IS FAIRLY OBVIOUS. IT'S BECAUSE YOUR EYES LINE UP HORIZONTALLY.

THINGS WOULD BE DIFFERENT IF YOU HAD YOUR EYES ARRANGED ONE ON TOP OF THE OTHER.

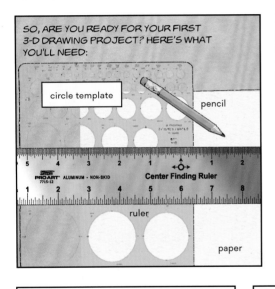

I USED TO HAVE MY PICTURE TAKEN AT A PHOTO BOOTH THAT HAD TWO CAMERAS ON TOP OF EACH OTHER, TAKING NEAR-IDENTICAL PICTURES. TO GET A STEREO EFFECT, I TURNED SIDEWAYS.

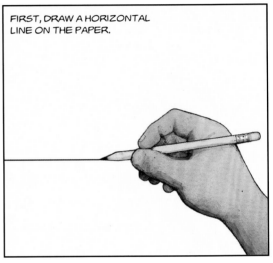

SO, ARE YOU READY FOR YOUR FIRST 3-D DRAWING PROJECT? HERE'S WHAT YOU'LL NEED:

circle template

pencil

ruler

paper

FIRST, DRAW A HORIZONTAL LINE ON THE PAPER.

USE THE TEMPLATE TO DRAW TWO CIRCLES RESTING ON THAT LINE. MAKE THEM DIFFERENT SIZES SO YOU CAN TELL THEM APART.

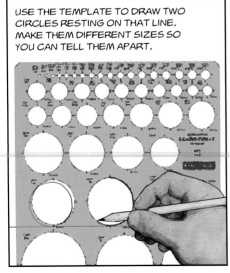

THEN, DRAW TWO MORE CIRCLES IMMEDIATELY TO THE RIGHT. MAKE THE DISTANCE BETWEEN THEM A FRACTION OF AN INCH LONGER THAN BETWEEN THE FIRST PAIR.

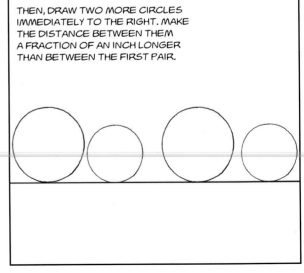

CROSS YOUR EYES TO VIEW.

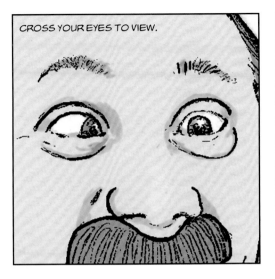

THE CIRCLE ON THE RIGHT SHOULD POP FROM THE PAGE IN A WAY THAT IS DIFFICULT TO DEPICT ON A FLAT SURFACE!

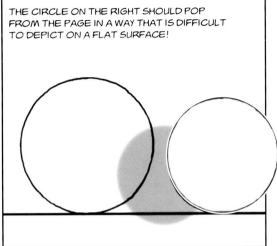

IF YOU ABSOLUTELY CAN'T CROSS YOUR EYES, TRY THE RED/BLUE METHOD. HERE ARE YOUR MATERIALS:

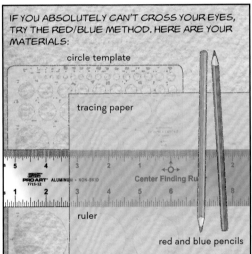

circle template

tracing paper

ruler

red and blue pencils

DRAW THE SAME TWO CIRCLES IN RED ON ONE SIDE OF THE TRACING PAPER.

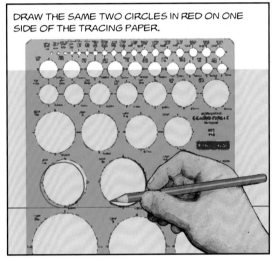

TURN THE PAPER OVER, AND DRAW THE CIRCLES IN BLUE. DRAW ONE EXACTLY IN THE SAME PLACE, AND THE OTHER A BIT TO THE RIGHT OR LEFT.

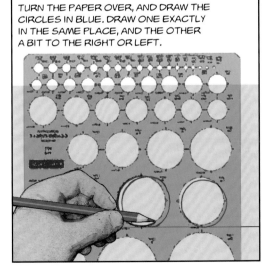

VIEWED THROUGH THE ANAGLYPH LENSES, ONE OF THOSE CIRCLES SHOULD REALLY POP!

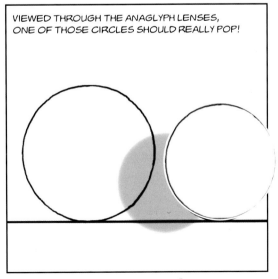

YOU CAN EMPHASIZE THE DISTANCE BETWEEN THE TWO CIRCLES BY DRAWING STRAIGHT LINES BETWEEN THEM.

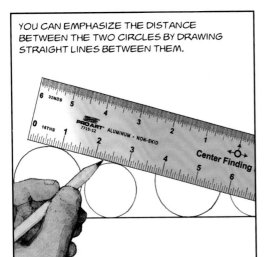

WHEN VIEWED IN STEREO, THESE BECOME A SINGLE LINE RECEDING IN SPACE.

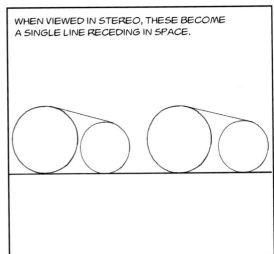

ARE YOU READY FOR THE NEXT PROJECT? HERE'S WHAT YOU'LL NEED:

scissors

two copies of the same magazine

paper

glue

FIRST, CUT THE PICTURES YOU WANT OUT OF THE MAGAZINES.

TRY TO MAKE THE CUTS ON EACH PAIR OF CLIPPINGS MATCH EXACTLY.

TAKE ONE SET OF CLIPPINGS AND MAKE A COLLAGE.

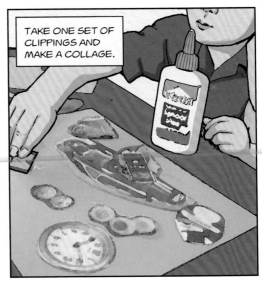

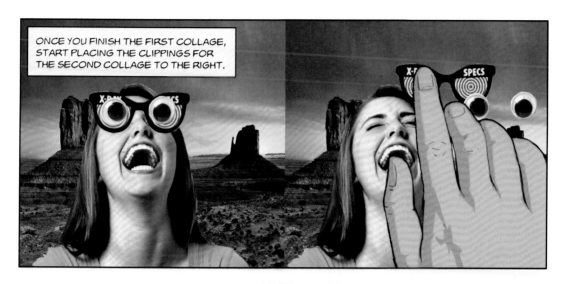

ONCE YOU FINISH THE FIRST COLLAGE, START PLACING THE CLIPPINGS FOR THE SECOND COLLAGE TO THE RIGHT.

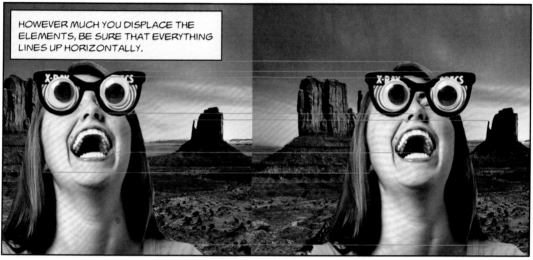

HOWEVER MUCH YOU DISPLACE THE ELEMENTS, BE SURE THAT EVERYTHING LINES UP HORIZONTALLY.

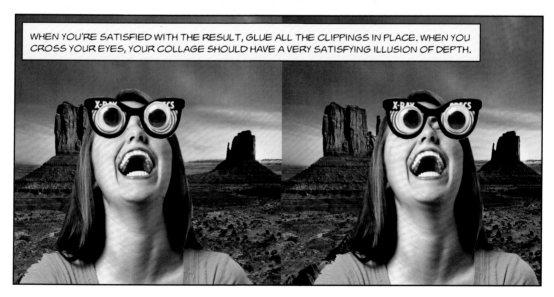

WHEN YOU'RE SATISFIED WITH THE RESULT, GLUE ALL THE CLIPPINGS IN PLACE. WHEN YOU CROSS YOUR EYES, YOUR COLLAGE SHOULD HAVE A VERY SATISFYING ILLUSION OF DEPTH.

IF YOU KNOW YOUR WAY AROUND PHOTOSHOP, THE WHOLE PROCESS SHOULD BE EVEN EASIER. NO SCISSORS OR GLUE IS REQUIRED, AND YOU CAN MAKE YOUR OWN COPIES OF EACH ELEMENT.

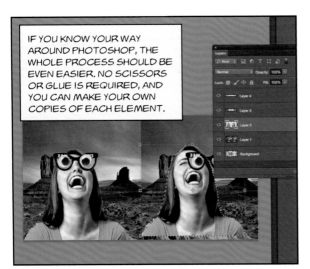

IN PHOTOSHOP, IT IS EASY TO CONVERT YOUR CROSS-EYED COLLAGE INTO AN ANAGLYPH!

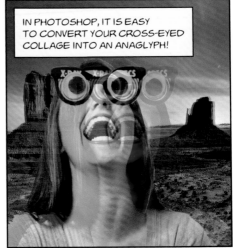

SCAN YOUR COLLAGE AS A BLACK-AND-WHITE IMAGE (OR, IF YOU'RE ALREADY WORKING IN PHOTOSHOP, CONVERT IT TO GRAYSCALE).

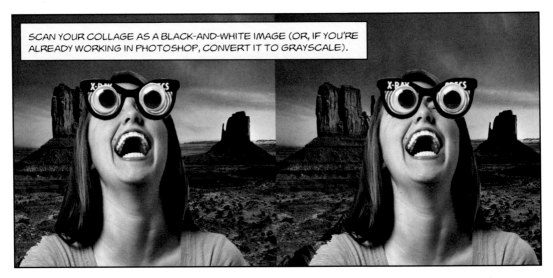

THEN, CONVERT THE IMAGE TO RGB.

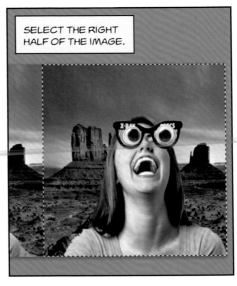

SELECT THE RIGHT HALF OF THE IMAGE.

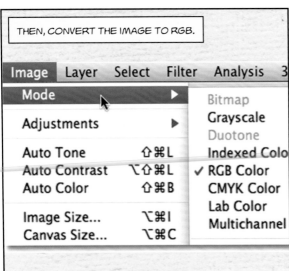

CUT AND PASTE THE IMAGE INTO THE RED CHANNEL.

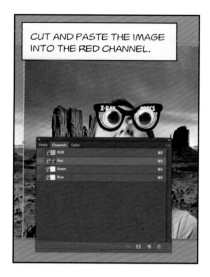

THEN, SLIDE IT OVER TO COVER THE LEFT IMAGE IN THE RED CHANNEL.

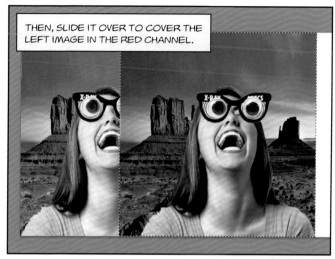

YOU SHOULD END UP WITH AN IMAGE THAT LOOKS LIKE THIS.

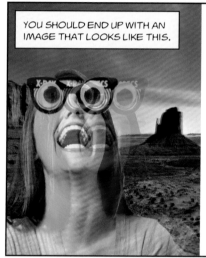

(YOU CAN CROP OUT THE BLANK RIGHT SIDE.)

TO MINIMIZE GHOSTING (THAT IS, A FAINT SHADOW OF THE BLUE IMAGE SHOWING THROUGH THE RED LENS), DARKEN THE BLUE CHANNEL SLIGHTLY USING THE CURVES CONTROL. THIS SHOULD GIVE THE OVERALL IMAGE A SLIGHT YELLOWISH TONE.

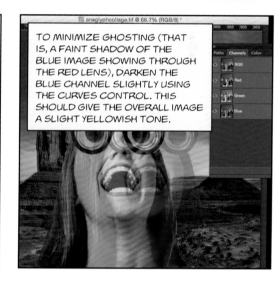

OF COURSE, YOU DON'T HAVE TO USE MAGAZINE CLIPPINGS (AS ON PAGE 122). YOU CAN USE YOUR OWN DRAWINGS. DRAW EVERY ELEMENT IN YOUR PICTURE SEPARATELY.

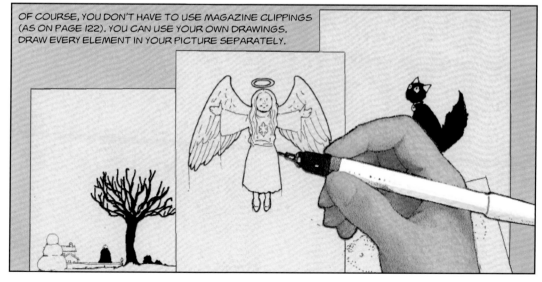

MAKE TWO COPIES OF EVERYTHING (I DON'T RECOMMEND USING ORIGINALS BECAUSE IT'S ALMOST IMPOSSIBLE TO GET A COPY EXACTLY THE SAME SIZE).

ASSEMBLE THEM INTO A DOUBLE COLLAGE AS YOU DID WITH THE MAGAZINE PICTURES (SEE PAGE 122).

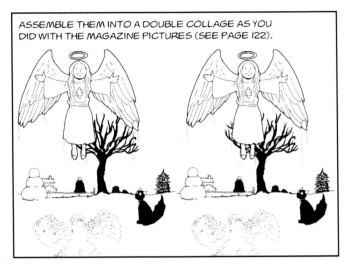

THIS IS NOT FAR FROM THE METHOD USED TO CREATE OLD-SCHOOL 3-D COMICS IN THE 1950s.

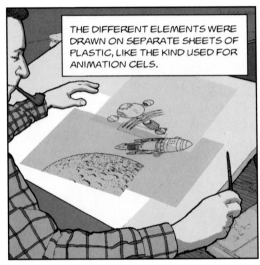

THE DIFFERENT ELEMENTS WERE DRAWN ON SEPARATE SHEETS OF PLASTIC, LIKE THE KIND USED FOR ANIMATION CELS.

THE INTERIOR OF EACH OBJECT WOULD BE PAINTED WHITE ON THE BACK OF THE CEL.

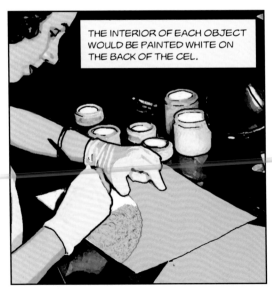

THE DRAWINGS WERE STACKED AND PHOTOGRAPHED. THE NUMBER OF LAYERS WAS USUALLY LIMITED TO FIVE OR SO BECAUSE THE CAMERA HAD DIFFICULTY SEEING LINES THROUGH MULTIPLE LAYERS OF PLASTIC.

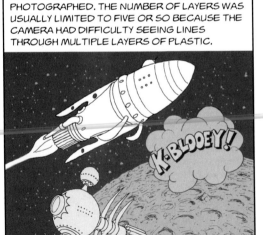

THEN, THE STACK WAS PHOTOGRAPHED AGAIN, WITH THE POSITION OF EACH LAYER SHIFTED. (OFTEN TWO SEPARATE SETS OF PEGS WERE USED TO FIX THE CELS IN POSITION.)

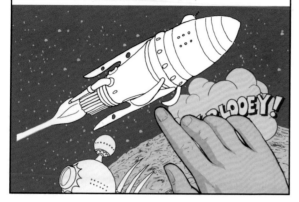

EVENTUALLY, THE TWO VERSIONS WOULD BE PRINTED IN RED AND BLUE FOR THE FINAL COMIC.

ONCE PHOTOCOPIES CAME INTO WIDESPREAD USE, AN ARTIST COULD WORK ON TWO COPIES. ONE WOULD BE USED INTACT, WHILE A SECOND COPY WOULD BE CUT INTO PIECES AND ITS PARTS PAINSTAKINGLY REASSEMBLED INTO A SECOND VERSION.

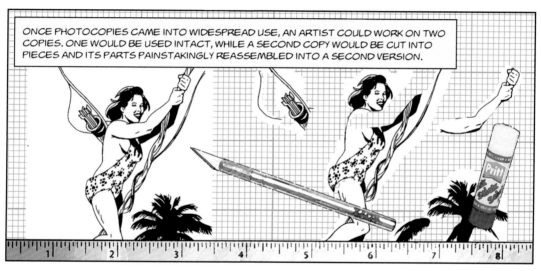

THE MINUTE SHIFTS WOULD MAKE PARTS OF THE IMAGE APPEAR TO POP OFF THE PAGE.

NO MATTER HOW MUCH WORK IS DEVOTED TO 3-D CONVERSION, ALL THESE METHODS SUFFER FROM A "POP-UP BOOK" EFFECT--VIVID AND CONVINCING THREE-DIMENSIONAL SPACE SEPARATING ELEMENTS THAT ARE OBVIOUSLY FLAT.

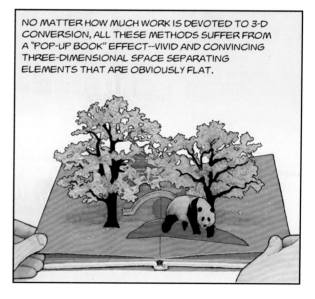

WANT TO CREATE SOMETHING NOT SO FLAT? GET OUT YOUR TRACING PAPER AND RED AND BLUE COLORED PENCILS.

DRAW A PICTURE IN RED PENCIL ON ONE SIDE OF YOUR TRACING PAPER.

FLIP THE PAPER OVER, AND DRAW A SLIGHTLY DIFFERENT FIGURE ON THE OTHER SIDE IN BLUE PENCIL. THE GENERAL RULE IS THAT FEATURES FURTHER BACK IN SPACE WILL BE DRAWN TO THE LEFT OF THE ORIGINAL LINE AND FEATURES CLOSER TO THE EYE WILL BE TO THE RIGHT. IT IS HELPFUL TO WEAR YOUR RED AND BLUE GLASSES WHILE WORKING . . .

. . . EVEN THOUGH IT MAY GIVE YOU AN EYESTRAIN HEADACHE!

PUT A SHEET OF BUFF PAPER BEHIND YOUR TRACING PAPER TO MINIMIZE GHOSTING.

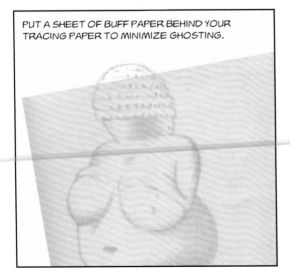

ONE MORE WORD ON ANAGLYPH DRAWING: PLEASE, DON'T USE ANY COLORS BESIDES RED AND BLUE!

ANAGLYPH IS A METHOD THAT ONLY WORKS PERFECTLY FOR MONOCHROME IMAGES. OTHER COLORS WILL SIT AWKWARDLY ON THE PICTURE, NOT EXACTLY MATCHING THE EDGES OF THE OBJECT. IF A COLOR HAS TOO MUCH RED OR BLUE IN IT, IT WILL APPEAR DARK IN ONE EYE AND LIGHT IN THE OTHER, WHICH SEVERELY LIMITS YOUR PALETTE. IN MY OPINION, IT IS BEST TO AVOID OTHER COLORS ALTOGETHER.

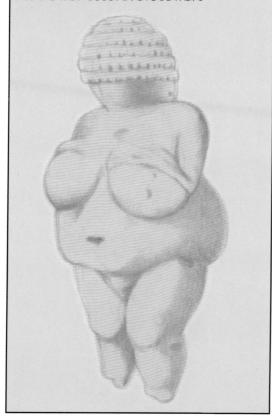

THE TRACING PAPER METHOD WILL ALSO WORK FOR CROSS-EYED VIEWING. FIRST DRAW YOUR FIGURE IN GRAPHITE PENCIL.

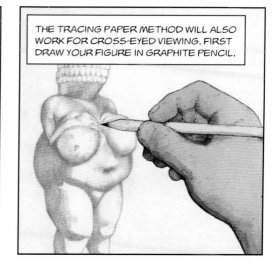

THEN, TRACE THE DRAWING, SHIFTING THE PAPER LEFT AND RIGHT TO MAKE FEATURES COME FORWARD OR RECEDE.

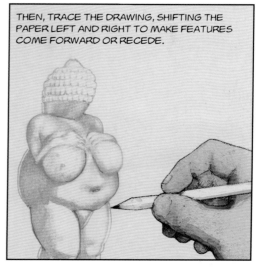

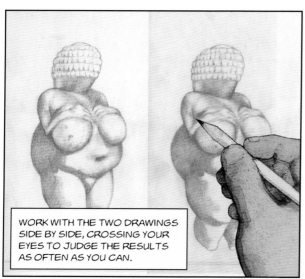

WORK WITH THE TWO DRAWINGS SIDE BY SIDE, CROSSING YOUR EYES TO JUDGE THE RESULTS AS OFTEN AS YOU CAN.

TAKE FREQUENT BREAKS!

STEREO PERSPECTIVE 129

IT WILL TAKE PATIENCE AND A STEADY HAND TO GET SATISFACTORY RESULTS. WORK LIGHTLY AND KEEP YOUR ERASER HANDY.

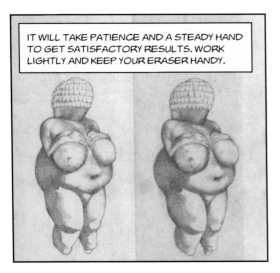

ONE NICE THING ABOUT THIS METHOD: YOU CAN FLIP ONE OF THE DRAWINGS OVER AND VIEW THE PAIR WITH A MIRROR.

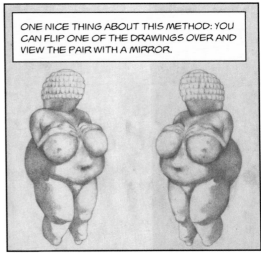

FOR THOSE OF YOU WITH A COMPUTER, 3-D DRAWING IS PRETTY EASY TO DO IN PHOTOSHOP. START WITH A BASIC SKETCH.

THEN, COMPLETELY REDRAW IT, BREAKING ALL THE BODY PARTS INTO SEPARATE BITS AND PIECES.

CONVERT THE DOCUMENT TO RGB MODE. (IT LOOKS NO DIFFERENT-- UNTIL YOU START MESSING WITH IT!)

THIS NEXT PART'S A LITTLE TRICKY. OPEN THE CHANNELS WINDOW AND SELECT RED. THEN HIT THE GRAY SQUARE ON THE FAR LEFT OF THE RGB WINDOW.

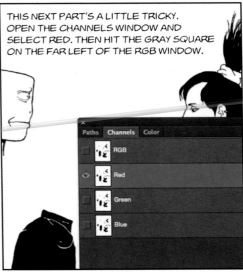

SO NOW YOU'RE IN THE RED CHANNEL BUT VIEWING THE RGB WINDOW.

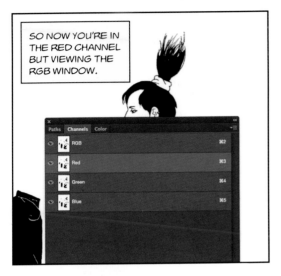

THAT MEANS YOU CAN MOVE THINGS AROUND IN THE RED CHANNEL WITHOUT DISTURBING ANYTHING ELSE. YOU SHOULD PUT YOUR RED/BLUE GLASSES ON AT THIS POINT.

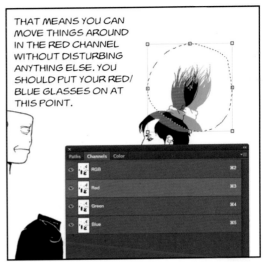

NOW YOU CAN GO TO WORK MOVING LINES AROUND. EXPERIMENT. GET CREATIVE. USE THE PERSPECTIVE TOOL, THE SCALE TOOL, THE SKEW TOOL, AND SO ON. PERSONALLY, THE ONE I FIND MOST USEFUL IS THE WARP TOOL.

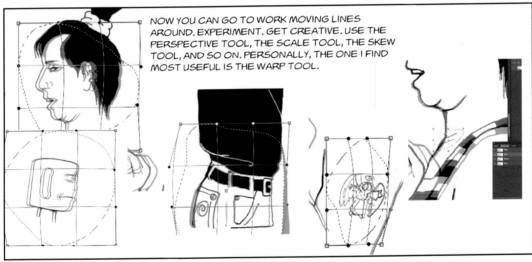

EVENTUALLY, YOU SHOULD WIND UP WITH A FILE IN WHICH ALL THE BITS AND PIECES HAVE A NICE SENSE OF DEPTH.

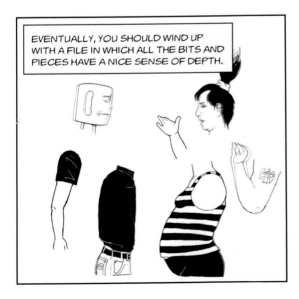

NOW, CREATE A NEW GRAYSCALE DOCUMENT.

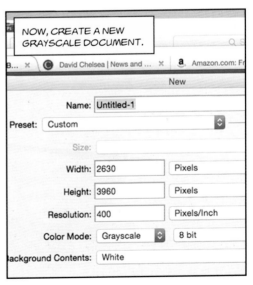

GO TO ONE OF THE CHANNELS (RED IS A GOOD ONE), AND START SELECTING PARTS.

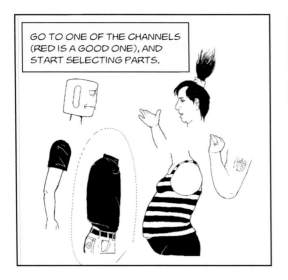

PASTE THEM ALL INTO THE NEW DOCUMENT--AS SEPARATE LAYERS, NOT ALL TOGETHER.

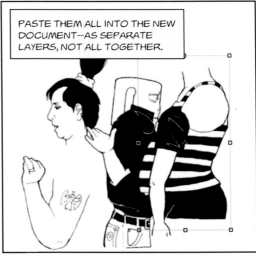

TRIM OFF THE WHITE SURROUNDING AREAS. (A GOOD WAY TO DO THIS IS TO USE THE BUCKET TOOL TO COLOR THOSE AREAS GRAY AND THEN USE THE MAGIC WAND TOOL TO DELETE THEM.)

ONCE YOU'VE ASSEMBLED ALL THE PIECES INTO A COHERENT WHOLE, FLATTEN THE LAYERS.

GO TO THE OTHER CHANNEL (IF YOU DID RED FIRST, SELECT GREEN OR BLUE; THEY ARE IDENTICAL). THEN, COPY AND PASTE ALL THE BITS IN LAYERS, AS YOU DID BEFORE.

ASSEMBLE ALL THE PIECES INTO A SECOND VERSION. IT WILL BE HELPFUL TO TURN ON A BACKGROUND GRID TO MAKE SURE ALL THE PARTS LINE UP HORIZONTALLY.

YOU CAN CHECK THE EFFECT BY CONVERTING THE FILE TO RGB, THEN GOING TO THE RED CHANNEL AND SLIDING THE RIGHT HALF TO COVER THE LEFT.

HERE YOU CAN CORRECT THE INEVITABLE SMALL MISTAKES.

ONCE YOU HAVE EVERYTHING LOOKING GOOD, YOU MAY DECIDE TO LEAVE IT . . .

. . . OR YOU MIGHT GO TO THE BLUE CHANNEL AND DARKEN IT A BIT TO ADD AN OVERALL YELLOW TONE THAT MINIMIZES GHOSTING.

YOU MIGHT WANT
TO ADD COLOR.
TO DO THAT,
FIRST COPY AND
PASTE BOTH
CHANNELS INTO
A GRAYSCALE
DOCUMENT AS
SIDE-BY-SIDE
IMAGES. IT MIGHT
BE USEFUL TO
CONVERT TO
BITMAP MODE
(WHICH WILL
TURN ALL THE
LINES BLACK),
THEN BACK
TO GRAYSCALE,
AND THEN
TO RGB.

SELECT THE BLACK LINES WITH THE
MAGIC WAND TOOL, AND THEN COPY
AND PASTE THEM TO AN UPPER LAYER.

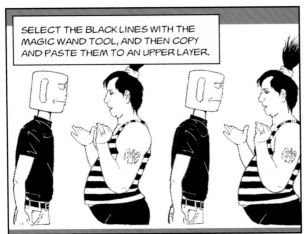

ON THE BACKGROUND LAYER,
START FILLING IN AREAS USING
THE BUCKET TOOL.

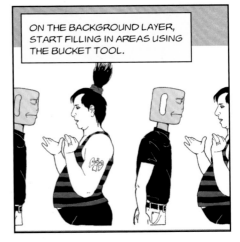

ONCE YOU HAVE THE BASIC COLOR DOWN,
CAREFULLY BEGIN APPLYING MIDTONES WITH THE
BRUSH. (I'M ASSUMING YOU HAVE SOME KIND OF
STYLUS. THIS KIND OF THING IS VERY DIFFICULT
TO DO WITH JUST THE MOUSE.) USE THE GRID TO
MAKE SURE EVERYTHING LINES UP HORIZONTALLY.

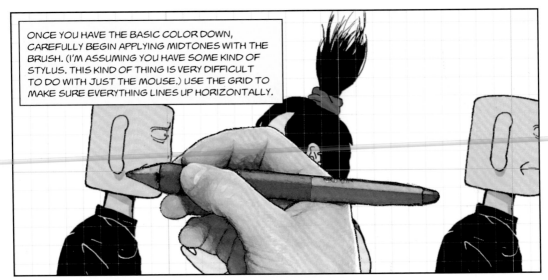

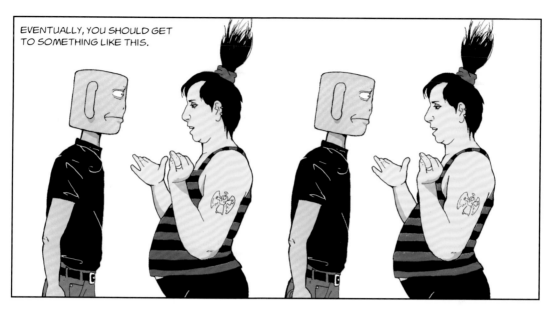

EVENTUALLY, YOU SHOULD GET TO SOMETHING LIKE THIS.

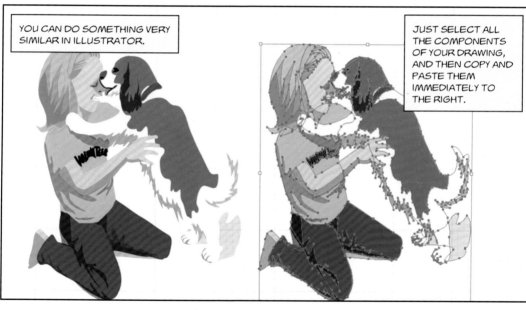

YOU CAN DO SOMETHING VERY SIMILAR IN ILLUSTRATOR.

JUST SELECT ALL THE COMPONENTS OF YOUR DRAWING, AND THEN COPY AND PASTE THEM IMMEDIATELY TO THE RIGHT.

MOVE, STRETCH, AND MANIPULATE THE PATCHES OF COLOR THE WAY YOU DID WITH LAYERS IN PHOTOSHOP, CROSSING YOUR EYES FREQUENTLY TO CHECK YOUR WORK.

EVENTUALLY . . .

THERE'S ANOTHER TECHNIQUE FOR CREATING 3-D IMAGES THAT I HESITATE TO MENTION BECAUSE IT INVOLVES LEARNING DIFFERENT SOFTWARE, BUT I WILL BECAUSE IT'S SO MUCH FUN: RELIEF MAPPING.

THIS IS A GRAYSCALE IMAGE IN WHICH EACH SHADE STANDS FOR A DIFFERENT LEVEL, EXACTLY LIKE THE COLORS ON A CONTOUR MAP.

START WITH A DRAWING. IT WILL BE HELPFUL IF THERE'S NO OCCLUSION--THAT IS, PARTS OF THE OBJECT DIRECTLY IN FRONT OF ANOTHER PART.

NOW, ANALYZE THAT DRAWING. TRY TO ESTIMATE HOW A CONTOUR MAP OF IT WOULD LOOK. IN PHOTOSHOP, START DRAWING CONTOUR LINES ON AN UPPER LAYER. TRY TO DRAW AT LEAST TEN LEVELS.

ON YET ANOTHER LAYER, START FILLING IN THOSE AREAS WITH DIFFERENT COLORS. (I FIND THIS EASIER THAN WORKING IN GRAY; IT CAN BE DIFFICULT TO SEE THE DIFFERENCE IN GRAYS THAT ARE CLOSE IN VALUE.)

WHEN YOU'RE DONE, REPLACE EACH COLOR WITH A GRAY, FROM BLACK AT THE BACK TO WHITE IN FRONT IN CONSISTENT INTERVALS. IF YOU HAVE TEN LEVELS, MAKE EACH TONE 10% LIGHTER THAN THE ONE BEHIND IT. IF TWENTY LEVELS, MAKE THEM 5% APART.

YOUR FINISHED MAP WILL HAVE A VERY TERRACED APPEARANCE IF YOU LEAVE THE EDGES BETWEEN TONES SHARP. SOFTEN THEM BY APPLYING GAUSSIAN BLUR.

NOW GO TO A CG APPLICATION (I USE LIGHTWAVE). CREATE A MESH MODEL--A RECTANGLE DIVIDED UP INTO THOUSANDS OF SMALL SQUARES, KIND OF LIKE A BEDSHEET WITH A HIGH THREAD COUNT.

IN LIGHTWAVE-- AFTEREFFECTS, MAYA, OR BLENDER WILL ALSO WORK--APPLY THE ORIGINAL DRAWING AS AN IMAGE AND THE GRAYSCALE AS A "DISPLACEMENT MAP." THIS WILL MOLD THE MESH MODEL INTO AN UNDULATING SHAPE LIKE AN EMBOSSED POSTCARD.

CREATE TWO RENDERINGS, SHIFTING YOUR VIRTUAL CAMERA A SLIGHT DISTANCE HORIZONTALLY. (FOR COMPARISON, YOUR EYES ARE ROUGHLY 2 INCHES APART.)

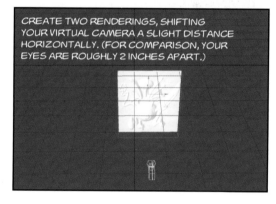

IF ALL GOES RIGHT, YOU SHOULD WIND UP WITH TWO RENDERINGS THAT YOU CAN PLACE SIDE BY SIDE FOR CROSS-EYED VIEWING.

THE RESULTING IMAGE WILL HAVE A SUBTLE, TEXTURED ROUNDNESS THAT'S IMPOSSIBLE TO ACHIEVE JUST THROUGH PHOTOSHOP MANIPULATION.

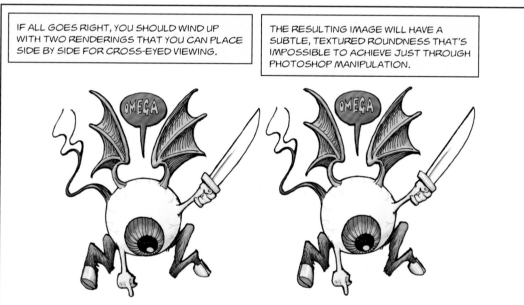

OF COURSE, IT ALSO WORKS AS AN ANAGLYPH.

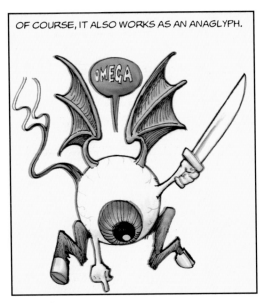

SO, THIS IS A BOOK ABOUT PERSPECTIVE. WHAT HAVE WE NOT TALKED ABOUT AT ALL IN THIS CHAPTER?

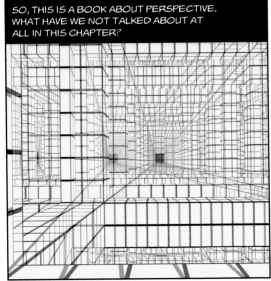

ANSWER: *PERSPECTIVE!*

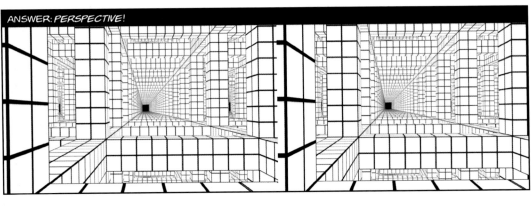

HOW DO YOU DRAW PERSPECTIVE IN 3-D?

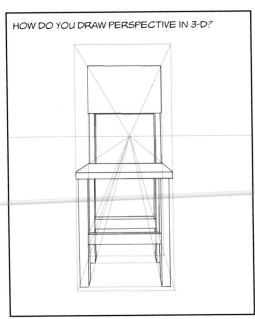

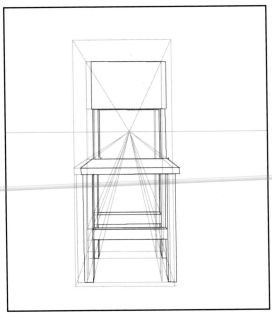

ONE-POINT PERSPECTIVE IS EASIEST. START BY DRAWING A BOX LIKE THIS.

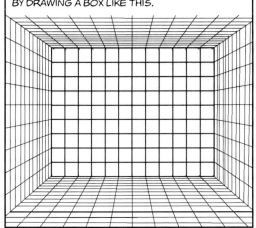

HOW MUCH SHOULD THE SECOND IMAGE BE DISPLACED? IT DEPENDS ON THE SCALE. YOUR EYES ARE ABOUT 2 INCHES APART.

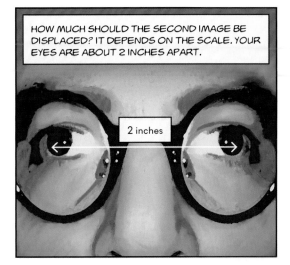

2 inches

SO, FOR EXAMPLE, IF THIS ROOM IS 12 FEET WIDE, THEN THE SHIFT BETWEEN EACH EYE'S VIEW IS ONE-SIXTH THE WIDTH OF A SQUARE.

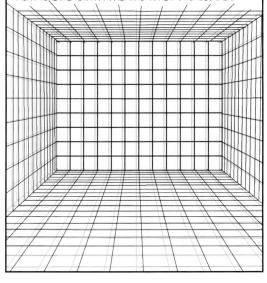

HOWEVER, IF YOU'RE LOOKING AT A BOX 2 FEET WIDE, THEN EACH SQUARE IS 2 INCHES AND THE SHIFT BETWEEN EYES IS A FULL SQUARE.

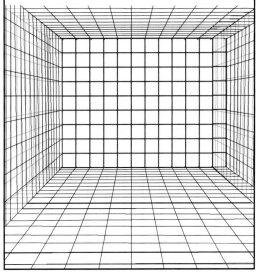

WHATEVER THE SHIFT, THE VANISHING POINT STAYS PUT!

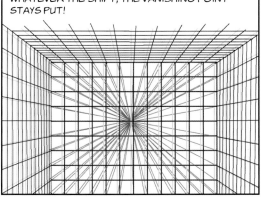

YOU SHOULD WIND UP WITH SOMETHING LIKE THIS.

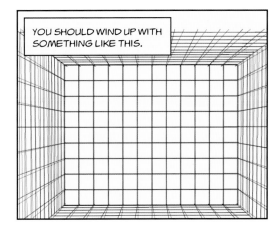

IF SETTING UP 3-D PERSPECTIVE IN ONE-POINT PERSPECTIVE IS (RELATIVELY) EASY, WHAT ABOUT TWO-POINT PERSPECTIVE?

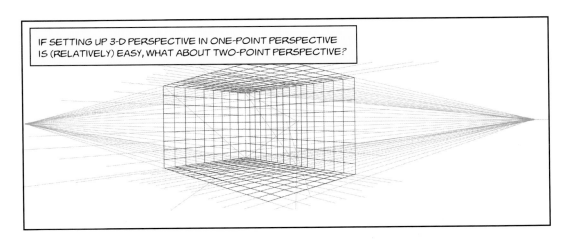

AS WITH ONE-POINT PERSPECTIVE, THE SECRET TO 3-D DRAWING IS SHIFTING THINGS OVER HORIZONTALLY. AFTER DRAWING YOUR DIAGRAM, DRAW A RECTANGLE TOUCHING BOTH WALLS, AS WELL AS THE CEILING AND FLOOR, ON AN UPPER LAYER OR SHEET OF TRACING PAPER. BE SURE TO MARK THE HORIZONTAL DIVISIONS ON EACH WALL.

NOW, SHIFT THE RECTANGLE OVER A BIT. YOU KNOW THE DRILL: MORE IF THE SCALE IS SMALL, LESS IF IT'S LARGE.

USING THE SAME LEFT AND RIGHT VANISHING POINTS, DRAW A NEW ROOM, WITH THE LINES DEFINING THE EDGES BETWEEN FLOOR AND CEILING PASSING THROUGH THE CORNERS OF THE RECTANGLE. THE EDGE WHERE THE TWO WALLS MEET SHOULD BE THE SAME HEIGHT, BUT SHIFTED TO THE RIGHT.

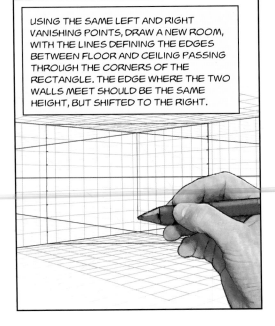

NOW, CARRY OVER THE SQUARE DIVISIONS ON THE LOWER LAYER TO THE EDGES ON THE TOP LAYER. MAKING A GRID VISIBLE WILL HELP LINE THE MARKS UP HORIZONTALLY. (IF YOU'RE WORKING ON PAPER, USE A T-SQUARE AND TRIANGLE.)

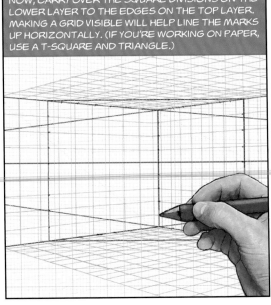

USE THE VANISHING POINTS TO DRAW LINES THROUGH THE DIVISIONS ON EACH WALL USING DIAGONAL DIVISIONS TO DOUBLE-CHECK YOUR PROPORTIONS.

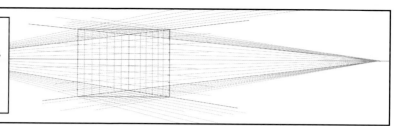

ONCE YOU HAVE ALL THE LINES DRAWN, GO OVER THE SQUARE DIVISIONS IN BLACK. USE DIAGONALS TO ADD SQUARES OUTSIDE THE RECTANGLE.

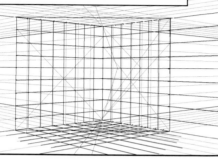

WHEN YOU HAVE THE ROOM DRAWN, YOU SHOULD HAVE TWO PIECES THAT CAN WORK IN 3-D.

THAT DOES IT FOR TWO-POINT PERSPECTIVE. WHAT ABOUT THREE-POINT PERSPECTIVE? WELL, FIRST DRAW THREE WALLS MEETING AT A CORNER IN THREE-POINT PERSPECTIVE.

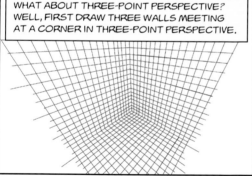

ON AN UPPER LAYER, DRAW A TRIANGLE WITH EACH OF ITS CORNERS TOUCHING AN EDGE BETWEEN WALLS AND EACH SIDE PARALLEL TO ONE OF THE THREE HORIZONS. THIS TRIANGLE IS A "TRUE SHAPE," ABSOLUTELY PERPENDICULAR TO YOUR LINE OF SIGHT. IF THE PICTURE PLANE WERE TO SLICE THROUGH THE ROOM AND CUT OFF ONE CORNER, THIS IS WHAT THE CUT WOULD LOOK LIKE.

MARK WHERE DIVISION LINES INTERSECT THE SIDES OF THE TRIANGLE. (TO SIMPLIFY YOUR WORK, JUST MARK THE INTERSECTIONS FOR ONE SET OF LINES ON EACH SIDE.)

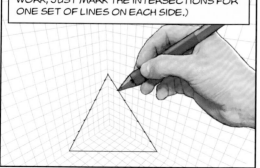

NOW, SHIFT THE TRIANGLE SLIGHTLY TO THE LEFT HORIZONTALLY.

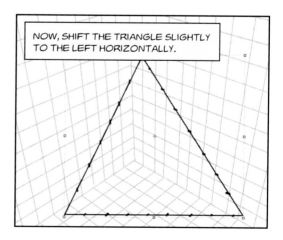

DRAW A NEW EDGE LINE FROM THE TOP CORNER TO THE BOTTOM VANISHING POINT.

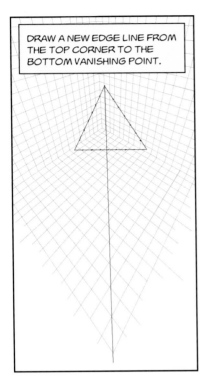

TURN ON THE GRID, OR USE A RULER TO CARRY OVER THE VERTICAL DIVISIONS ALONG THE EDGE TO THE NEW EDGE LINE.

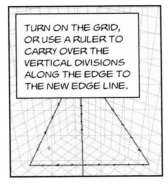

ADD EDGE LINES FROM THE CORNERS TO THE POINT REPRESENTING THE CORNER OF THE ROOM. ADD DIVISION MARKS TO THE EDGES.

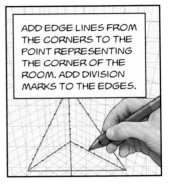

DRAW LINES FROM THE VANISHING POINTS THROUGH THOSE DIVISIONS TO DIVIDE THE WALLS OF THE ROOM INTO SMALLER SQUARES.

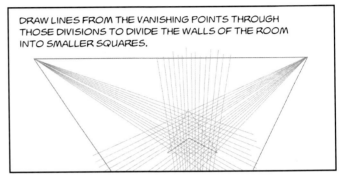

GO OVER THE LINES IN BLACK AND USE DIAGONALS TO EXTEND THE GRIDDED AREA OUTSIDE THE TRIANGLE.

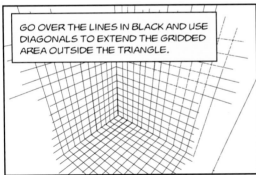

EVENTUALLY, YOU WILL WIND UP WITH A GRID THAT CAN BE COMBINED WITH YOUR ORIGINAL DRAWING TO MAKE A STEREO IMAGE.

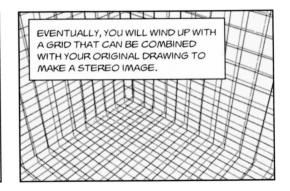

KNOWING WHAT WE KNOW ABOUT SHIFTING LINES OVER, LET'S DRAW A SCENE IN 3-D PERSPECTIVE! TO MAKE IT SIMPLE, LET'S MAKE IT IN ONE-POINT PERSPECTIVE.

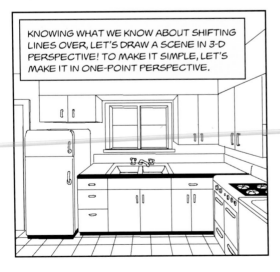

MARK THE VANISHING POINT.

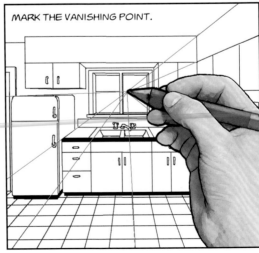

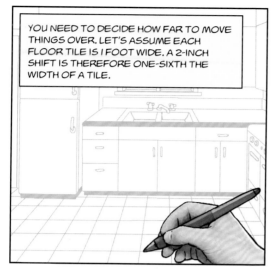

YOU NEED TO DECIDE HOW FAR TO MOVE THINGS OVER. LET'S ASSUME EACH FLOOR TILE IS 1 FOOT WIDE. A 2-INCH SHIFT IS THEREFORE ONE-SIXTH THE WIDTH OF A TILE.

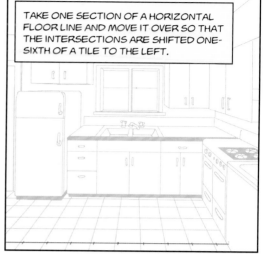

TAKE ONE SECTION OF A HORIZONTAL FLOOR LINE AND MOVE IT OVER SO THAT THE INTERSECTIONS ARE SHIFTED ONE-SIXTH OF A TILE TO THE LEFT.

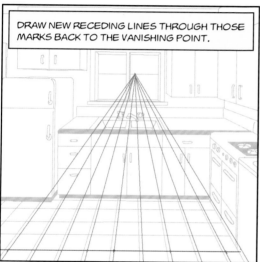

DRAW NEW RECEDING LINES THROUGH THOSE MARKS BACK TO THE VANISHING POINT.

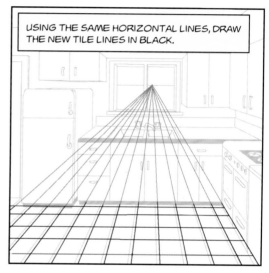

USING THE SAME HORIZONTAL LINES, DRAW THE NEW TILE LINES IN BLACK.

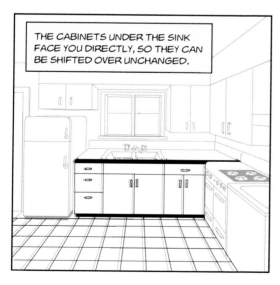

THE CABINETS UNDER THE SINK FACE YOU DIRECTLY, SO THEY CAN BE SHIFTED OVER UNCHANGED.

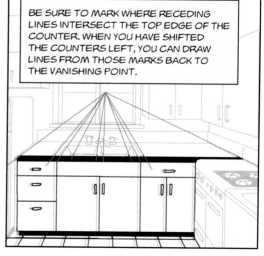

BE SURE TO MARK WHERE RECEDING LINES INTERSECT THE TOP EDGE OF THE COUNTER. WHEN YOU HAVE SHIFTED THE COUNTERS LEFT, YOU CAN DRAW LINES FROM THOSE MARKS BACK TO THE VANISHING POINT.

GO OVER THOSE COUNTERTOP LINES IN BLACK. YOU CAN ALSO DRAW THE BACKSPLASH OVER THE BACK EDGE OF THE COUNTER.

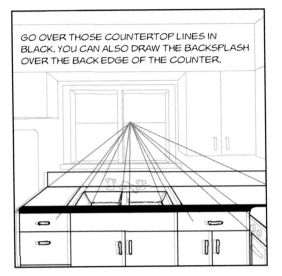

THE BACKSPLASH TOUCHES THE WALL, SO YOU CAN SELECT EVERYTHING ON THE WALL: WINDOW FRAME, EDGES OF CABINETS, BACK OF THE REFRIGERATOR, AND SO ON . . .

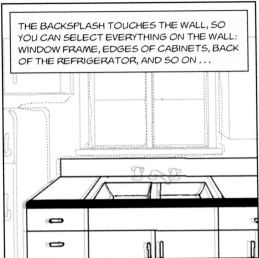

. . . AND SHIFT THEM TO THE LEFT THE SAME AMOUNT AS THE BACKSPLASH.

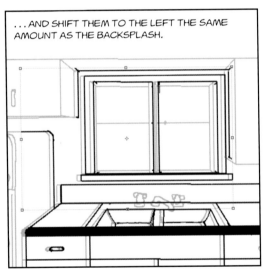

NEXT, DRAW LINES OUT FROM THE VANISHING POINT TO DRAW THE EDGES OF THE UPPER CABINETS.

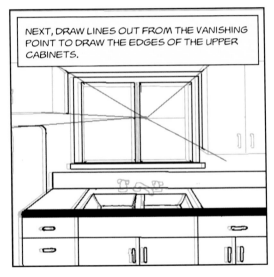

LINK RECEDING LINES AND THE HORIZONTAL LINES AT THE TOP AND BOTTOM OF THE CABINET DOOR ON THE RIGHT TO DRAW A NEW LINE DEFINING THE LEFT EDGE OF THAT DOOR . . .

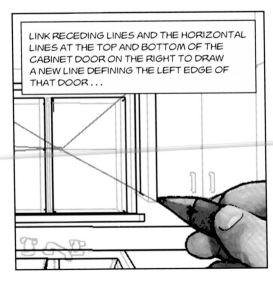

. . . AND THEN SHIFT THE ENTIRE TOP SECTION OF THE CABINET OVER SO THAT THE LEFT EDGE OF THE CABINET DOOR IS EXACTLY ON THAT LINE.

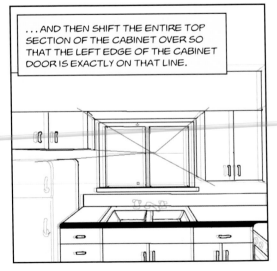

DON'T FORGET TO DRAW THE RECEDING EDGES AROUND THE WINDOW IN BLACK.

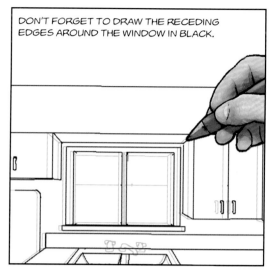

TO START TO REDEFINE THE CABINETS IN PERSPECTIVE TO THE LEFT, DRAW LINES FROM THE VANISHING POINT THROUGH THE POINTS WHERE EDGE LINES MEET AT A CORNER.

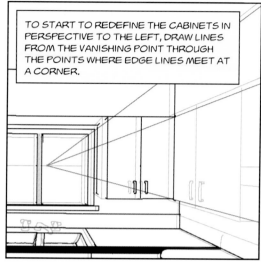

TO FIND WHERE TO DRAW VERTICAL LINES ON THE CABINET IN PERSPECTIVE, CARRY THE TOP AND BOTTOM POINTS OVER TO THE NEW RECEDING LINES. MAKE SURE THEY EXACTLY LINE UP HORIZONTALLY.

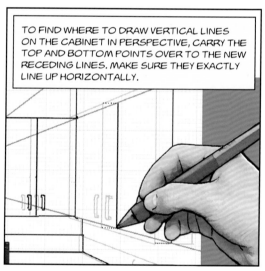

IT IS MUCH THE SAME FOR THE VERTICAL LINES ON THE STOVE.

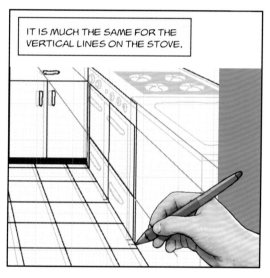

AFTER SOME WORK SHIFTING LAYERS OVER AND LINKING THEM WITH LINES DRAWN BACK TO THE VANISHING POINT, YOU SHOULD HAVE A DRAWING SOMETHING LIKE THIS.

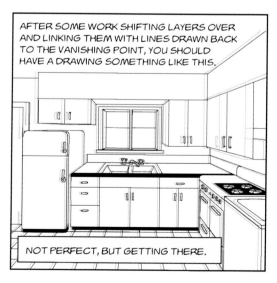

NOT PERFECT, BUT GETTING THERE.

YOU'RE NOW READY TO CONVERT THE ORIGINAL DRAWING TO RGB MODE AND PASTE THE NEW DRAWING INTO THE RED CHANNEL.

IT STILL NEEDS A FEW TWEAKS (ESPECIALLY IN THE AREA AROUND THE STOVE).

LASSO THOSE KNOBS AND HANDLES ONE AT A TIME, AND SHIFT EACH OF THEM OVER A BIT, MAYBE APPLYING SOME PERSPECTIVE OR WARP, UNTIL THEY LOOK REASONABLY CORRECT.

SIMILARLY, STRETCH THE SCALE OF THE FAUCET HORIZONTALLY TO GIVE IT A BIT OF DEPTH.

ONCE YOU'VE GOT THE PICTURE LOOKING GOOD . . .

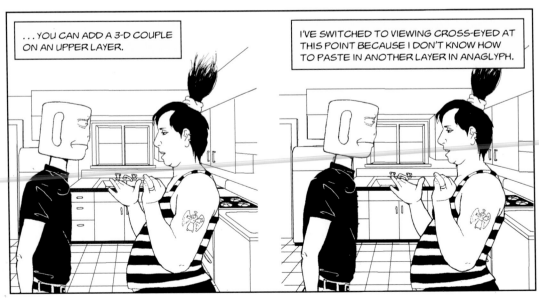

. . . YOU CAN ADD A 3-D COUPLE ON AN UPPER LAYER.

I'VE SWITCHED TO VIEWING CROSS-EYED AT THIS POINT BECAUSE I DON'T KNOW HOW TO PASTE IN ANOTHER LAYER IN ANAGLYPH.

LET'S ADD ONE MORE THING TO THE PICTURE:

A RELIEF-MAPPED JELLO MOLD! YOU SHOULD KNOW THE DRILL BY NOW

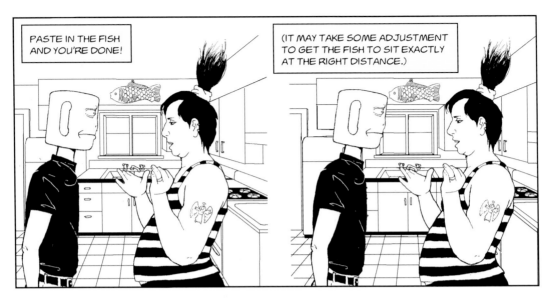

PASTE IN THE FISH AND YOU'RE DONE!

(IT MAY TAKE SOME ADJUSTMENT TO GET THE FISH TO SIT EXACTLY AT THE RIGHT DISTANCE.)

TAKE A REST--YOU'VE EARNED IT!

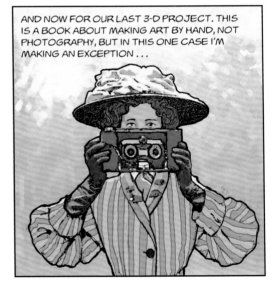

AND NOW FOR OUR LAST 3-D PROJECT. THIS IS A BOOK ABOUT MAKING ART BY HAND, NOT PHOTOGRAPHY, BUT IN THIS ONE CASE I'M MAKING AN EXCEPTION . . .

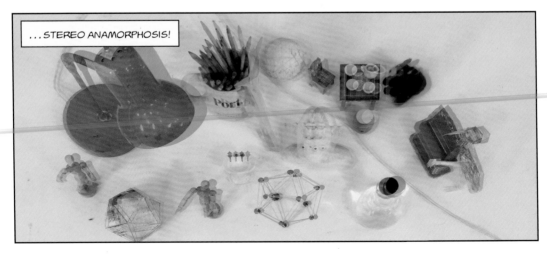

. . . STEREO ANAMORPHOSIS!

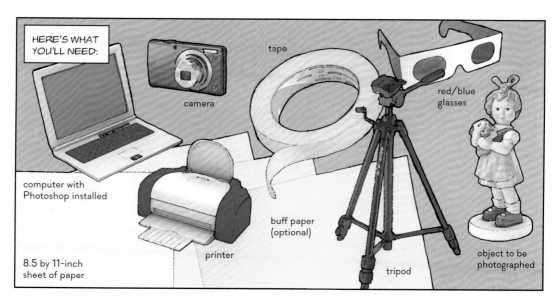

HERE'S WHAT YOU'LL NEED:

camera

tape

red/blue glasses

computer with Photoshop installed

buff paper (optional)

8.5 by 11-inch sheet of paper

printer

tripod

object to be photographed

IF YOU HAPPEN TO OWN A STEREO CAMERA, SO MUCH THE BETTER. THERE WEREN'T ANY FOR A LONG TIME AFTER THE CONVERSION FROM FILM TO DIGITAL, BUT NOW THERE ARE MODELS ON THE MARKET.

IF YOU DON'T HAVE A STEREO CAMERA, YOU WILL HAVE TO WORK OUT A SYSTEM FOR SHIFTING THE CAMERA. START BY SETTING YOUR TRIPOD ON THE GROUND WITH THE CAMERA ON TOP SET AT THE HEIGHT OF YOUR EYE.

MARK THE SPOT WHERE EACH FOOT TOUCHES THE FLOOR WITH AN "X" IN TAPE.

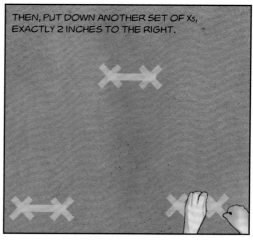

THEN, PUT DOWN ANOTHER SET OF Xs, EXACTLY 2 INCHES TO THE RIGHT.

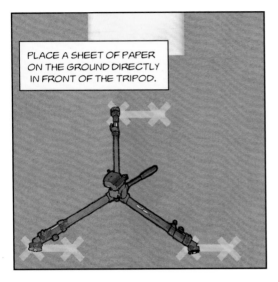

PLACE A SHEET OF PAPER ON THE GROUND DIRECTLY IN FRONT OF THE TRIPOD.

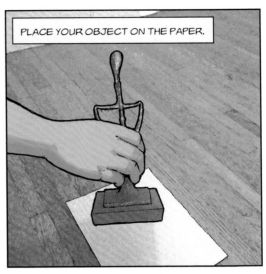

PLACE YOUR OBJECT ON THE PAPER.

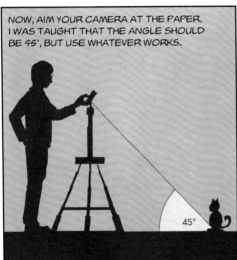

NOW, AIM YOUR CAMERA AT THE PAPER. I WAS TAUGHT THAT THE ANGLE SHOULD BE 45°, BUT USE WHATEVER WORKS.

45°

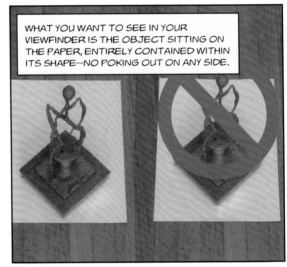

WHAT YOU WANT TO SEE IN YOUR VIEWFINDER IS THE OBJECT SITTING ON THE PAPER, ENTIRELY CONTAINED WITHIN ITS SHAPE--NO POKING OUT ON ANY SIDE.

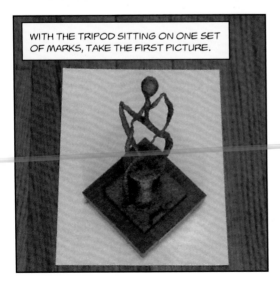

WITH THE TRIPOD SITTING ON ONE SET OF MARKS, TAKE THE FIRST PICTURE.

NOW, SHIFT THE TRIPOD OVER TO THE SECOND SET OF MARKS, AND TAKE A SECOND PICTURE.

SCAN, BEAM, E-MAIL, OR OTHERWISE LOAD BOTH PICTURES ONTO YOUR COMPUTER.

OPEN PHOTOSHOP.

ONCE THE IMAGE IS A RECTANGLE, SIZE IT TO 8.5 BY 7:1, OR WHATEVER THE SIZE OF YOUR PAPER IS.

USE THE PERSPECTIVE CROPPING TOOL, AND CROP EVERYTHING OUT BUT THE PAPER.

ONCE THE IMAGE IS A RECTANGLE, SIZE IT TO 8.5 X 11 INCHES , OR WHATEVER THE SIZE OF YOUR PAPER IS.

IF THE IMAGE IS IN COLOR, CONVERT IT TO GRAYSCALE.

THEN, BELIEVE IT OR NOT, CONVERT THE FILE BACK TO RGB.

REPEAT THE ENTIRE PROCESS FOR THE SECOND IMAGE.

COPY AND PASTE THE ENTIRE RIGHT IMAGE INTO THE RED CHANNEL OF THE LEFT IMAGE.

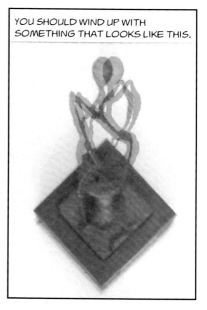

YOU SHOULD WIND UP WITH SOMETHING THAT LOOKS LIKE THIS.

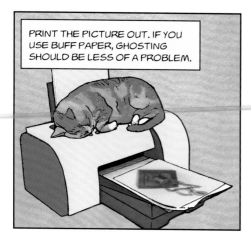

PRINT THE PICTURE OUT. IF YOU USE BUFF PAPER, GHOSTING SHOULD BE LESS OF A PROBLEM.

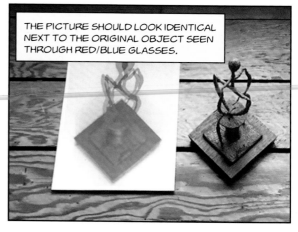

THE PICTURE SHOULD LOOK IDENTICAL NEXT TO THE ORIGINAL OBJECT SEEN THROUGH RED/BLUE GLASSES.

I KNOW I SAID THAT YOU SHOULD NEVER USE OTHER COLORS IN ANAGLYPH, BUT SOME PEOPLE ABSOLUTELY CANNOT LIVE WITHOUT FULL COLOR. THIS PART IS FOR THEM.

AS BEFORE, TAKE TWO PICTURES OF YOUR OBJECT ON A SHEET OF PAPER, MOVING THE CAMERA 2 INCHES BETWEEN SHOTS.

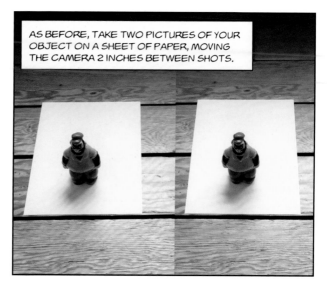

CROP AND SIZE EACH IMAGE AS YOU DID BEFORE. HOWEVER, SKIP THE STEP OF CONVERTING THEM TO GRAYSCALE.

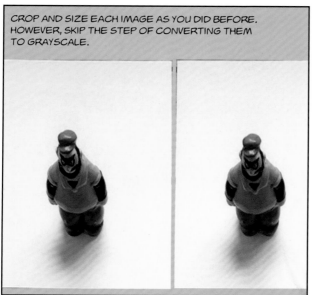

PASTE THE RED CHANNEL OF THE LEFT IMAGE INTO THE RED CHANNEL OF THE RIGHT IMAGE.

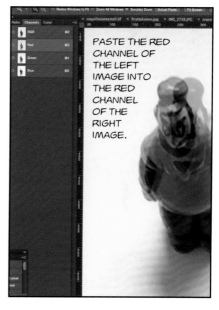

PRINT THE PICTURE OUT, AND VIEW IT IN PERSPECTIVE THROUGH RED/BLUE GLASSES.

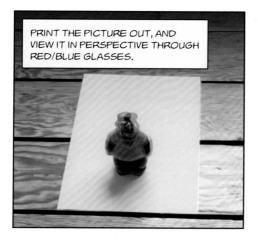

JUST DON'T SHOW IT TO ME!

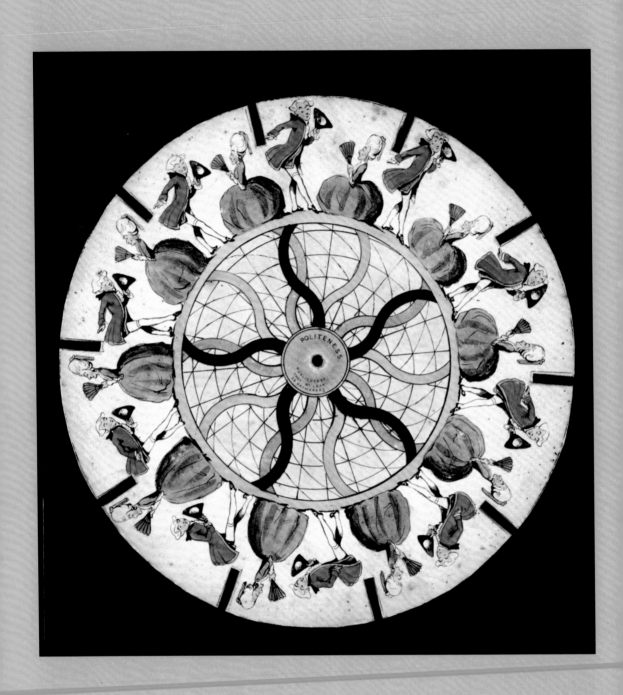

7
MOTION PERSPECTIVE

The first motion pictures were actually animated cartoons, created to be viewed on early-nineteenth-century optical devices like the disc-shaped phenakistoscope and the drum-shaped zoetrope. These cartoons preceded the first photographed motion pictures by half a century. Most—or let's just say all—of these early animations involved moving figures rather than motion perspective. That had to wait for the advent of the animated cartoon in the early twentieth century. Although motion perspective took care of itself in photographed motion pictures, early animators had to figure out how to get moving backgrounds to look plausible. Most of the time, it looks as if they were winging it but having fun. Animation pioneers Walt Disney and Max Fleischer seemed to be in competition for who could create the most impressive perspective pieces throughout the 1930s. Eventually, both devised mechanical means of avoiding the hard calculations involved in getting motion perspective to look right. One of the more charming stratagems was the "Setback Camera"—miniature sets on a revolving tabletop placed behind characters like Popeye and Betty Boop in Fleischer cartoons. (Stop-motion animator George Pal took realism a step further in his Puppetoons, which had entirely three-dimensional sets and models sculpted out of wood.) Disney countered with multiplane backgrounds mounted on multiple layers of glass, which produced a realistic effect when the camera moved sideways, but less so when the camera moved forward or back.

Artists who do not happen to be animators may think this does not concern them. However, manga artists in Japan know how to evoke a sense of dizzying speed by adding motion lines not to their figures, but to backgrounds, something that can only be done if one has a good grasp of motion perspective. Since a manga-influenced style is rapidly becoming default mode among younger cartoonists, an awareness of motion perspective is sure to become more and more important.

A zoetrope optical illusion disc from 1870: when spun it displays the illusion of motion (a man and woman bowing) in the circle of the disc's outer edge. Courtesy of Universal History Archive.

HOW TO EXPLAIN MOTION PERSPECTIVE?
LET'S START BY DRAWING THE HORIZON.

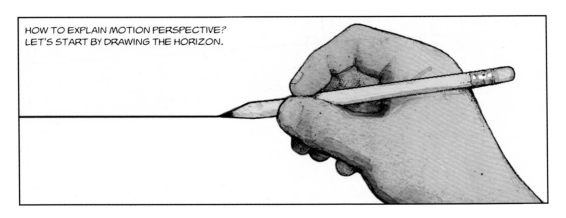

IN MY FIRST BOOK ON PERSPECTIVE, I EXPLAINED THAT THE HORIZON IS ALWAYS AT YOUR EYE LEVEL. I DEMONSTRATED THIS EFFECT BY SHOWING THE SAME FIGURE AT VARIOUS SIZES WITH HER EYES ALWAYS AT THE LEVEL OF THE HORIZON.

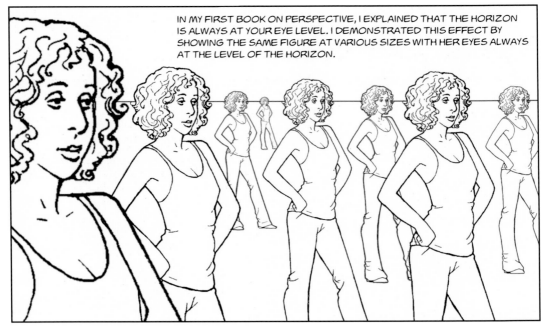

IMAGINE ALL OF THESE VERSIONS OF THIS FIGURE LINED UP FROM BIGGEST TO SMALLEST.

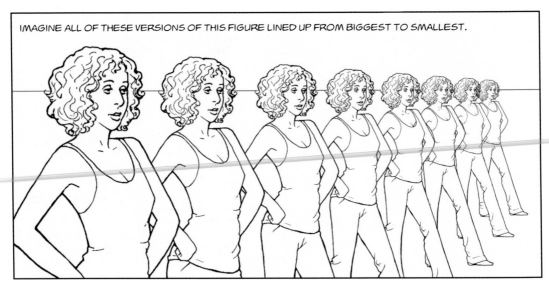

NOW, IMAGINE THAT YOU SEE EACH ONE IN QUICK SUCCESSION.

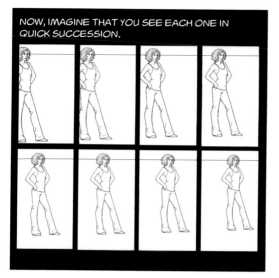

COMPILE ALL OF THESE INTO A FLIP BOOK. YOU WILL SEEM TO BE MOVING AWAY FROM THE FIGURE! TRUST ME!

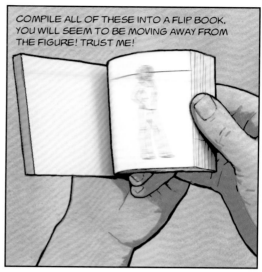

LET'S START A LOOPING ANIMATION. HERE'S WHAT YOU'LL NEED:

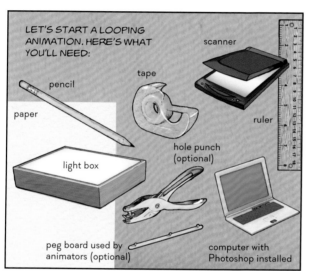

pencil

paper

light box

hole punch (optional)

tape

scanner

ruler

peg board used by animators (optional)

computer with Photoshop installed

DRAW A SERIES OF FIGURES, EACH A CERTAIN DISTANCE APART.

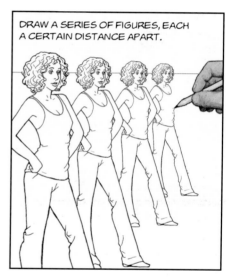

HOW FAR APART? THAT GETS COMPLICATED . . .

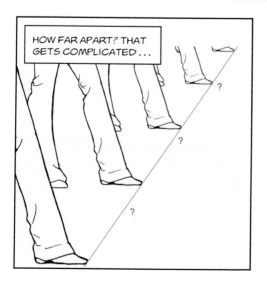

. . . BUT IT'S NOTHING THAT YOU CAN'T SOLVE BY DRAWING A SIMPLE GRID!

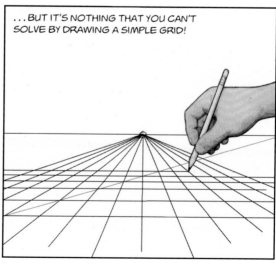

WITH THIS GRID, YOU CAN KNOW WITH PRECISION HOW FAR APART THOSE FIGURES WILL BE. (NOT THAT IT MATTERS.)

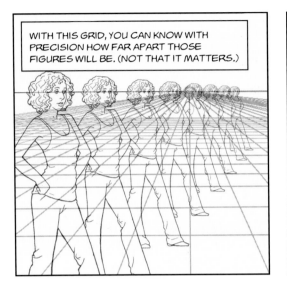

IN FACT, THE RECEDING LINES DON'T MATTER--ALL THAT MATTERS ARE THE HORIZONTAL LINES. (FOR THE MOMENT.)

DRAW TWO IDENTICAL BUT DIFFERENT-SIZE FIGURES. MAKE SURE THAT THEIR EYES LINE UP ON THE HORIZON AND THAT EACH HAS ONE TOE EXACTLY ON A HORIZONTAL LINE OF THE GRID.

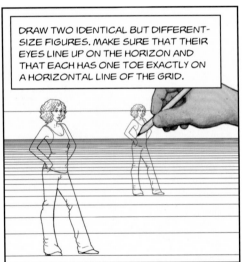

DRAW LINES BETWEEN THEM, LINKING UP MATCHING FEATURES. THOSE LINES SHOULD CONVERGE AT A POINT ON THE HORIZON.

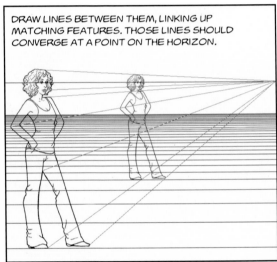

COUNT THE SPACE BETWEEN THEM, AND THEN ADD ANOTHER FIGURE AT THAT SAME DISTANCE BUT FARTHER BACK IN SPACE.

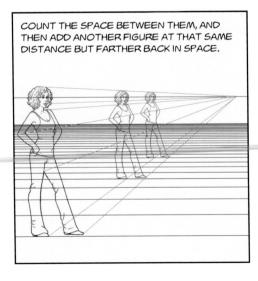

ADD AS MANY ADDITIONAL FIGURES AS YOUR SPACE WILL ALLOW.

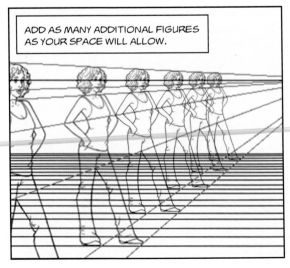

NOW LAY ANOTHER SHEET OF PAPER ON TOP, EXACTLY IN PLACE. ANIMATORS DO THIS USING PEGS AND PUNCHED PAPER. YOU CAN GET AWAY WITH LAYING THE PAPER AGAINST AN EDGE--LIKE A TAPED-DOWN RULER.

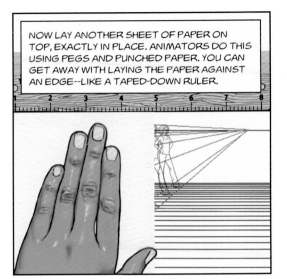

TURN ON THE LIGHT BOX, AND TRACE ALL OF YOUR FIGURES. (THIS MAY SEEM SILLY, BUT YOU WANT A VERSION WITHOUT THE RECEDING LINES.) LABEL THIS AS FRAME #1

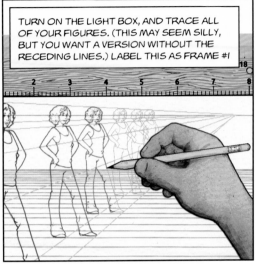

LAY ANOTHER PIECE OF PAPER OVER YOUR DRAWING.

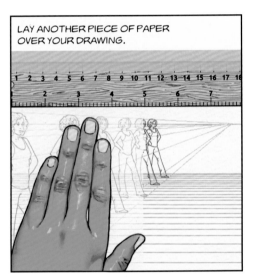

FIND THE LINE HALFWAY BETWEEN THE TWO NEAREST FIGURES, AND DRAW AN INTERMEDIATE-SIZED FIGURE BETWEEN THEM. DO THE SAME FOR THE HALFWAY POINT BETWEEN FIGURES FARTHER BACK IN SPACE. GIVE THIS PANEL A NUMBER (SINCE IT IS FOUR LINES BACK IN SPACE FROM LINE NUMBER ONE, LABEL IT AS FRAME #5.),

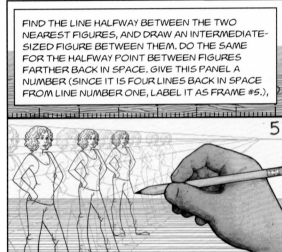

USING AS MANY PIECES OF PAPER AS YOU NEED, DRAW THE FRAMES BETWEEN FRAME #1 AND FRAME #5. NAME EACH DRAWING WITH THE APPROPRIATE NUMBER. ANIMATORS CALL THIS PROCESS "IN-BETWEENING."

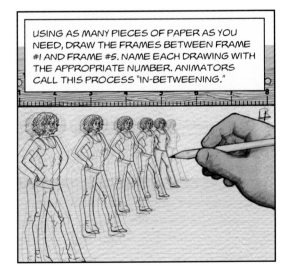

YOU MAY RUN INTO A PROBLEM SEEING THROUGH ALL THOSE LAYERS OF PAPER. AT THIS POINT, REMOVE ALL THE DRAWINGS ON TOP OF FRAME #5.

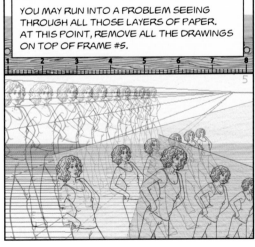

DRAW ALL THE FIGURES BETWEEN THE MIDDLE FIGURE AND THE NEXT ONE BACK IN SPACE. THESE WOULD BE FRAMES 6, 7, AND 8. (FRAME 9 WILL BE FRAME 1 REPEATED.)

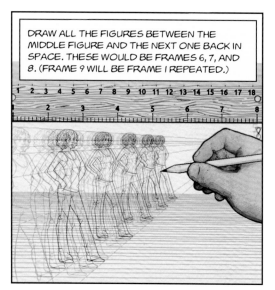

YOU SHOULD NOW HAVE A COMPLETE CYCLE--ONE THAT WILL LOOP INFINITELY.

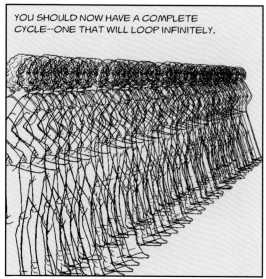

NEXT STEP: SCAN ALL THE FRAMES.

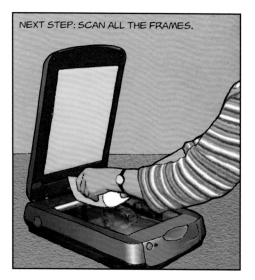

OPEN PHOTOSHOP AND CREATE A SINGLE IMAGE FILE, WITH ALL THE FRAMES IMPORTED AS LAYERS IN ORDER.

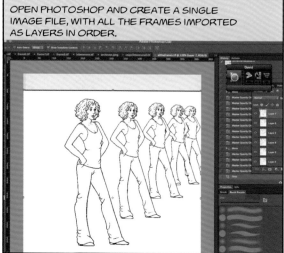

OPEN UP THE TIMELINE WINDOW.

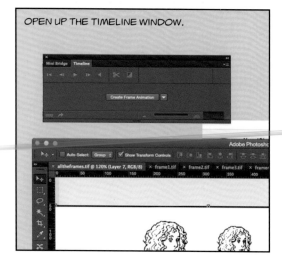

IN THE TIMELINE WINDOW, CLICK *CREATE FRAME ANIMATION*.

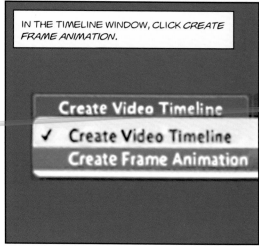

Create Video Timeline

✓ Create Video Timeline

Create Frame Animation

YOU SHOULD SEE ONE IMAGE FROM YOUR ANIMATION IN THE WINDOW.

CLICK ON THE TINY LITTLE DOWN-ARROW BUTTON AT THE FAR RIGHT OF THE TIMELINE WINDOW. WHEN YOU CLICK ON THAT, YOU SHOULD SEE AN OPTION CALLED *MAKE FRAMES FROM LAYERS*.

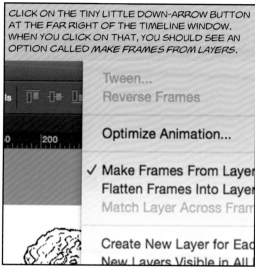

NOW, YOU SHOULD SEE ALL THE FRAMES FROM YOUR ANIMATION. EACH FRAME WILL ALSO HAVE A NUMBER BELOW THE IMAGE THAT LETS YOU SET THE LENGTH OF TIME THAT EACH FRAME IS DISPLAYED.

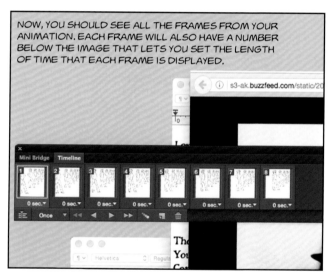

ONCE YOU HAVE SELECTED THE TIME FOR EACH FRAME, YOU'RE READY TO SAVE YOUR ANIMATION TO A GIF FILE.

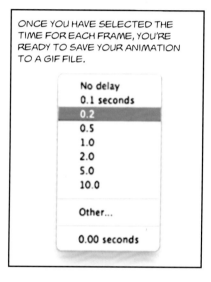

GO TO FILE AND CLICK ON *SAVE FOR WEB*.

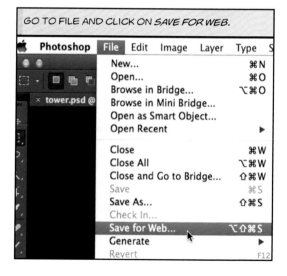

YOU SHOULD SEE A WINDOW.

BE SURE TO HAVE YOUR FILE TYPE SET TO GIF. PREVIEW THE ANIMATION BEFORE SAVING IT.

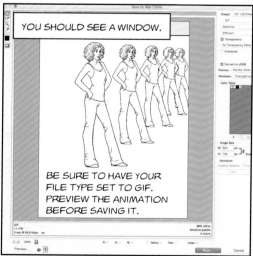

AFTER THAT, YOU CAN ANNOY PEOPLE WITH YOUR LOOPING GIF ALL OVER THE WEB.

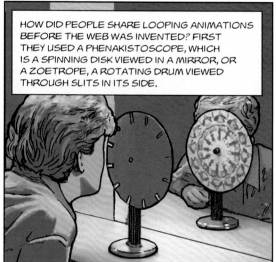

HOW DID PEOPLE SHARE LOOPING ANIMATIONS BEFORE THE WEB WAS INVENTED? FIRST THEY USED A PHENAKISTOSCOPE, WHICH IS A SPINNING DISK VIEWED IN A MIRROR, OR A ZOETROPE, A ROTATING DRUM VIEWED THROUGH SLITS IN ITS SIDE.

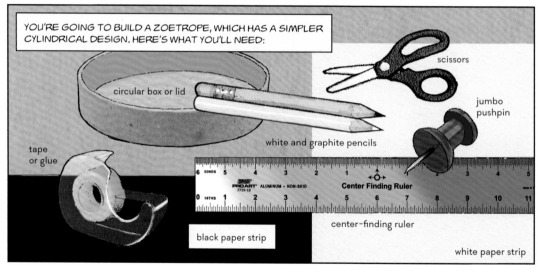

YOU'RE GOING TO BUILD A ZOETROPE, WHICH HAS A SIMPLER CYLINDRICAL DESIGN. HERE'S WHAT YOU'LL NEED:

circular box or lid

scissors

jumbo pushpin

white and graphite pencils

tape or glue

black paper strip

center-finding ruler

white paper strip

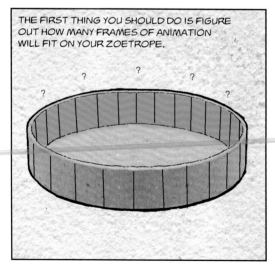

THE FIRST THING YOU SHOULD DO IS FIGURE OUT HOW MANY FRAMES OF ANIMATION WILL FIT ON YOUR ZOETROPE.

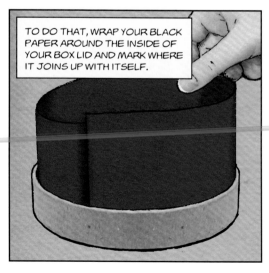

TO DO THAT, WRAP YOUR BLACK PAPER AROUND THE INSIDE OF YOUR BOX LID AND MARK WHERE IT JOINS UP WITH ITSELF.

LAY THE PAPER FLAT AND DIVIDE IT UP INTO EQUAL SECTIONS.
THEY SHOULD BE ABOUT TWICE AS TALL AS THEY ARE WIDE.

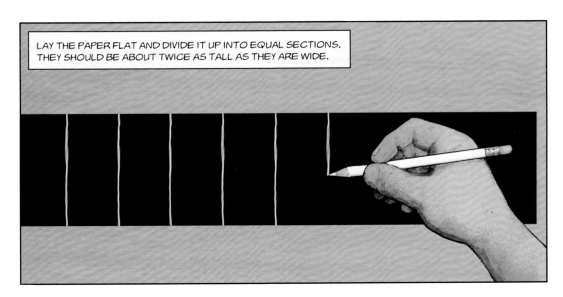

AT EACH DIVISION, CUT A THIN SLIT
ABOUT HALFWAY DOWN THE PAPER.

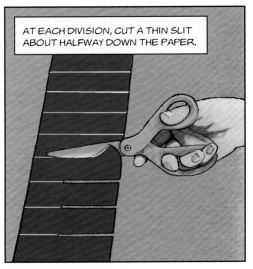

CUT OUT A WHITE STRIP OF PAPER ABOUT HALF
AS TALL AS THE BLACK STRIP, BUT THE SAME
WIDTH, WITH THE SAME DIVISIONS.

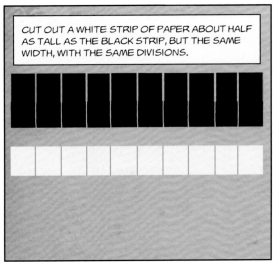

EITHER DRAW YOUR ANIMATION WITHIN THE
DIVISIONS, OR DRAW THEM SOMEWHERE
ELSE AND PASTE THEM DOWN.

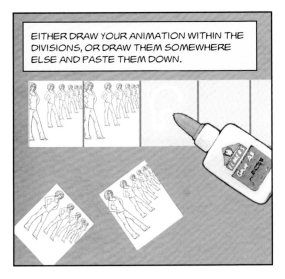

YOUR BOX LID WILL NEED TO SPIN. TO ALLOW
IT TO DO THAT, YOU NEED TO POKE A HOLE
IN THE MIDDLE OF IT.

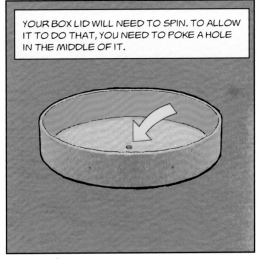

YOU CAN FIND THE CENTER USING THE CENTER-FINDING RULER. WHEN YOUR RULER IS AT THE MAXIMUM LENGTH THAT WILL FIT WITHIN THE CIRCLE, MARK THE CENTER.

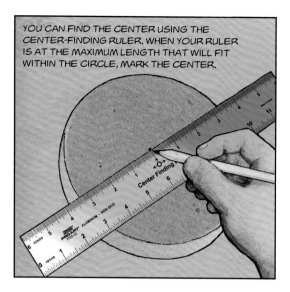

POKE THE PUSHPIN THROUGH TO MAKE A HOLE.

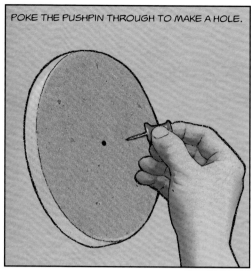

GLUE OR TAPE THE BLACK STRIP IN PLACE WITHIN THE BOX LID.

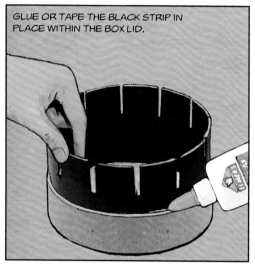

TAPE OR GLUE THE WHITE PAPER STRIP TOGETHER AND PLACE IT INSIDE THE BLACK PAPER. DON'T TAPE OR GLUE IT DOWN, BECAUSE YOU MAY WANT TO USE THIS ZOETROPE FOR ANOTHER ANIMATION.

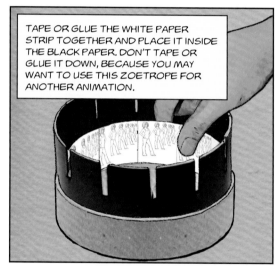

SPIN THE BOX LID ON TOP OF THE PUSHPIN AND VIEW THE ANIMATION THROUGH THE SLITS. IT SHOULD TOTALLY WORK!

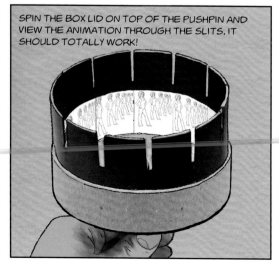

SO FAR, I'VE COVERED MOTION PERSPECTIVE GOING FORWARD AND BACK IN SPACE. BUT WHAT ABOUT MOVING SIDE TO SIDE?

ONCE AGAIN, DRAW A SQUARE TILE PATTERN ON THE GROUND. BUT THIS TIME THE SIDE-TO-SIDE DIVISIONS DEFINITELY MATTER!

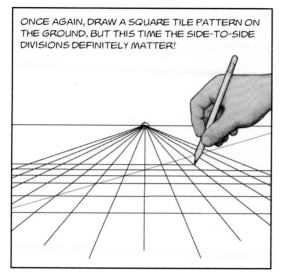

DRAW SOME IDENTICAL FIGURES A CERTAIN DISTANCE APART.

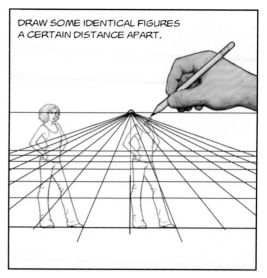

I WON'T INSULT YOUR INTELLIGENCE. IT SHOULD BE PRETTY EASY TO FIGURE OUT HOW TO CREATE A LOOPING GIF FROM THESE.

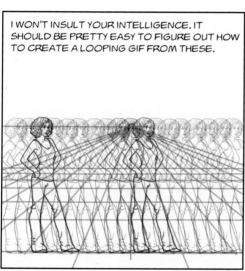

USE THE HORIZONTAL DIVISIONS TO PLOT HOW MUCH TO MOVE FIGURES FROM FRAME TO FRAME. FIGURES FARTHER BACK IN SPACE WILL COVER A SMALLER VISUAL DISTANCE IN THE SAME AMOUNT OF TIME, AND FIGURES FARTHER BACK THAN THAT WILL APPEAR TO MOVE EVEN LESS.

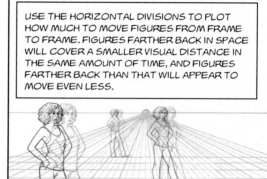

A VERY DISTANT OBJECT IN THE BACKGROUND WILL NOT APPEAR TO MOVE AT ALL.

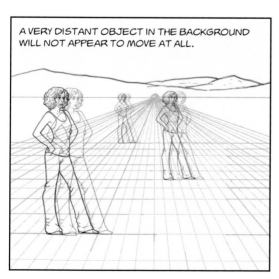

SO FAR, SO SIMPLE. NONE OF THE OBJECTS MOVING SIDE TO SIDE ACTUALLY CHANGE APPEARANCE AT ALL. YOU COULD HAVE THE DRAWINGS ON DIFFERENT LAYERS AND JUST PULL THEM SIDEWAYS.

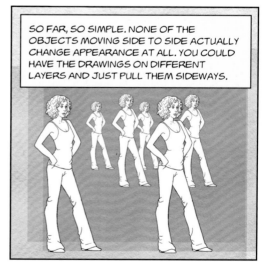

THINGS GET MORE COMPLICATED IF YOU HAVE AN OBJECT MOVING BACK IN SPACE.

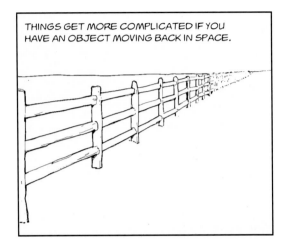

THE FENCE RAILS HAVE TO BE DRAWN DIFFERENTLY FOR EACH FRAME SO THEY ALWAYS GO TO THE VANISHING POINT.

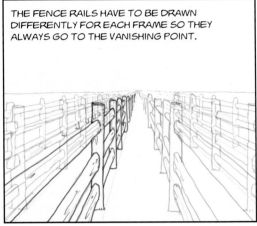

OF COURSE, NOT ALL ANIMATORS BOTHER TO GET MOTION PERSPECTIVE RIGHT. THERE ARE SOME VERY INGENIOUS WAYS TO WORK AROUND IT, SUCH AS THE CYCLING BACKGROUND YOU OFTEN SEE WHEN CHARACTERS ARE CHASING EACH OTHER AROUND.

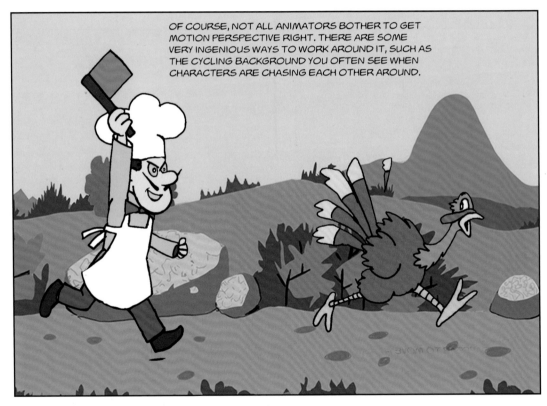

ALL IT REALLY CONSISTS OF IS A STRIP OF LANDSCAPE ELEMENTS THAT EVENTUALLY REPEATS. TO USE ONE, JUST MOVE THE CAMERA ALONG IT A LITTLE BIT EACH FRAME, AND WHEN YOU GET TO THE END, START OVER.

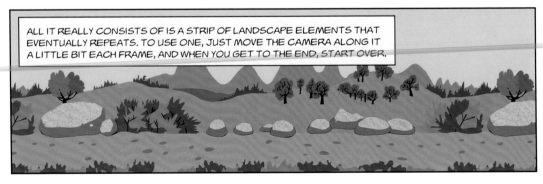

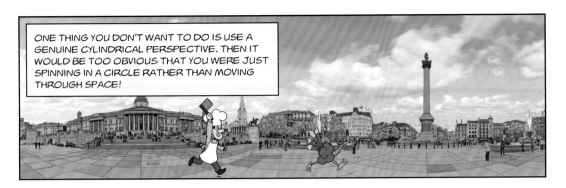

ONE THING YOU DON'T WANT TO DO IS USE A GENUINE CYLINDRICAL PERSPECTIVE. THEN IT WOULD BE TOO OBVIOUS THAT YOU WERE JUST SPINNING IN A CIRCLE RATHER THAN MOVING THROUGH SPACE!

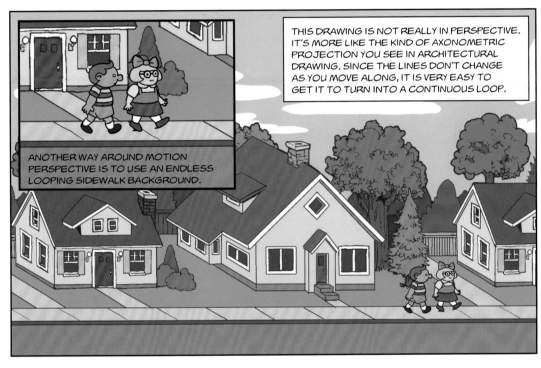

THIS DRAWING IS NOT REALLY IN PERSPECTIVE. IT'S MORE LIKE THE KIND OF AXONOMETRIC PROJECTION YOU SEE IN ARCHITECTURAL DRAWING. SINCE THE LINES DON'T CHANGE AS YOU MOVE ALONG, IT IS VERY EASY TO GET IT TO TURN INTO A CONTINUOUS LOOP.

ANOTHER WAY AROUND MOTION PERSPECTIVE IS TO USE AN ENDLESS LOOPING SIDEWALK BACKGROUND.

DOES THIS COVER THE WHOLE TOPIC? NOT EVEN CLOSE! HOWEVER, FOR FURTHER STUDY YOU SHOULD REFER TO A BOOK ABOUT ANIMATION WRITTEN BY SOMEONE WHO REALLY HAS THIS SUBJECT DOWN COLD.

CONCLUSION

This book is only the beginning. The projects in the previous pages are not ends in themselves, but a means for you to learn to think spatially by exploring some of the cooler aspects of perspective. Perhaps you can devise a better means of tracing an image than Tim Jenison's, or a more ingenious illusion than the Ames Room. You may want to consider further explorations in anamorphosis, such as painting on the interior of a dome, or across all the walls of one room, or onto a mountainside (it has been done). The basic pattern of six-point perspective drawn on a sphere can be projected and distorted in an infinite number of ways. Three-dimensional drawing is an art form with possibilities that have barely been scratched. Motion perspective is of course a major component of animation, which is a whole art form of its own. I hope that you regard what you have read as a starting point for your own explorations, and take the principles in it even further. Astonish me!

INDEX

To my wife, Eve, and our children,
Benjamin and Rebecca, who are always
there to provide a perspective check.

Published in the United States by Watson-Guptill Publications,
an imprint of the Crown Publishing Group, a division of Penguin
Random House LLC, New York.
www.crownpublishing.com
www.watsonguptill.com

WATSON-GUPTILL and the WG and Horse designs are registered
trademarks of Penguin Random House LLC.

Library of Congress Cataloging-in-Publication Data
Names: Chelsea, David, author.
Title: Perspective in action / David Chelsea.
Description: First edition. | New York : Watson-Guptill, 2017.
Identifiers: LCCN 2016045493 | (paperback)
Subjects: LCSH: Perspective—Comic books, strips, etc. | Graphic novels. |
 BISAC: ART / Techniques / General. | ART / Study & Teaching. |
 COMICS & GRAPHIC NOVELS / Nonfiction.

Classification: LCC NC750 .C4447 2017 | DDC 741.5—dc23

LC record available at https://lccn.loc.gov/2016045493

Trade Paperback ISBN: 978-1-60774-946-2

eBook ISBN: 978-1-60774-947-9

Printed in China

Design by Emily Blevins and Mari Gill

Art Assistance by Jacob Mercy

10 9 8 7 6 5 4 3 2 1

First Edition